THE JOYOUS ENVIRONMENT

Photographs and text by Pedro E. Guerrero

Foreword by Alexander S. C. Rower

Calder

OF ALEXANDER CALDER

Stewart, Tabori & Chang

An Archetype Press Book

at Home

CONTENTS

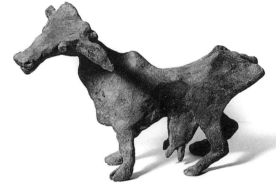

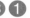
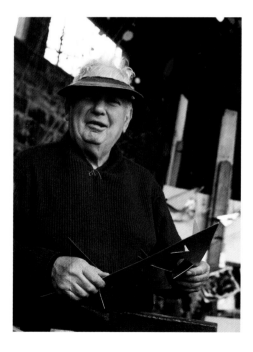

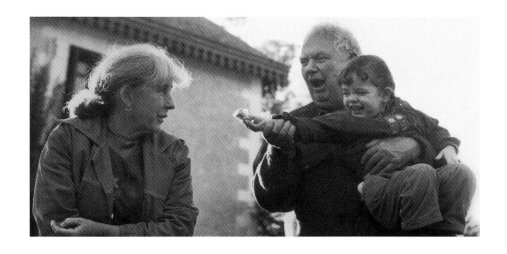

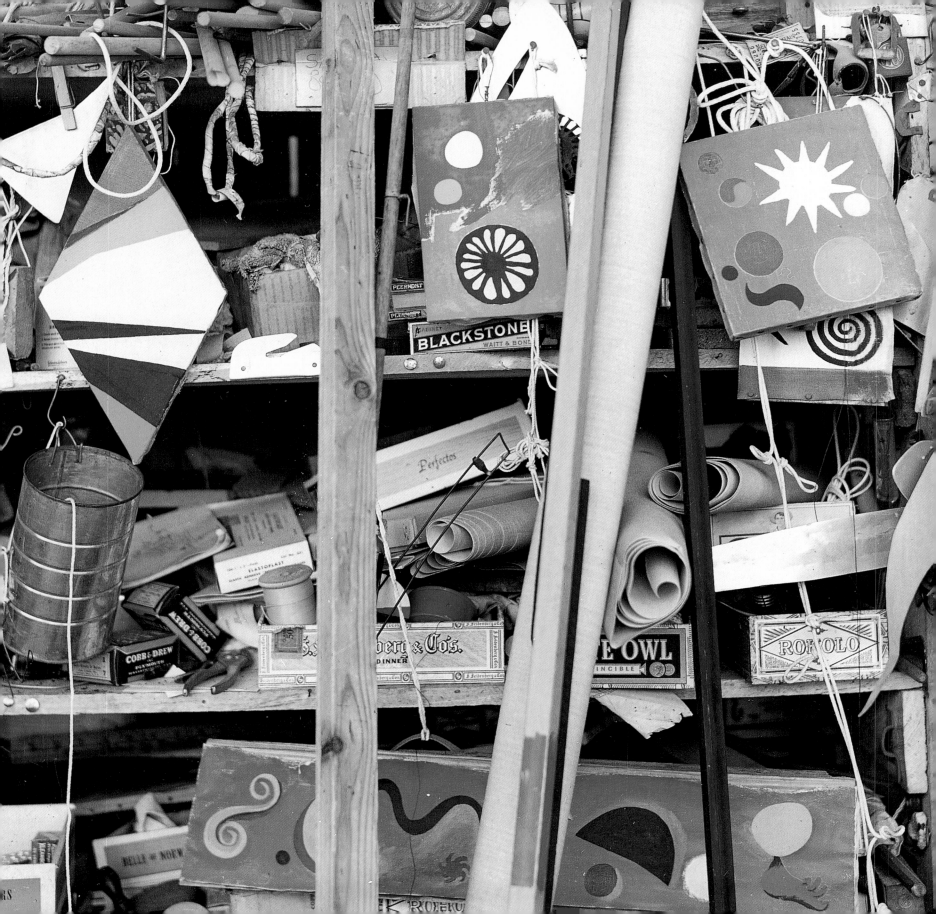

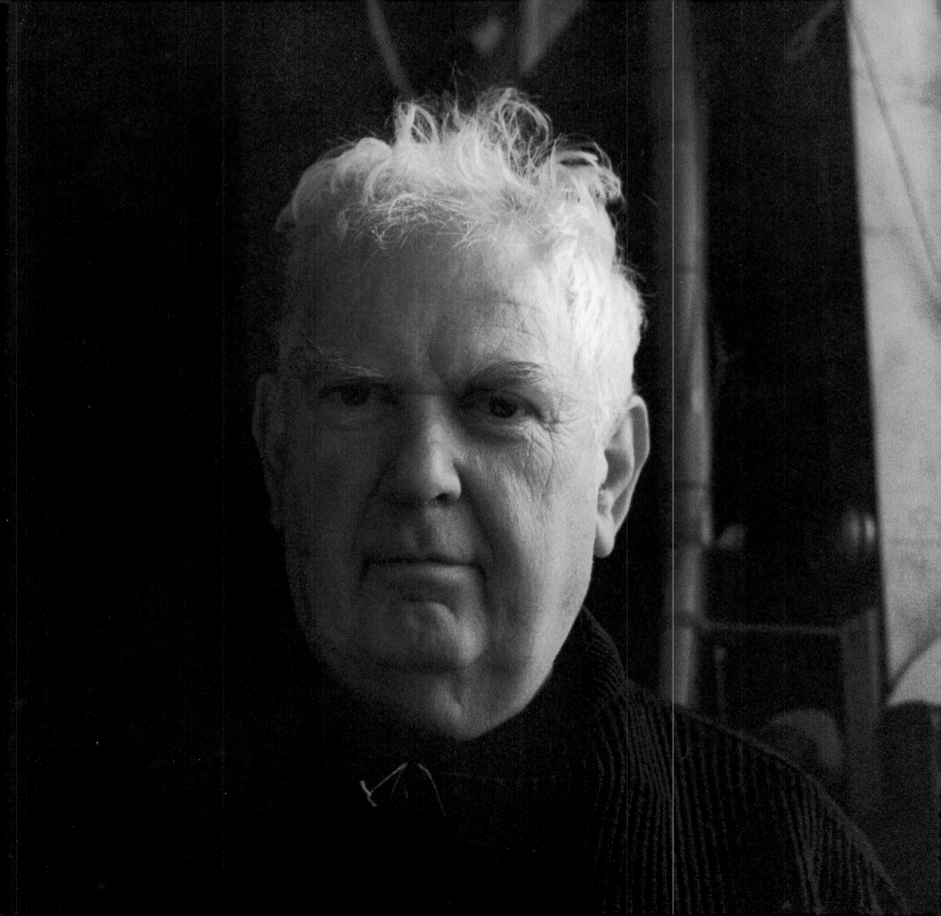

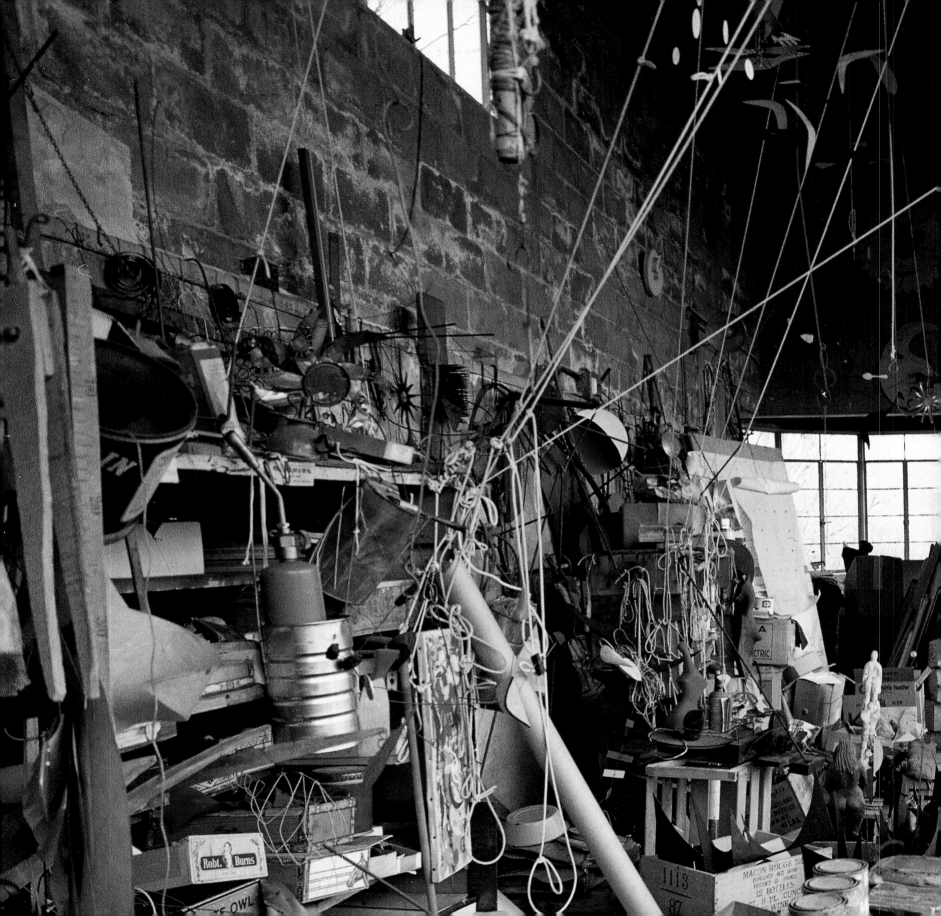

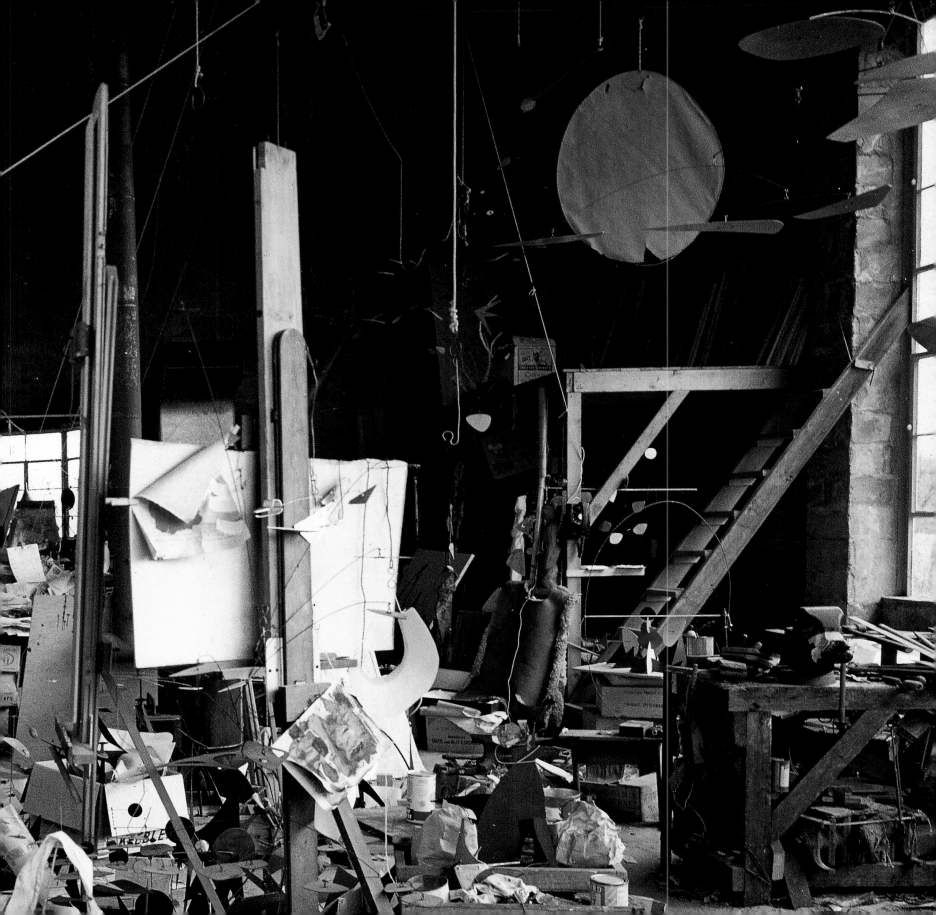

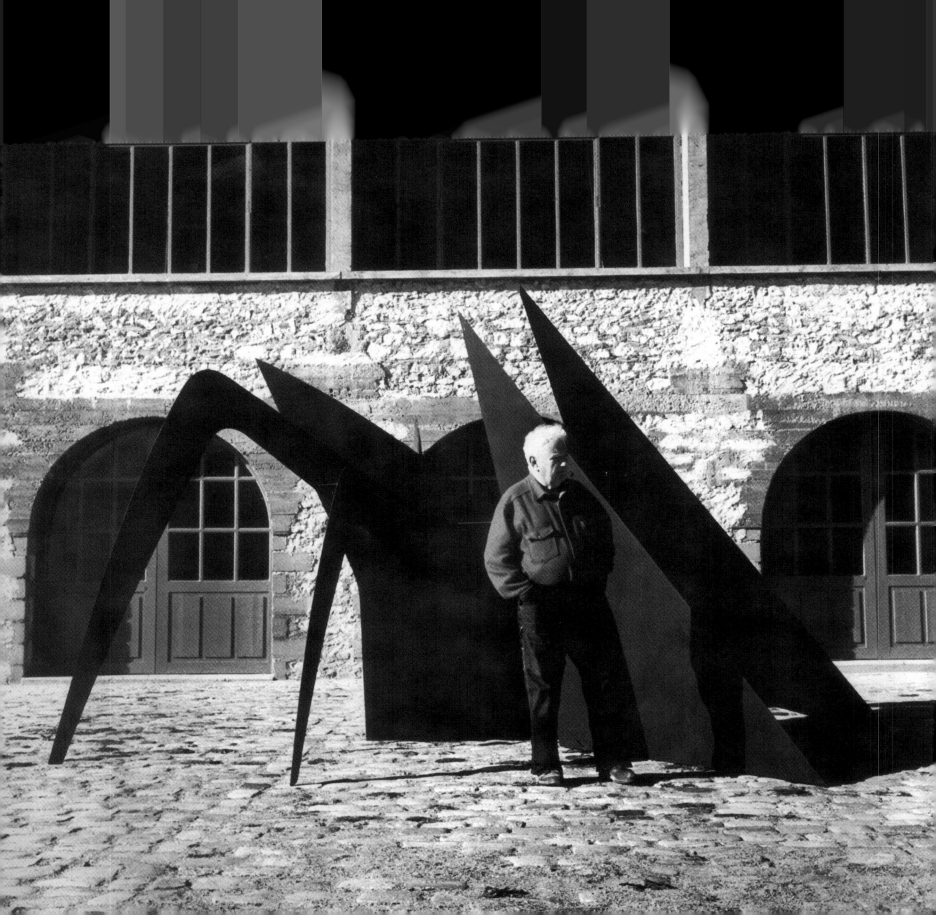

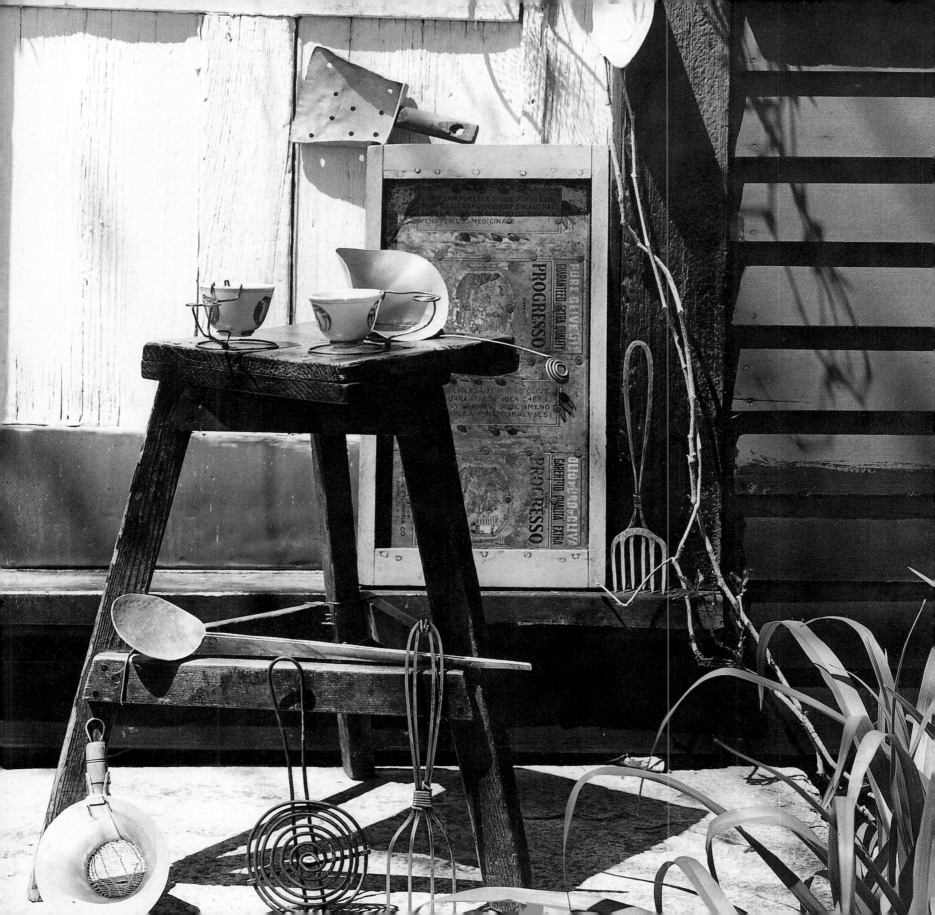

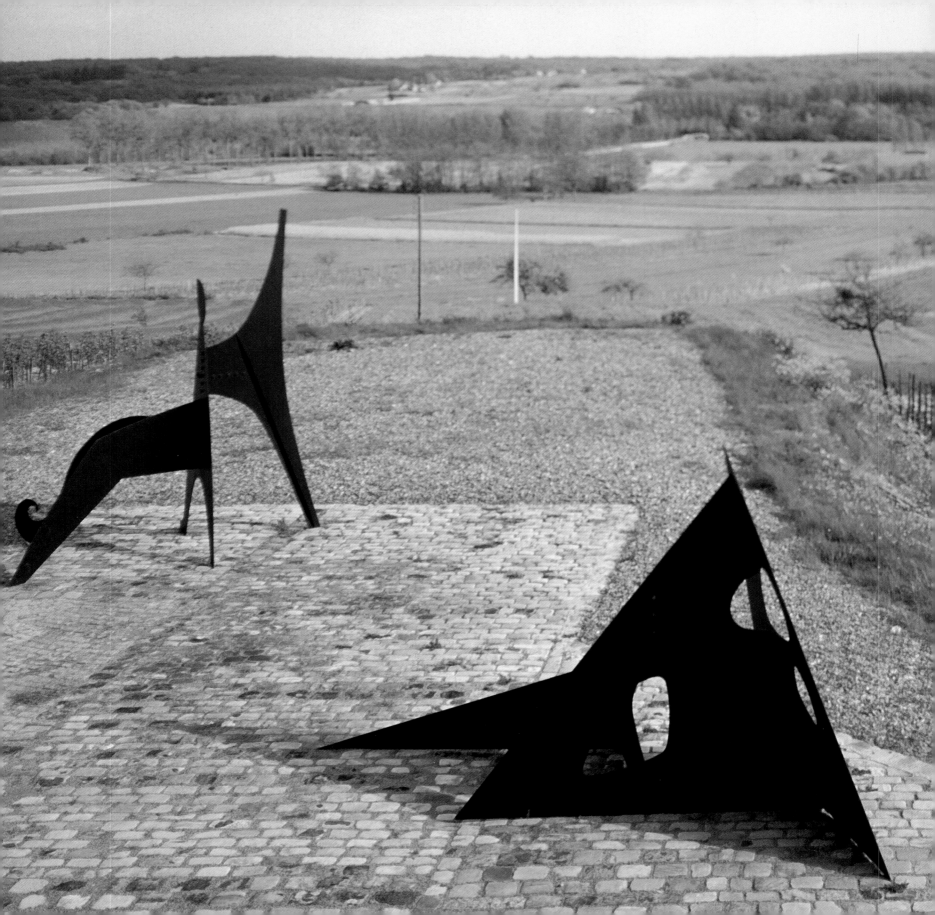

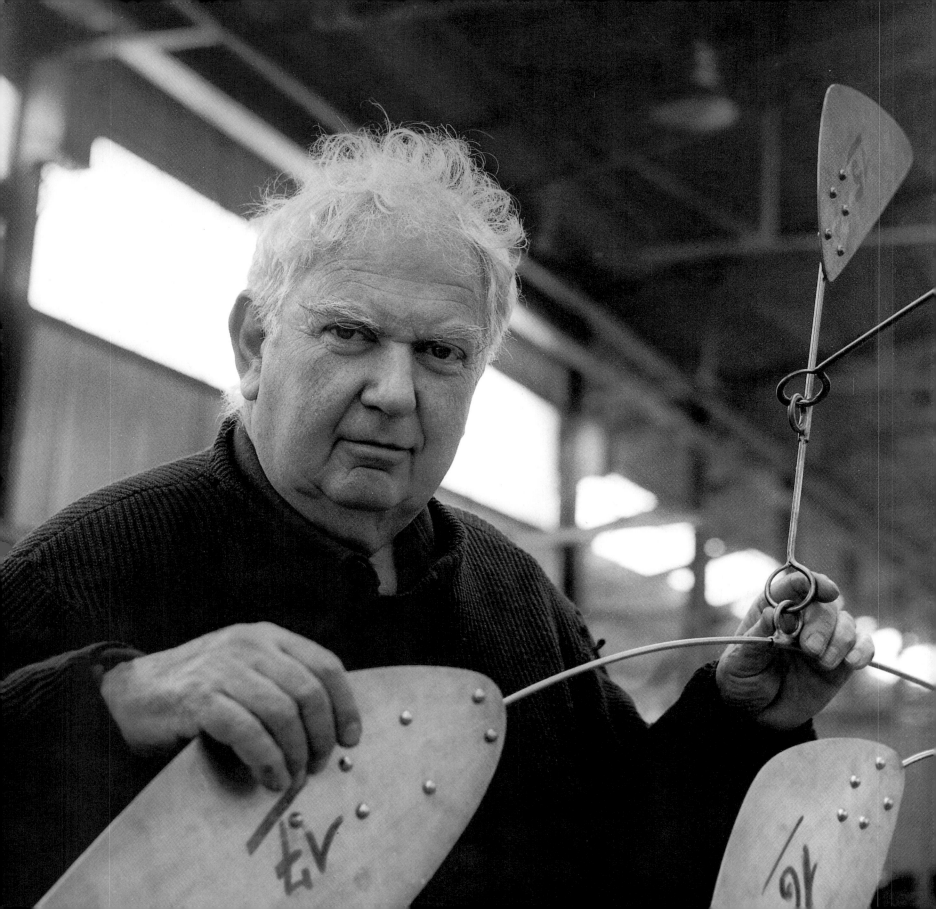

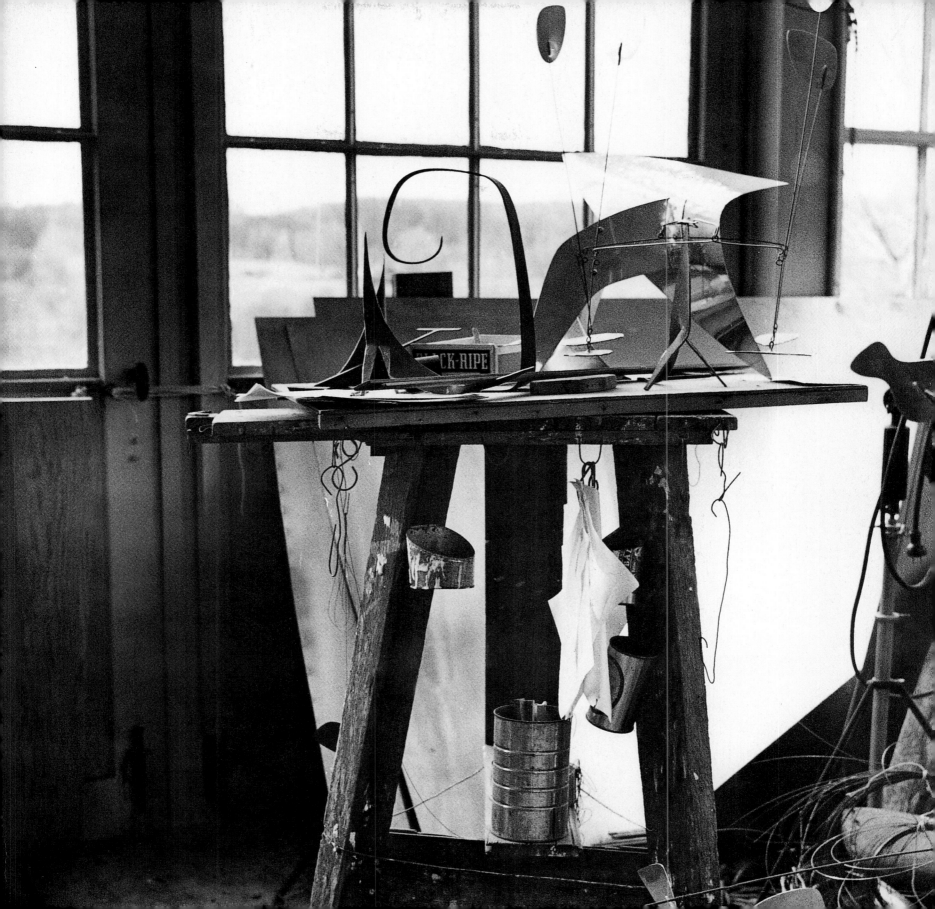

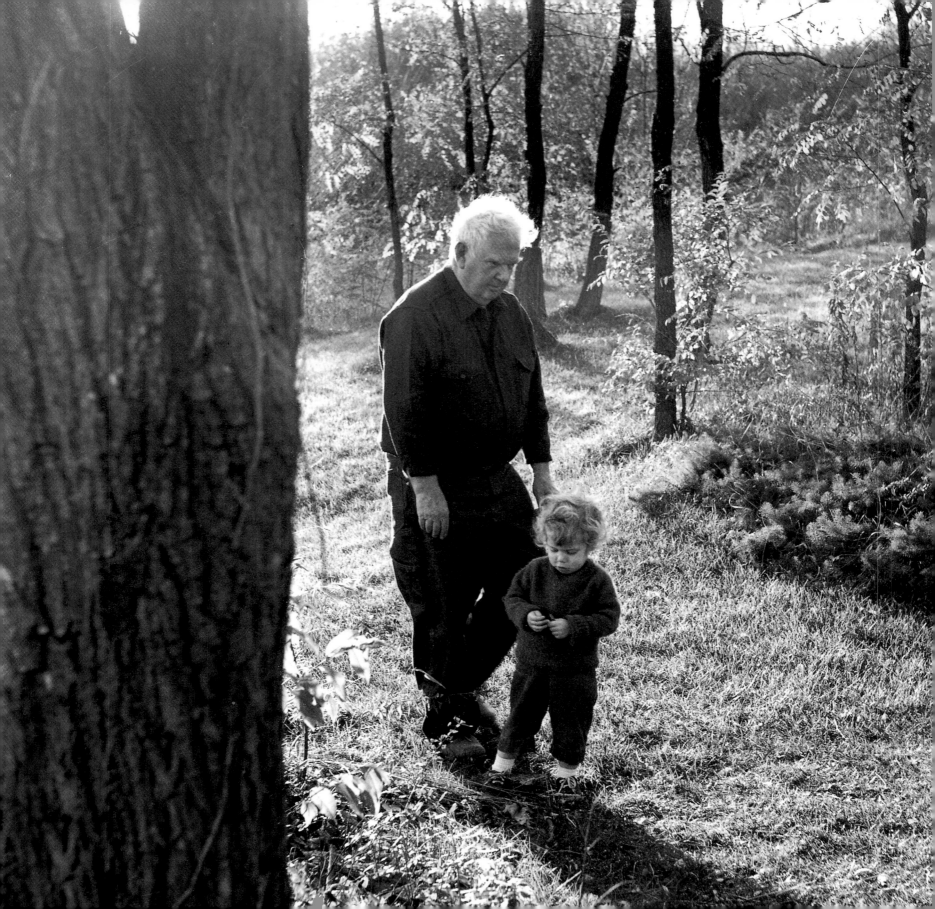

FOREWORD

lexander Calder (1898–1976), my grandfather, was an artist who virtually spun straw into gold: he used the simplest industrial materials—steel and aluminum—and made them into exceptional constructions. An irrepressible experimenter, he redefined sculpture by first inventing wire sculpting and then formalizing kineticism with the development of the mobile.

Born into a family of artists, Calder grew up in the culture of the studio in an extended artistic community. Maturing in the time of industrial mechanization made a deep impression on him, one that nurtured his innate mechanical ability. Calder began his kinetic experiments in earnest, shortly after arriving in Paris in 1926, when he developed his articulated *Circus* (1926–30), a miniaturized performance piece brought to life with his own hands. His work moved toward abstraction in 1929, when Calder perfectly married articulation and motion in his figurative sculpture and added the dimension of time. By 1931, the year Louisa James became his wife, his work was already completely abstract, and he would soon be making what we recognize today as mobiles.

The Calders returned to America in 1933 after living in Paris and established the first of three homes and various studios that you will see and read about in the following pages. Visiting their first house, in Roxbury, Connecticut, Pedro Guerrero was astonished to discover how the Calders lived—simply and without pretension. Fascinated and inspired by them, he continued for more than a decade to make his handsome and intimate photographs. The informality of their lives was startling to some, but most people were immediately put at ease.

In 1966 Pedro published a book of his photographs, entitled *Calder,* in collaboration with the art historian H. H. Arnason and with a splendid design by Alexey Brodovitch. Calder even participated in the enterprise by painting some icons and lettering used throughout the pages, some of which have been reproduced here. Of the dozens of picture books on Calder's art, that one (now long out of print) remains my favorite. This new book contains many photographs never published before and accurately shows how my grandparents lived, with simplicity and humanity. These images illustrate the impact that knowing the Calders had on Pedro himself.

Alexander S. C. Rower
Director, The Alexander and Louisa Calder Foundation

Alexander Calder was a loving and patient grandfather, whether shepherding his grandson Alexander S.C. Rower around Roxbury (opposite) or gathering there with the whole clan (pages 18–19). In the back row (left to right) are Oscar Nitzschke (a visitor), Howard Rower, Alexander Rower, Alexander Calder, Howard Rower's brother Kenneth, the Davidsons—Andrea, Sandra Calder, Jean, and Shawn—and an unidentified friend. Posed in the front row (left to right) are three Guerreros—Barbara, with children Barbara and Ben—Louisa Calder, Holton Rower, Mary Calder Rower, and Susan Guerrero.

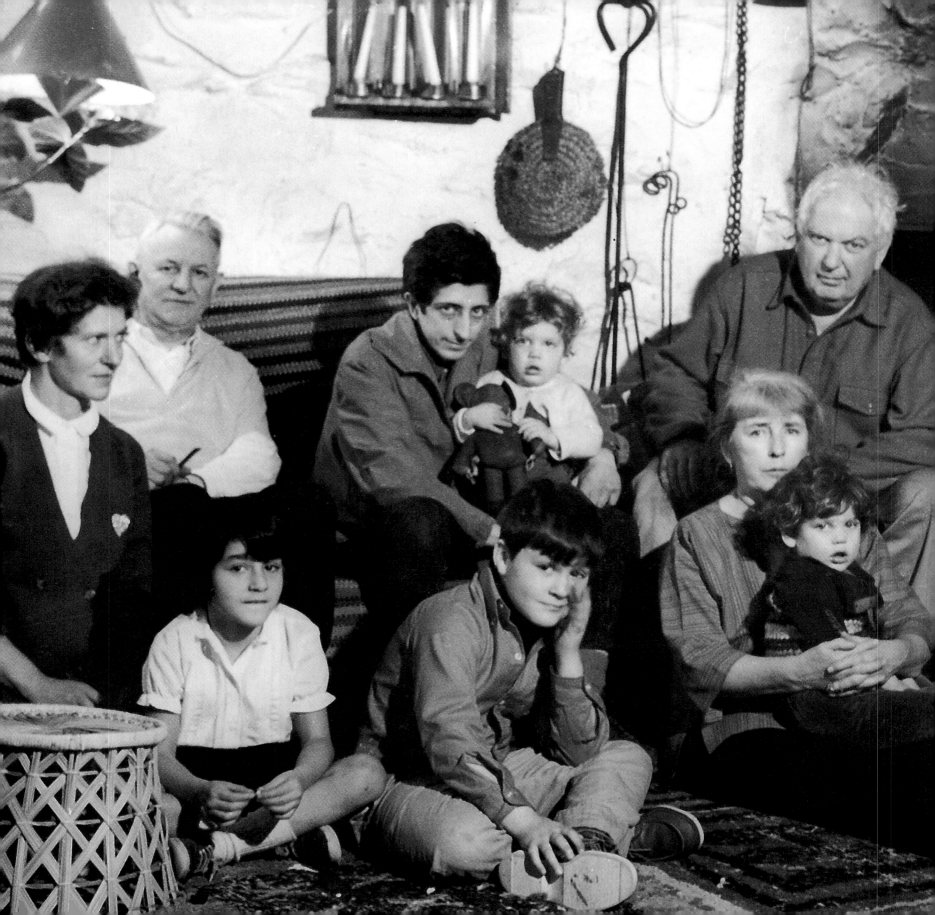

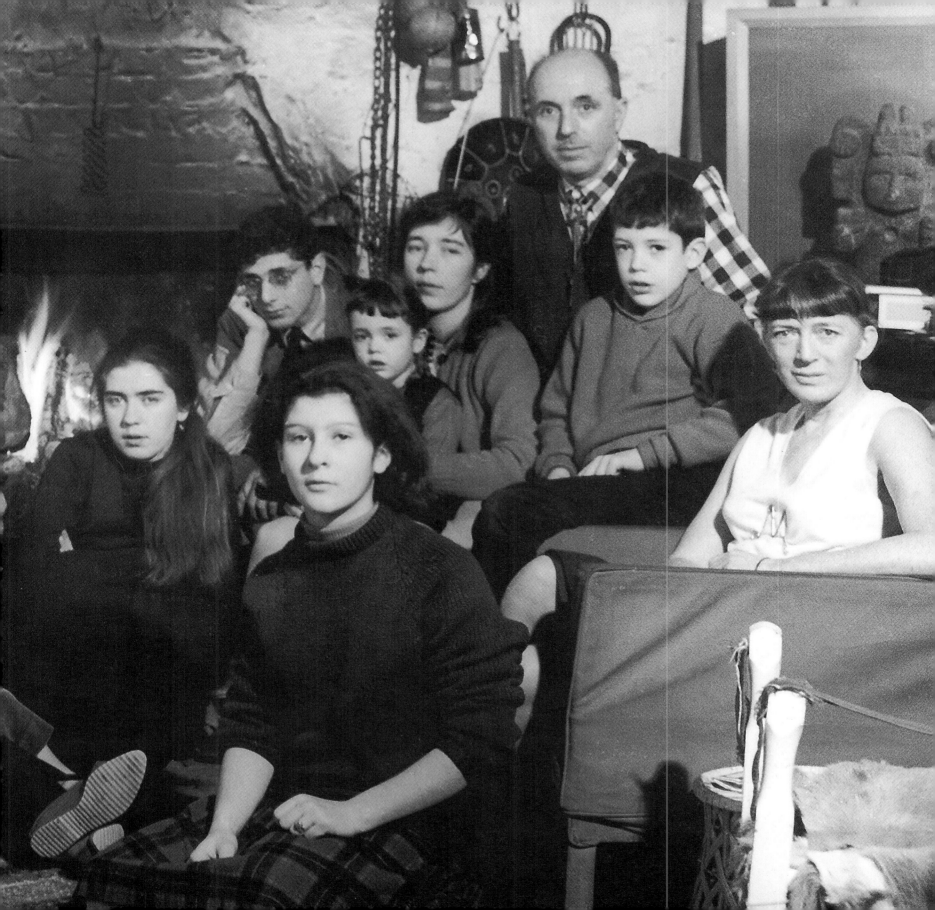

"CALDER'S MOTION MUST BE SEEN IN RELATION

TO HIS REPOSE. . . . "

Thomas M. Messer

e careful where you step. Everything here is important.

In his vast sculpture studio in Roxbury, Connecticut, Alexander Calder made it clear that what seemed to be clutter was in fact highly organized chaos. Calder admonished me in a friendly but emphatic tone, busying himself with snipping at a triangular piece of metal from which he was fashioning the prototype of some future stabile. Works in progress were strewn about, although Calder knew exactly where everything was.

Working gingerly on a platform at the studio's east end, I found a perch where my camera could capture the spectacle below. Calder, with his back to me, continued to work on the stabile. Not a small man by any means, he was dwarfed in the studio.

Calder was sixty-four when I met him in 1963: a stout man of middle height with bright blue eyes in a round face, under a shock of unruly white hair. He was gracious, generous, open, and forthright, even at first meeting. By then, he was long past his years of experimenting with different disciplines in a restless quest for meaningful and fulfilling work. Efficiency expert, toy designer, freelance artist, stoker on an ocean liner—he had tried it all. He even demonstrated garden tools for a while. Behind him, too, was the evolution from tinkerer, cartoonist, and whittler to world-renowned sculptor, painter, and originator of the mobile.

My first encounter with Calder came in the early spring of 1963 while I was on a routine photography assignment for *House and Garden* magazine. The story was to be "A Man's Influence in the Kitchen," and I was assigned to photograph the Calder kitchen in Roxbury. I had no idea what to expect. It's hard to believe that the editor expected Alexander Calder—the creator of the mobile—to flip pancakes or toss a salad for us.

As soon as the Calder house came into view, it was obvious how different it was from the hundreds of homes I had visited for *House and Garden,* with their tidy, manicured lawns spread out before stately, faux mansions. My car came to a stop in front of what must have been a corn crib. To the right was a typical Connecticut farmhouse—but this one was painted black.

In those days, a fairly good living could be made photographing for the home magazines. I traveled extensively and was privileged to interpret many prominent homes. Even so there was a numbing sameness to the work— butler's tables, wing chairs, love seats, coordinated colors. That world of sameness ended abruptly the day I drove up to Calder's house. I was about to discover complete happiness in heart-stopping clutter.

When I first saw Alexander Calder, he was just finishing his midday meal of bread, cheese, a simple salad, and red wine. *If I had known you were going to photograph that room,* said my editor as we drove away, *I would have straightened the slipcovers.* What a thing to notice! I wasn't listening. I was plotting my next move.

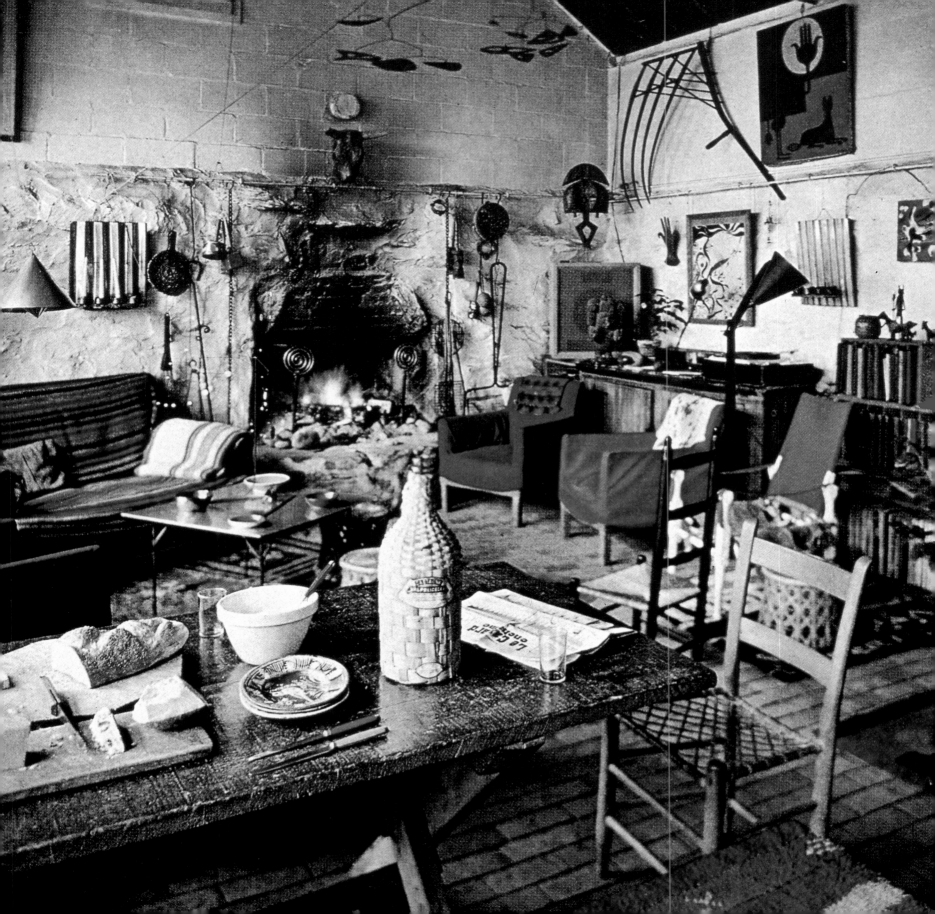

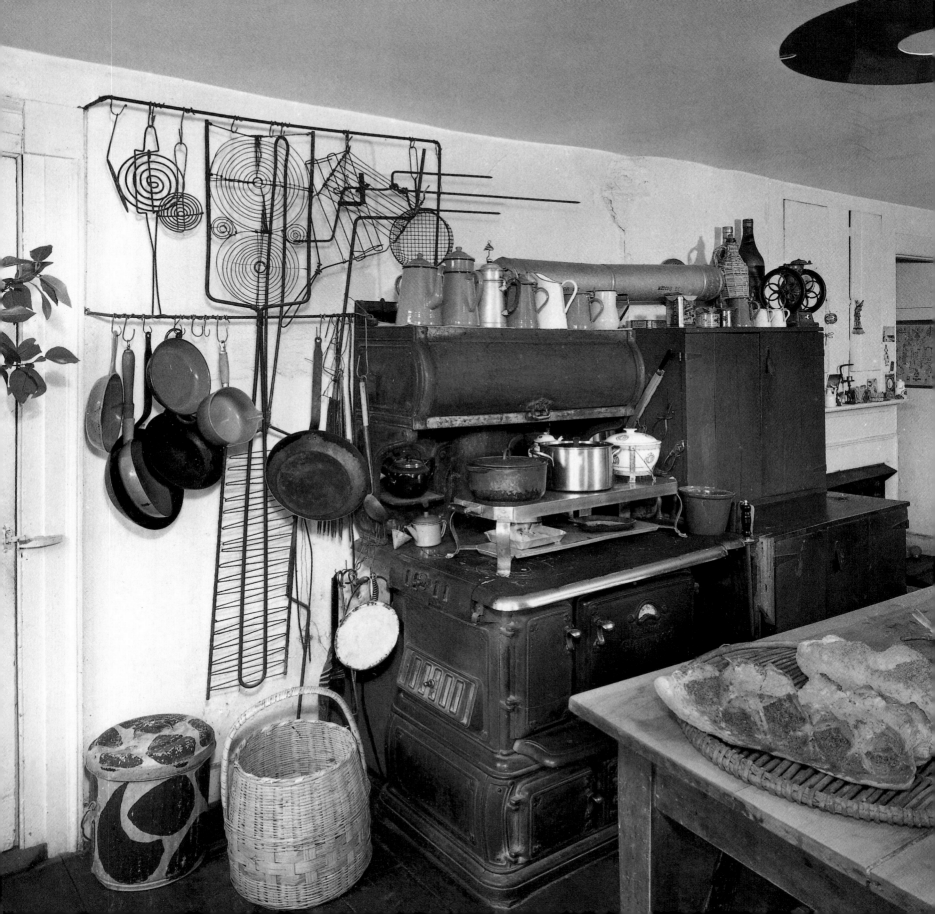

Calder was having lunch when the editor, Elizabeth Burris-Myers, and I walked in. On the table was a large bottle of wine, a slab of cheese, and a loaf of coarse bread. Colorful and inexpensive plastic and steel cutlery was strewn about. Calder was reading a French newspaper and enjoying the last few sips of wine. We were introduced.

Call me Sandy, he said. He was wearing his preferred attire for most occasions: a pair of blue denims, a blue, coarsely woven sweater, and heavy, brown, high-top work shoes. (He alternated between this outfit and a red shirt and khakis.) At first I thought that he was speaking to us in French; his speech was somewhat slurred because, I later learned, he had Parkinson's syndrome. Louisa Calder was our interpreter until I, at least, got used to him.

One could sense immediately that Elizabeth was not going to "do" the place. But always the diplomat, she sat and socialized with Louisa while I, like a thief, ran in to explore the kitchen. It was a room like none that I had ever been assigned to before—a kitchen that was meant to be used, not to impress. It told me everything that I didn't already know about these people—their charm, their informality, their intense passion, a life lived without pretense or sham.

I had made the great mistake of bringing along a big, cumbersome eight-by-ten-inch Deardorff camera, a heavy workhorse that produced a very large negative or transparency. The rest of the equipment was equally large and difficult to move, giving me time to do little more than set the camera level. I finished one shot in the kitchen just as Elizabeth and Louisa came in, then quickly moved to the living-dining room. Sandy was gone, but the table still held the evidence of his lunch. I shot it in a breathtaking hurry and was putting away my equipment when Louisa and Elizabeth returned.

I had been right—we were leaving. With its antique wood-and-coal stove and handmade utensils, this house was no subject for *House and Garden*. None of the magazine advertisers' products was anywhere to be seen here. But my appetite was whetted by this marvelous place.

Louisa Calder used the old wood-and-coal stove (opposite) for her daily bread. Sandy insisted on making his own kitchen utensils and created objects for the walls as well. If Louisa needed a special serving spoon, he quickly fashioned a graceful work of art in aluminum or silver (below).

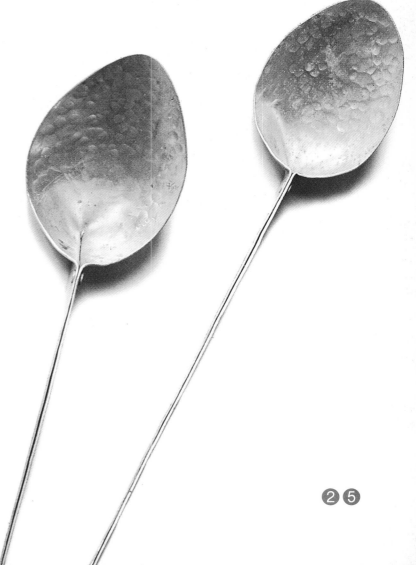

Little did I know that this would be the beginning of an association that was to last thirteen years and rival my most important working relationship before then—with Frank Lloyd Wright. For nearly two decades, from 1939 to 1959, I had taken assignments from Mr. Wright, first as a hired photographer, then as a member of his Taliesin Fellowship, and finally as his on-call photographer, working from my home in New York City and later in Connecticut. I fulfilled my last assignment for him in 1959 just three weeks before he died at the age of ninety-one—something neither he nor I believed would ever happen.

Mr. Wright had been central to my career as a photographer from the very beginning. He was my first employer, my mentor, and my friend. His death left a great void, one I thought impossible to fill. Had I been seeking to stem that loss, I doubt if I could have found anyone so completely different as Alexander Calder. Mr. Wright was almost starchy and so conscious of his image that he seldom looked relaxed or out of character. Stiff collared and tweedy, he was the very picture of an eighteenth-century architect—an aristocrat. Sandy, by contrast, recalled the image of a village blacksmith. He was seldom out of his classic garb—khaki pants or denims and a red or blue shirt. Even when he attended openings and formal functions, he would turn up in a rumpled suit, a colorful shirt, and a homemade tie. Mr. Wright, articulate and opinionated, was often taken for pompous. Sandy, on the other hand, chose his subjects and his words with metered economy.

But both men shared a dedication to their art. Their passion for work was all consuming, and they created forms and manipulated space with equal genius. It is impossible to imagine that either man ever had a moment when some symphony of his own creation wasn't running through his head. And yet, they were the antithesis of each other in every other way. I was comfortable with both, and with both I tried to remain a trusted observer.

Back in *House and Garden's* office in New York, the art director, just as I suspected, had convinced himself that Calder's home did not fit the *House and Garden* image. Because the magazine had not paid me, I asked him if he would release the photographs. He agreed. With those photos as a start, Sandy and his work became the objects of all my free time, pushing me further and further from the world of the decorators.

When Sandy worked in his vast studio in Roxbury (above and opposite), he moved among work stations, each fully equipped with coils of wire, sheets of aluminum, snips, hammers, and drills. These improvised work stations were like islands in narrow straits along a sea of stacked and stored works in progress—and some works deferred (pages 28–29).

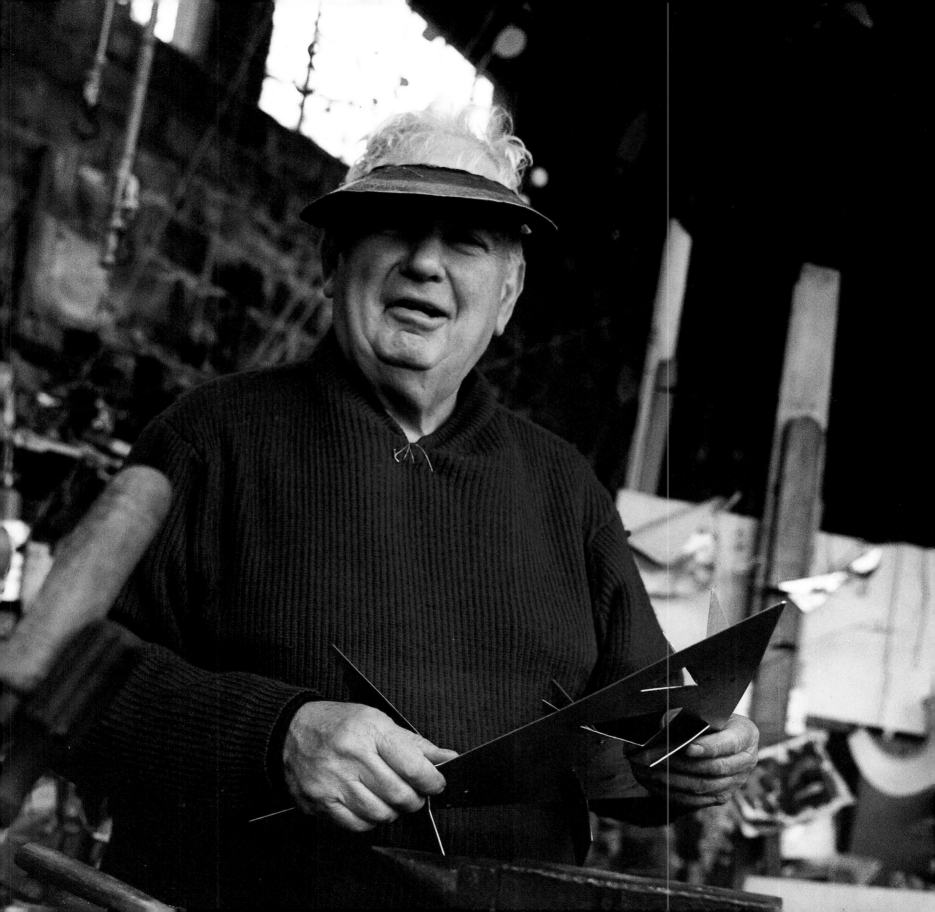

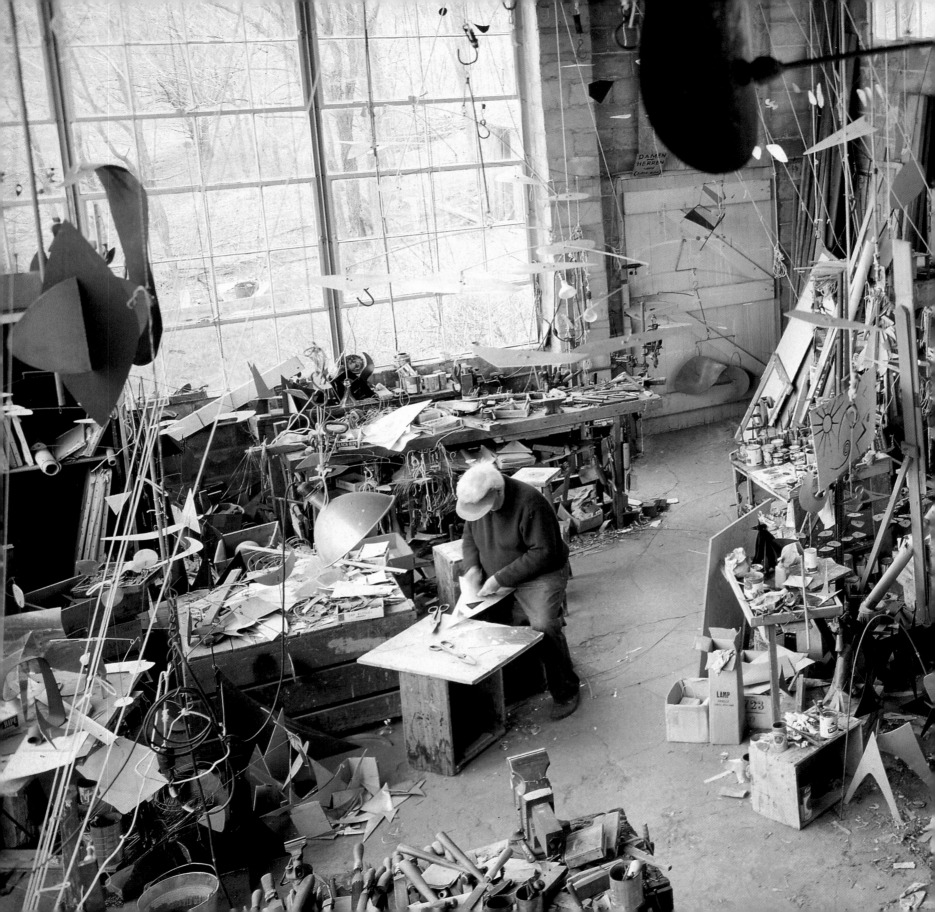

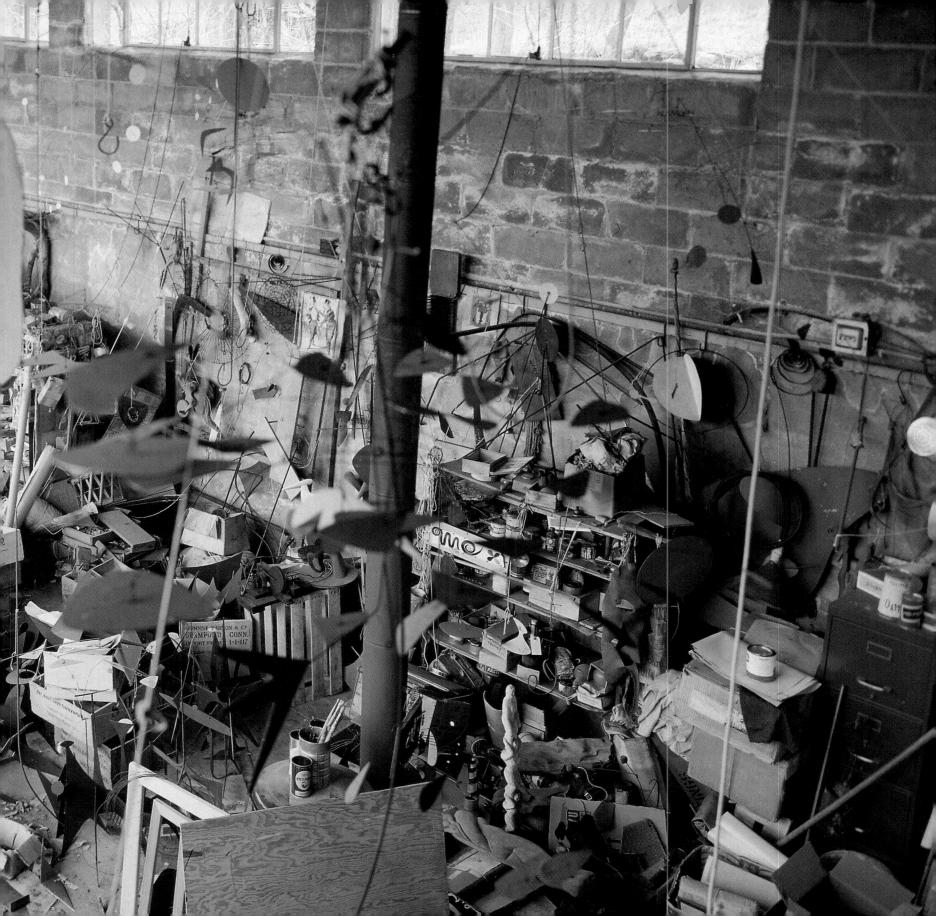

"... THE LOFT STUDIO AND

GREENWICH VILLAGE PAD RAISED TO A CELESTIAL LEVEL."

John Canaday

ive me the luxuries and I will learn to live without the necessities, Frank Lloyd Wright liked to say. Alexander Calder, by contrast, made luxuries, or rather works of art, out of necessities. This compulsion extended to every aspect of Sandy and Louisa's life in their Roxbury, Connecticut, home, from maracas made from beer cans with handles, to a ribald toilet paper holder in the shape of an upturned finger, to the striking black-and-white garbage cans that were often stolen at the curb while awaiting pickup.

Filled from floor to ceiling and from wall to wall with his creations, the Roxbury house was more like a craft museum than a home. Believing it almost a sin to buy something he could make himself, Sandy would drop anything he was involved in, no matter how important, and beat out a roasting pan for Louisa or fashion a large-capacity serving ladle or a sieve. This do-it-yourself dictum was undoubtedly a carryover from their earlier, leaner days, but it had become an obsession with Sandy.

The Calders met in 1929 aboard an ocean liner en route to the United States from Paris, where Sandy, then thirty-one, had been attempting to establish himself as an artist. His frequent trips to Paris proved extremely fruitful and had a lasting impact on his life, because it was during these visits that he was befriended by the young, avant-garde, Parisian art community—Joan Miró, Fernand Léger, Piet Mondrian, Jean Cocteau, Jean-Paul Sartre, Jean Arp, and Marcel Duchamp. Louisa, by contrast, had less success during her stay in Europe, according to Sandy. The grandniece of the famous brothers William and Henry James and their sister Alice James, Louisa James was returning with her father, Edward Holton James, from a trip arranged for her to mix with the "intellectual elite." *All she met,* Sandy said dryly, *were concierges, doormen, cab drivers, and finally me.* The attraction was immediate and intense. Less than two years later, on January 17, 1931, they were married in Concord, Massachusetts, Louisa's hometown.

Sandy and Louisa spent most of their early married life in a rented house in Paris, but when rumors of war spread throughout Europe, they decided to return to the States. Louisa was hoping to have a child with some degree of peace and tranquillity, and Europe seemed anything but tranquil at that time. After they landed in Massachusetts in June 1933, they bought a second-hand La Salle touring car and began driving around areas near New York City in search of a house that they could afford. Sandy's "formula," he said, was to find a *modest house with a barn out of which to make a studio.*

Outside the Calders' home in Roxbury, Connecticut, stood one of Sandy's stabiles. Named *Polygon on Triangles* (1964), it was better known, appropriately, as *The Nun.* This was just one of many Calder works that graced the property on Painter Hill Road.

32

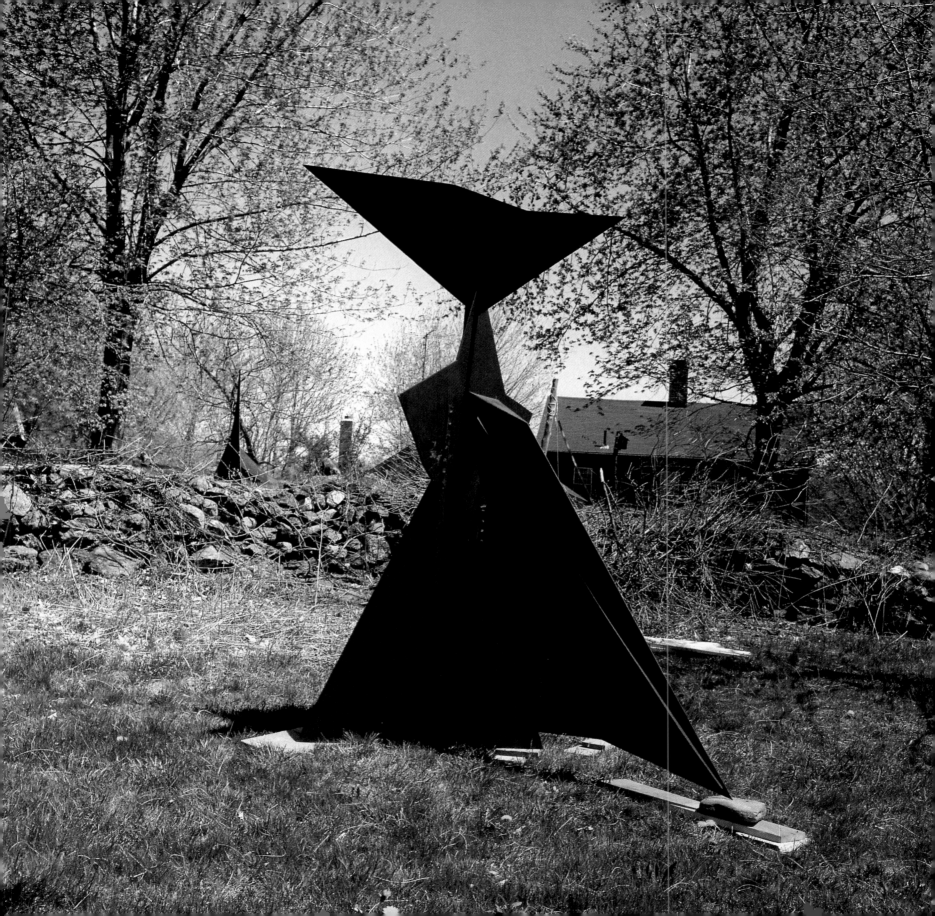

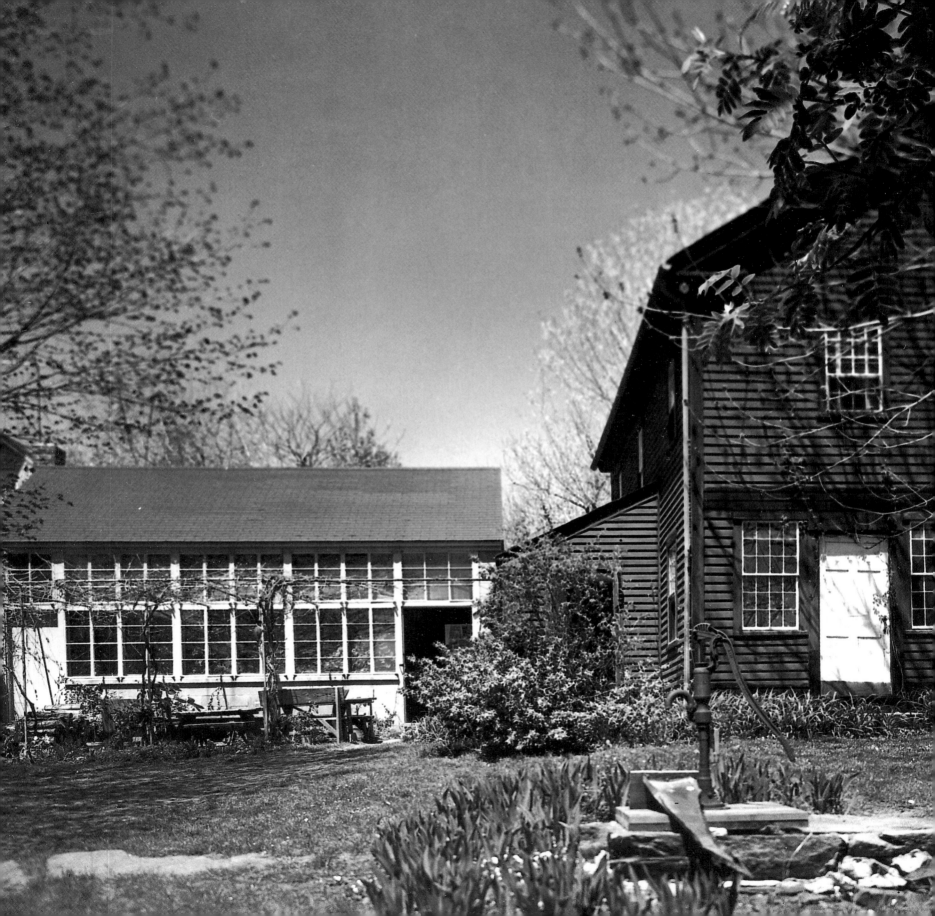

They looked on Long Island and nearby Westchester County with no luck. Finally the couple decided to try Connecticut. Driving over the crest of a hill near Roxbury and onto the aptly named Painter Hill Road, Sandy and Louisa simultaneously spied an old farmhouse and the burned-out remains of a barn. Both claimed to have been the first to declare, *That's it!* They bought the undistinguished eighteenth-century farmhouse, ruined barn, ice house, and eighteen acres of pasture for $3,500, borrowing the down payment from a friend. At the age of thirty-five, Sandy owned his first home.

The Calders immediately set about giving the house their own imprint, hiring plumbers and other help when they could afford to but doing most of the work themselves. Sandy turned the ice house into a studio by adding a few second-hand windows. What furniture they had in Paris was shipped in wooden crates to Connecticut. Sandy carefully dismantled the crates to make kitchen cupboards and shelves from the salvaged boards.

Because the Calders still spent winters in an apartment in New York City and visited Paris when they could, the house on Painter Hill Road served as their summer home. Two daughters were born to them, Sandra in 1935 and Mary in 1939. They continued to travel around the world to attend special exhibitions of Sandy's work and to see to important commissions. Roxbury became their permanent home in 1945, when Nanette Calder, Sandy's mother, moved in with them after his father, the sculptor Alexander Stirling Calder, died.

By the time I met Sandy and Louisa in 1963, the house was filled with Sandy's creations and Louisa's own artistry. Sandra and Mary were long gone by then, grown with families of their own. The accoutrements of their childhood— ingenious toys and a rather formidable training toilet and other gadgets made for them by their father—were still around. These came in handy when the grandparents were pressed into service as babysitters for Mary Rower's two toddlers, Holton and young Alexander, also known as Sandy.

If anything, the Calder home was even more enchanting the second time around. With complete license from the Calders to photograph anything I chose, I was able to document in detail the atmosphere that Louisa and Sandy together had created. And, as the days went by, I also got to know them better.

Painted black, the old farmhouse was enlarged in 1944, when the form- er ice-house studio was added to the living area.

Calder, like Mr. Wright, couldn't tolerate anything that wasn't well designed. He thus devised and hammered out an array of cunning implements, gadgets, tools, and trinkets. The Roxbury kitchen in particular was filled with his handiwork: A large red cupboard made from the Paris packing crates stood next to the antique stove. Nearby, on the wall, a wire rack held strainers and trivets in Calderesque spirals of wire, along with huge outdoor meat roasters. Overhead, a star-shaped aluminum baffle, painted black, diffused the light from an otherwise offensive bare bulb. Ladles of different sizes with intricate but varied handles and a fork in the shape of a hand, its thumb under the forefinger (a Brazilian motif), were hung from nails driven into the walls. The mantel over the fireplace and other shelves were crowded with small mobiles, clay statues, bottles, and china that caught Sandy and Louisa's fancy on their far-flung travels. Chinese teacups without handles were made easier to use with handles fashioned by Sandy from brass wire.

The Calders did a lot of their living in the kitchen. They often entertained there, especially for a small group. And even if the crowd spilled out of the kitchen and into the living room and parlor, the atmosphere was always informal. A large table, which seated six, stood in the center of the room. Near the windows was a smaller work table that could be moved to enlarge the seating capacity if the need arose. Two related but not exactly matching three-legged stools made by Sandy were positioned under the small table.

On my first visit, a large bowl of quince butter had been placed on the large kitchen table. The bowl rested on a beautiful tray that Sandy had fashioned from a flattened gallon can of Italian olive oil nailed to a wooden frame. There were also several bottles of wine, two plates—one with persimmons and the other quince, which they grew—and a tray of Calder-handled china cups. A loaf of one of Louisa's freshly baked breads cooled on the small table. Its perfume permeated the whole house.

As soon as I took my first photograph at the Calders' (opposite), I knew that not a single item here could be advertised in any shelter magazine— not the olive oil–can tray (above), not any of their furniture.

But objects crowding the floor and adorning the wall, even in the kitchen (pages 38–39), were evidence of an artist's creativity and the sensitivity of a woman who brought it all together to make an ambience of beauty.

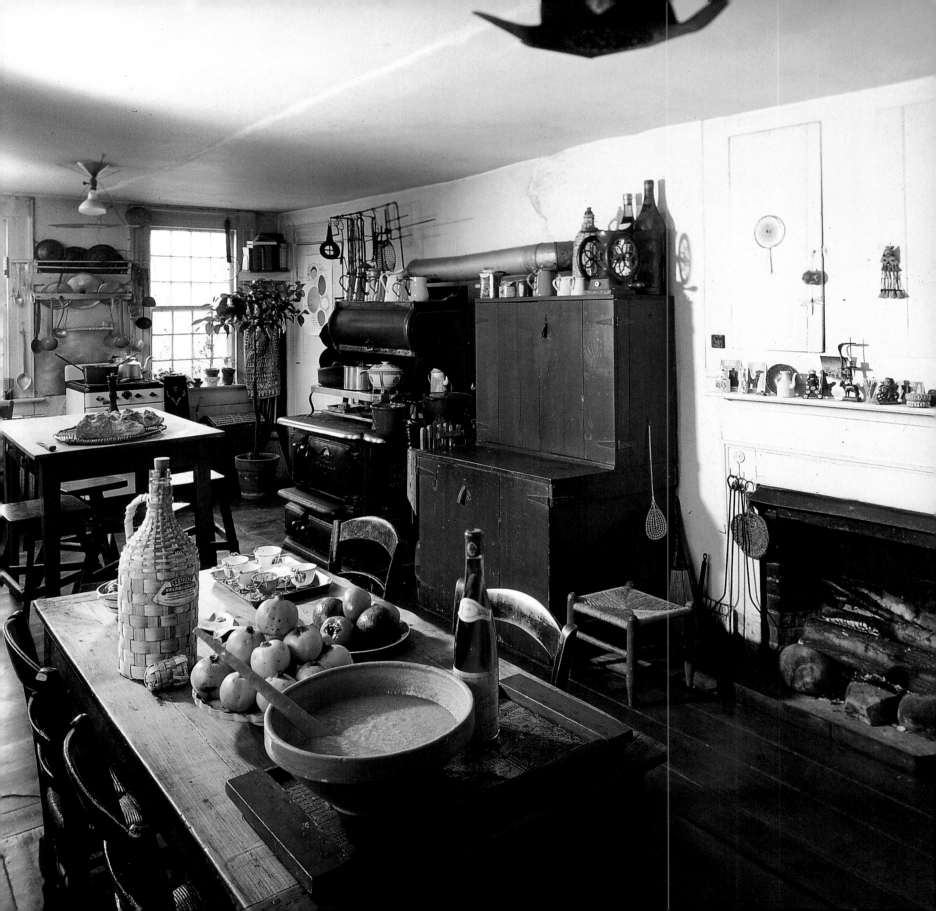

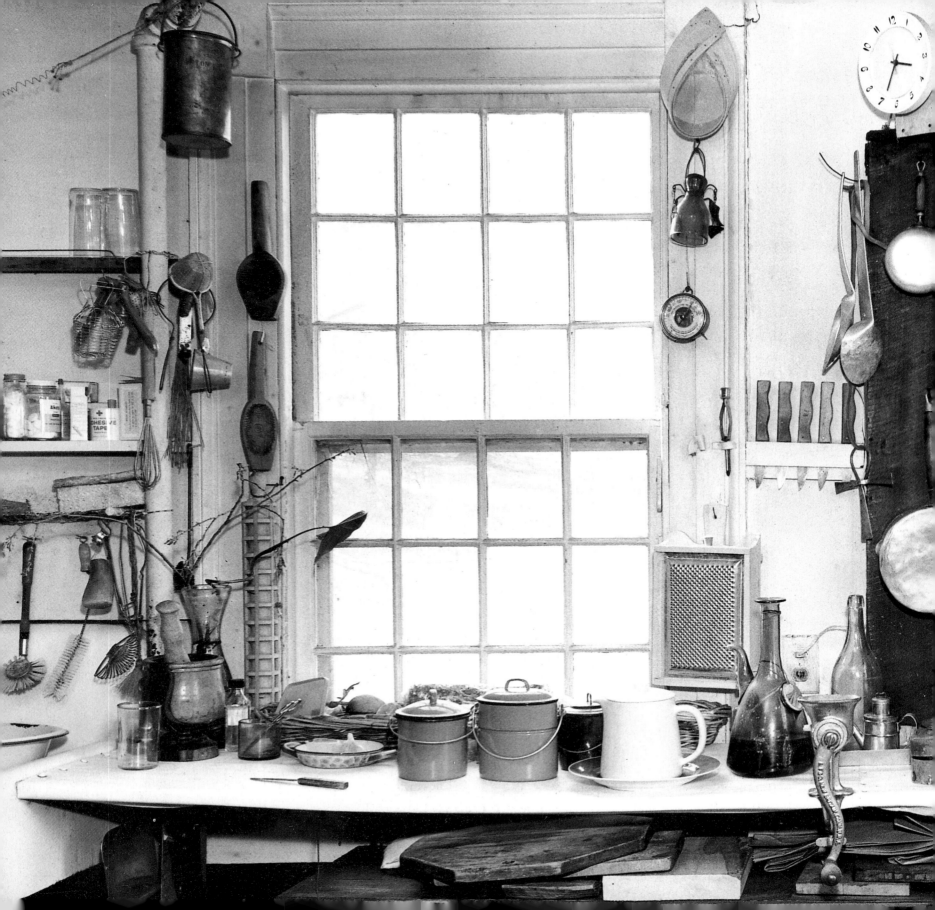

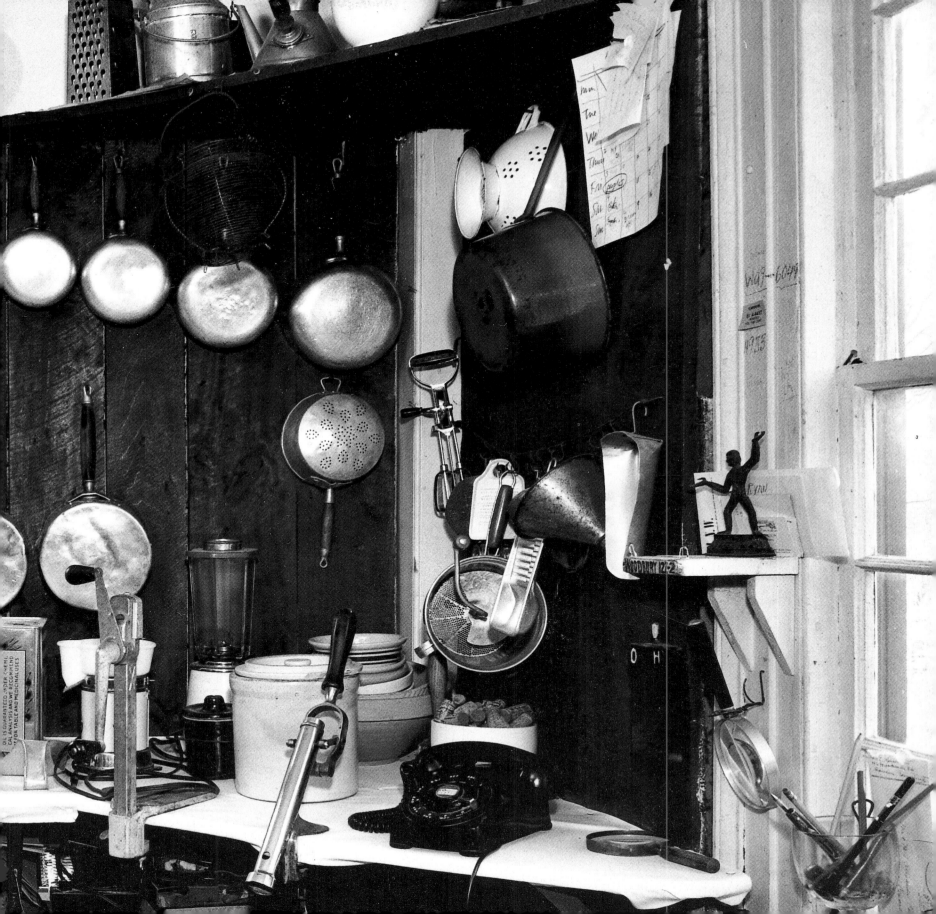

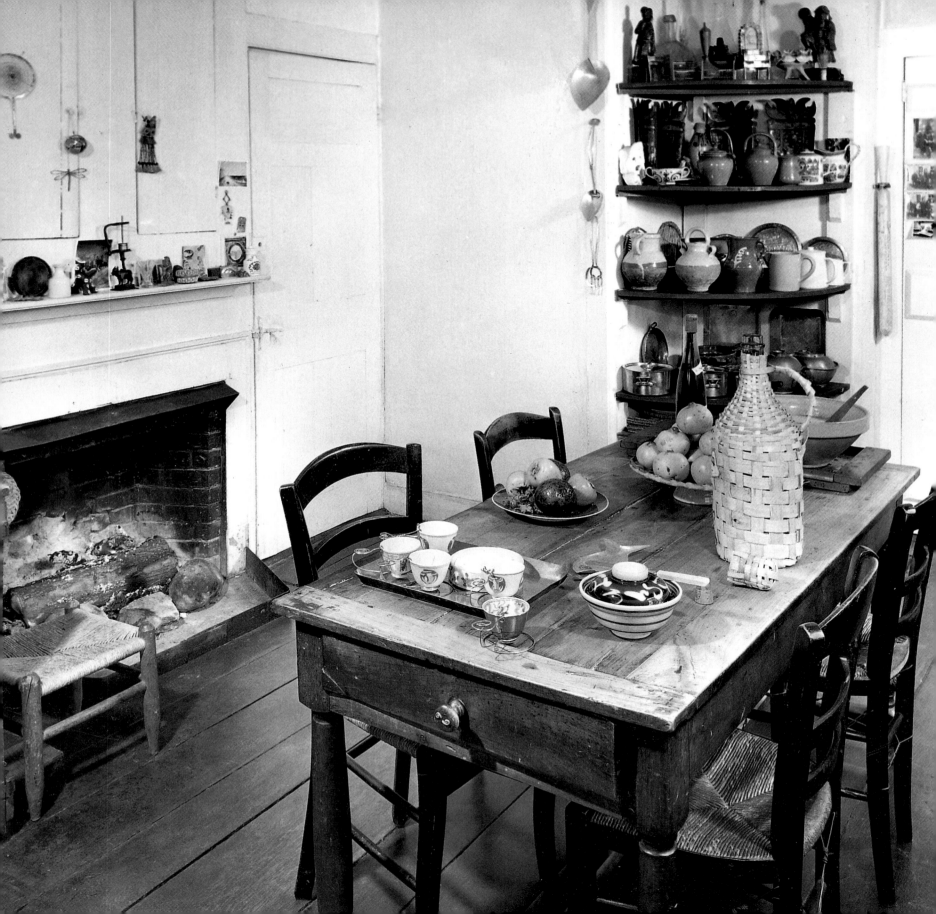

With her long gray hair tied back in a bun, Louisa reigned over the kitchen. Beautiful and regal, she was always adorned with some large and elegant piece of jewelry made for her by Sandy. Her penchant for simple peasant blouses showcased the jewelry perfectly. Louisa had three stoves to work with in her non-*House and Garden* kitchen—a large antique wood-and-coal stove, an old white enamel gas stove, and a portable food warmer.

On the opposite side of the room, Louisa filled a large expanse of casement windows with orchids and potted plants. Above them swam one of Sandy's fish-shaped mobiles made of steel wire and pieces of broken colored glass. Other gadgetry filled every available space. On the window trim next to a phone, the Calders scrawled important phone numbers in an expansive freehand with a magic marker. A magnifying glass hung on its own nail, the better to read the phone book. Leading from the kitchen to the living room, a special "album" door was covered with thumbtacked snapshots of their family and friends and postcards from all over the world.

This hospitable environment was as much a product of Louisa's vision as it was of Sandy's. Theirs was a strong and affectionate, respectful relationship. As he struggled to find his niche in the world of art, Louisa's faith in him held steady. Her good fortune, including an allowance from her parents, helped bridge the lean years until wealth caught up with acclaim.

Louisa's hand in the Calder household was obvious. She infused colors into the stark surroundings and made the interiors stunning. Working on designs that Sandy drew on canvas, Louisa hooked rugs that complemented the paintings and artwork of their genius friends. The floors were Louisa's, the ceiling belonged to Sandy, and their friends festooned the walls. From Louisa's sensibility came the objects and the wares and the plants that filled the surfaces.

A few of the pieces in their home that Sandy did not make himself, the kitchen table and chairs (opposite) were shipped from Paris. The shelves held items collected in their travels. In 1955 Sandy offered Louisa a thirteen-inch high *Valentine* (below) that was made of painted metal and wire.

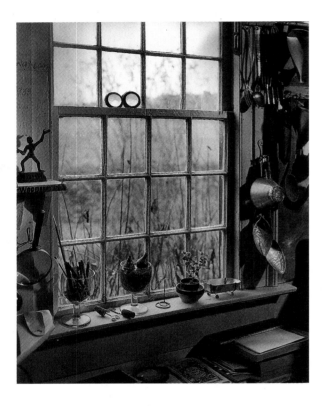

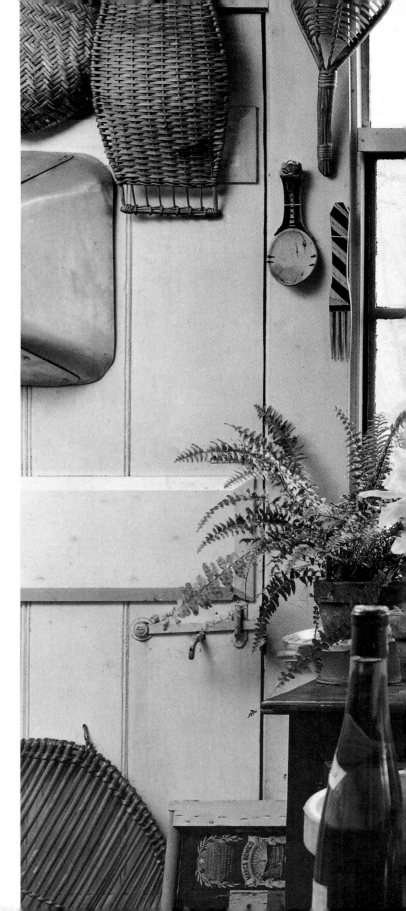

Unlike Sandy's studio, Louisa's kitchen was a study in order. No more than a step away were the implements she needed, some bought, more improvised at home. Whisks and swirls, funnels and sieves— all had a place on a windowsill or hook.

Caldrons and decanters of vinegar and oil shared walls and shelves with budding plants, exotic bottles, and jars of condiments. Out a window, under her husband's glassy fish, was the quince orchard, the source of Louisa's special quince butter.

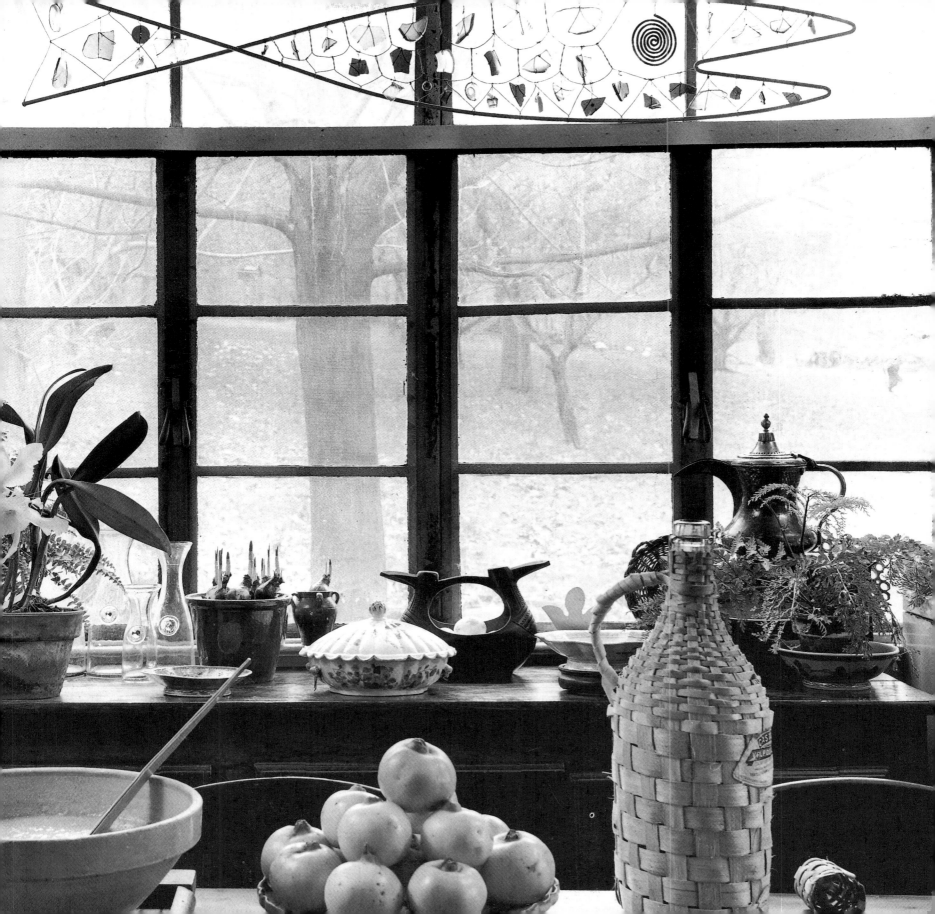

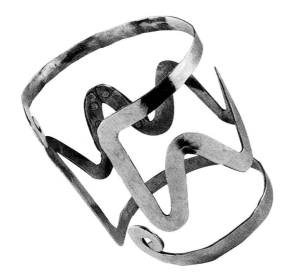

There were no limits to Sandy's inspirations when it came to making jewelry for Louisa. He fashioned rings and earrings, bracelets and belt buckles, broaches and combs for her. Earrings might be small animals and insects or tiny mobiles. From initials to fancy swirls, his brooches often intertwined gold, silver, or brass with small stones or pieces of colored glass. Like his rings, they could be marvels of one-piece simplicity. Louisa displayed some of these unique creations over her dresser in Roxbury. The peasant blouses and colorful native fabrics she bought while traveling in Mexico, South America, and India made wonderful backgrounds for this wearable art.

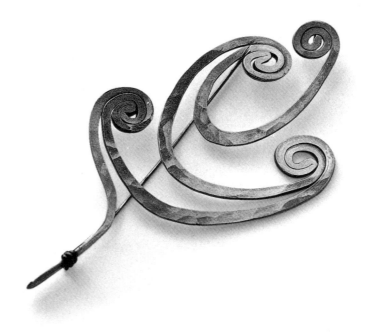

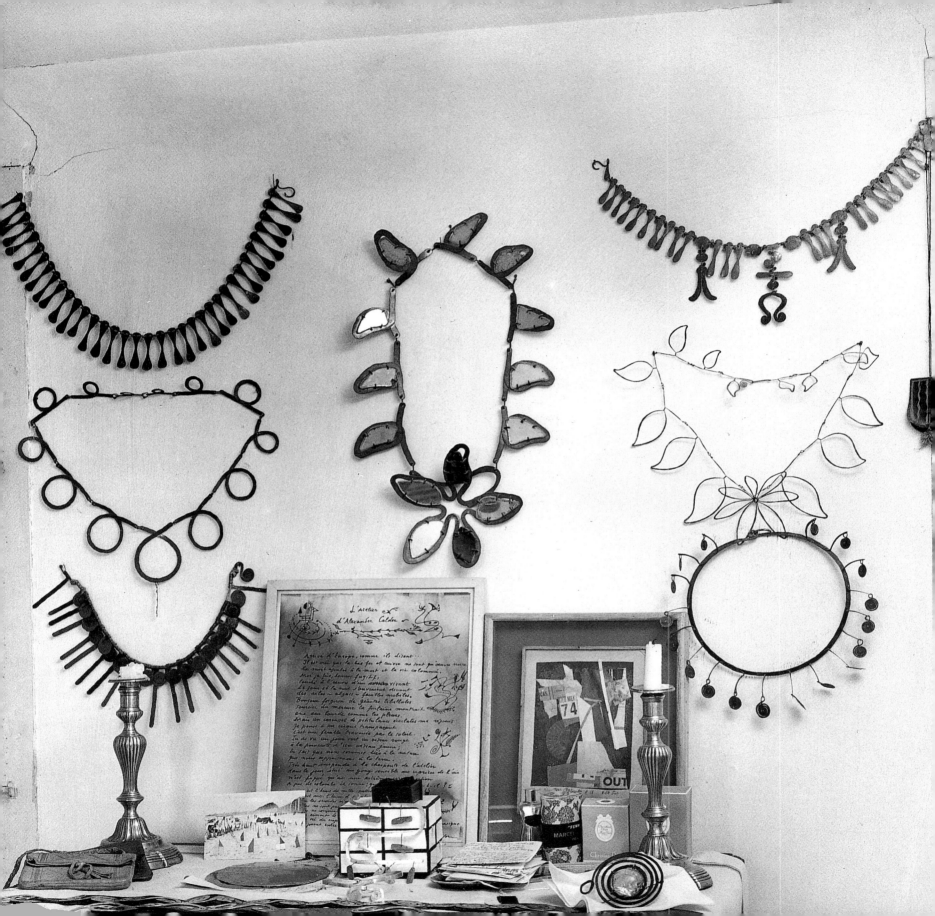

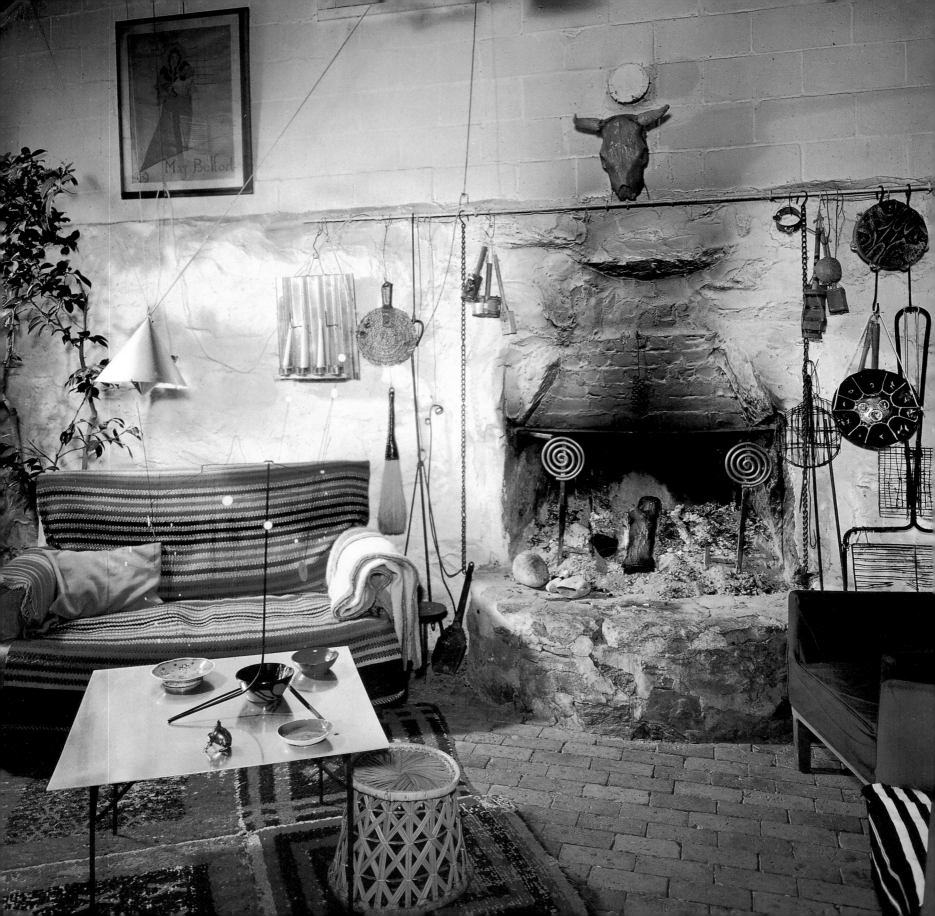

In 1943 a fire destroyed the old ice-house space that had served as Sandy's first studio in Roxbury. Because it was no longer needed as a studio—Sandy had built a new one in the fall of 1938—he incorporated the burned-out area into the rest of the ground floor in 1944, transforming it into a large whitewashed living room. Although much had been lost in that fire, most of the treasures had been replaced by the time I photographed the room. In addition to his own paintings, there were works by his friends—Léger, Miró, Tamayo—as well as a portrait of the young Sandy painted by his talented mother, Nanette. Mobiles hung from the ceiling, and standing mobiles rested on the floor. Potted plants were scattered about in profusion. A bull's skull found on the property and painted red hung over the hole-in-the-wall fireplace. Corrugated aluminum panels with empty beer-can bottoms served as wall sconces for candles. Tambourines and other noise makers decorated the fireplace.

The furniture was simple and unpretentious: Slipcovered armchairs in blue and red were arranged in a circle with a canvas camp chair. A store-bought picnic table, painted blue, and benches, covered in Louisa's hooked rugs, made up half of the living room. The sofa against the far wall was draped in a Columbian shawl. Rugs that Louisa had hooked from Sandy's designs were scattered around. Shelves and bookcases were, as in the kitchen, crowded with figures, jars, and small-scale bronze figures sculpted and cast by Sandy, as well as others picked up in Mexico or Africa. Among the other treasures was a bust of a young Louisa sculpted by her father-in-law, Alexander Stirling Calder. A huge Toulouse-Lautrec poster hung high over a bookcase. A baby grand piano was one of the few objects that the Calders had not made themselves.

On a windowsill, Sandy used to keep an outlandish set of "binoculars" fashioned from two Coca-Cola bottles bound together with wire. He made them, he said playfully, *so I can see Marilyn better.* Marilyn Monroe and her husband, the playwright Arthur Miller, were once the Calders' nearest neighbors in Roxbury. Although they were no longer married when I began documenting the Roxbury house, Sandy kept the binoculars standing by long afterward, just in case.

An ice house on the Roxbury property had been converted into Sandy's studio, but when it was no longer needed the space was incorporated into the main house. With its whitewashed walls, the brick-floored room was an exemplary canvas for the Calders' collection of art and objects that caught their fancy.

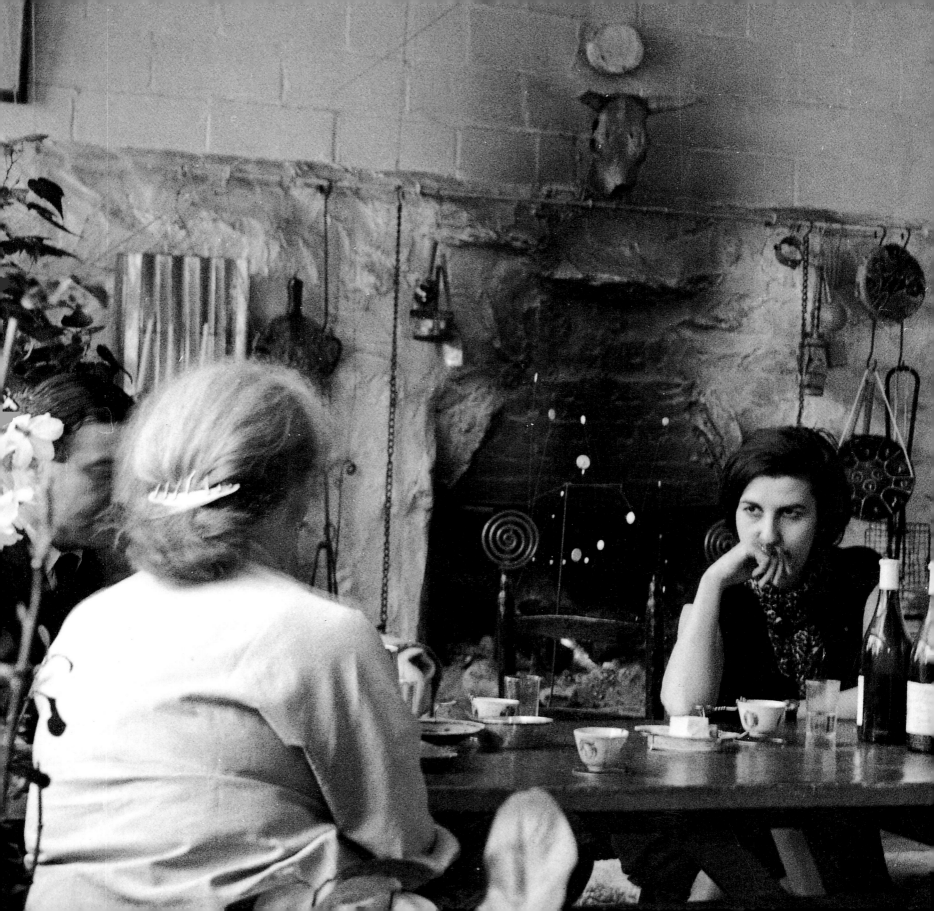

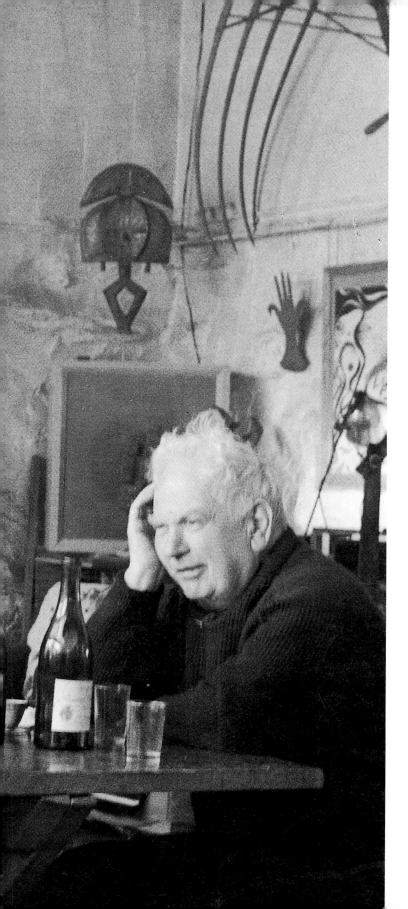

The Calders received guests from all over the world in their cozy home of crowded surfaces and eclectically festooned walls (Sandy's corrugated sconce can be seen here). Wine, coffee, and conversation entertained a rapt visitor as Louisa held court and Sandy watched.

Sandy was never more appealing nor more relaxed than when he was among close friends. In 1975 Jean Lipman and her editorial staff came to Roxbury to gather material for *Calder's Universe*, the catalogue produced for the Whitney Museum's 1976 Calder retrospective. The master of the house kept his hat on.

CITY GALS
PLEASE
THROW
NOTHING
INTO TOILET

BUT NOTHING

ESSUYEZ VOS PIEDS S.V.P.

PENDANT QUE VOUS Y ÊTES

Sandy was not one to leave any area of the Calder home untouched. From the toilet seat to the paper dispenser, from gesturing hooks to elegant door pulls—and a few messages in between—he was there. His unabashed honesty and humor on matters large and small almost defy description: *profane* and *ribald* are too harsh; *Rabelaisian* will have to do.

Alexander Calder was sixty-four years old when I caught him in his studio in Roxbury during a moment's pause between work stations, each equipped with an anvil and hammers awaiting his next idea or project (below). He was in his prime, powerfully built and seemingly tireless (opposite).

Sandy usually went to his studio early in the morning, breaking for a quick lunch, a glass or so of wine, a fast look at the newspaper, and then back to the studio. He would not make the fifty-foot return walk to the house until dinnertime.

Sandy's studio was not a particularly impressive or handsome building from the exterior. But inside it was a grand and breathtaking hall of works in progress— kinetic objects sweeping the ceiling, splashes of color on stacked canvases, and unfinished elements of a future or a dismantled work of art. Built on the foundation of the barn that had burned, it was made of concrete block with a pitched roof of timbers and asphalt shingles. Two long banks of windows, all with factory-made sash, flooded the interior with natural light.

A row of long tables or work stations took up the center. Each table was equipped with coils of wire and tools of every description—snips, hammers, chisels, wrenches, files, and vises. There was no need for Sandy to go from one work bench to another in search of a tool. In the narrow, twisting aisles, two anvils mounted on sections of tree trunks were also outfitted with a clutter of implements. Sheets of aluminum were stacked in large homemade crates, while other crates held finished gouaches. Coils of brass and steel wire in various gauges hung from table edges. Sandy had one electric drill press, but he preferred to do everything by hand.

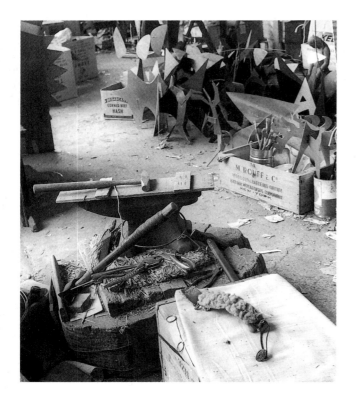

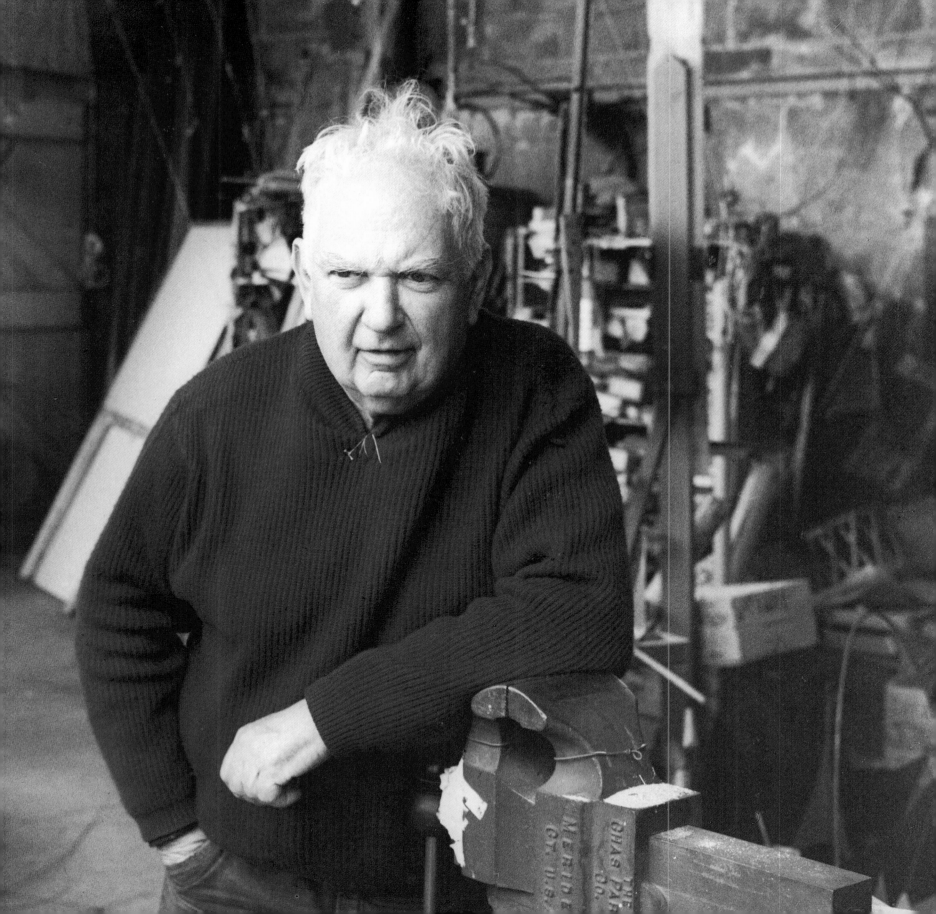

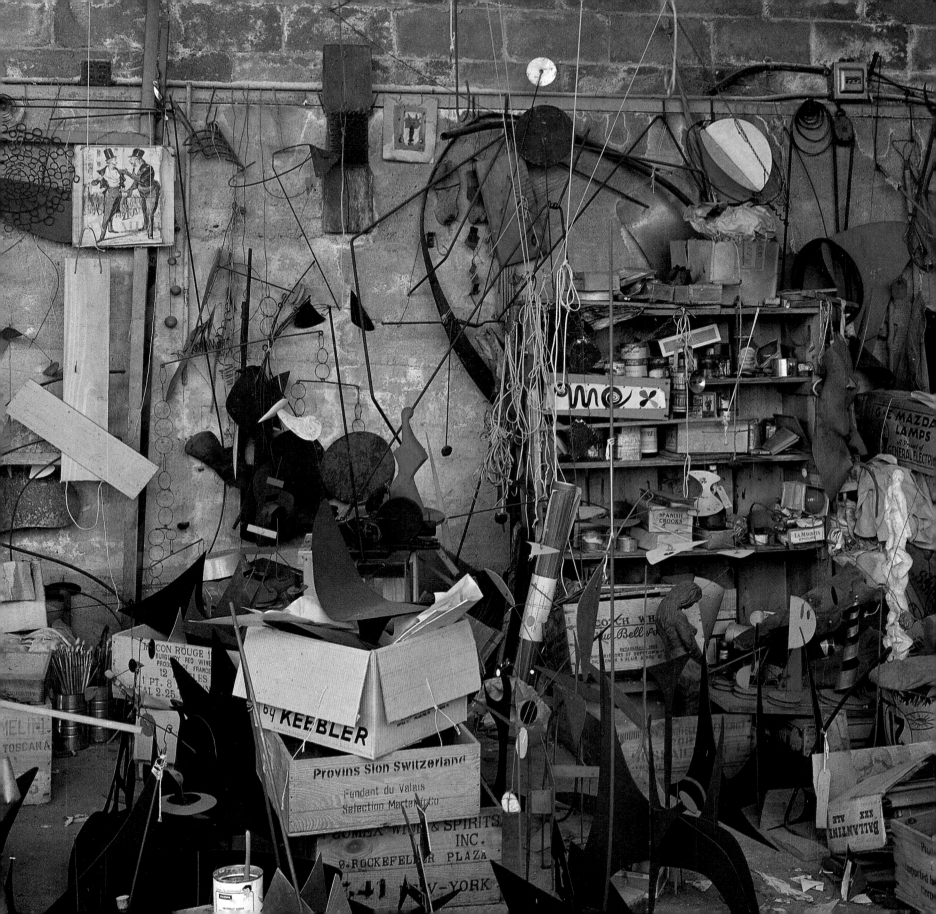

Under a stairway that
led to a platform over-
looking the Roxbury
studio were a few
unfinished works, wood
carvings, and mobiles
(opposite). Unexpected-
ly hanging here was a
sheepskin vest that
Sandy made for cold-
weather wear (right).
Even without exploring
it all, photographing it
was satisfaction enough.

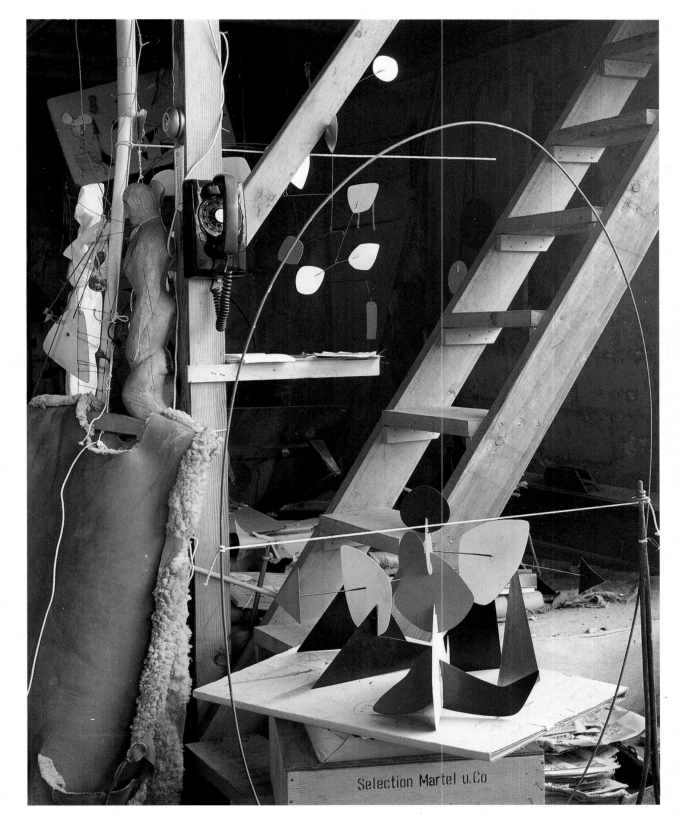

Selection Martel u.Co

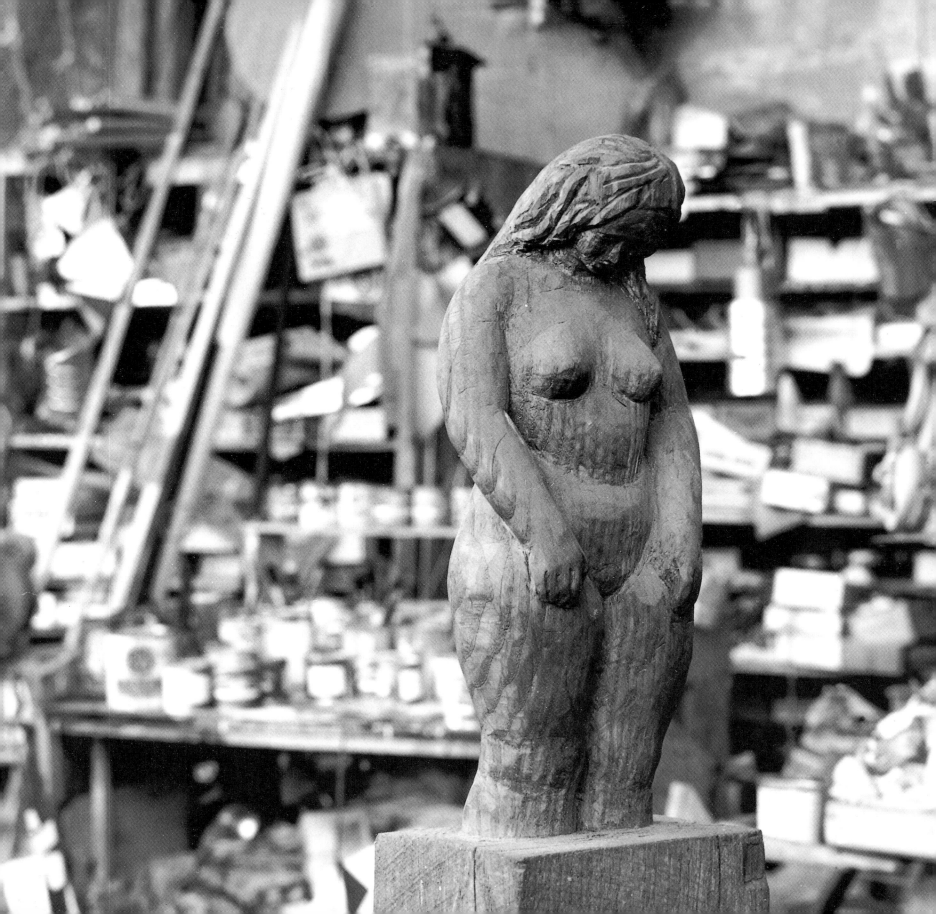

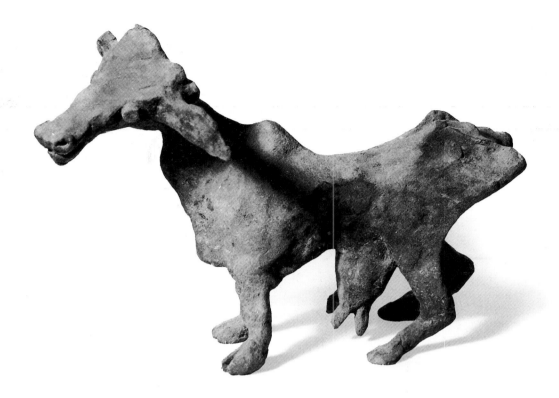

Sandy lavished care
even on small objects—
a Rubenesque woman
(1928), one of his last
realistic carvings (oppo-
site); noisemakers built
from tin cans (below);
and a bronze cow (right),
fashioned in 1930 during
a brief period that did
not hold his interest.

Against the studio's south wall shelves ran about thirty feet long, packed to overflowing with rolls of paper, cigar boxes (used for only Sandy knew what), coils of string and rope, shapes cut out of metal for a mobile or stabile in progress, and hundreds of cans of paint cascading down from the shelves to the narrow aisles. The rafters held a great number of screw eyes from which Sandy suspended mobiles, old and new, many of which I would recognize later on as they made their way from one exhibition to another. Frames and dowels and cardboard boxes, filled and empty, were everywhere. The whole atmosphere can best be described as the aftermath of Hurricane Sandy. It was fascinating but not a pretty sight.

One day Thomas Watson, the founder of IBM, stopped in to see him. Watson had heard that Sandy had some interesting new art forms. He studied a number of mobiles hanging in the studio and asked if he could buy one in particular. *How much is it?* Watson asked. Sandy told him that he could have it for $125. *Well,* said Watson, *I like it—but not that much!* Years later, when IBM wanted to purchase a stabile for one of its new buildings, Sandy remembered the slight and refused to sell any. His stabile *Saurien* (1976) has since been installed in front of IBM's New York City headquarters at Madison Avenue and 57th Street— but it belongs to the Minskoff Corporation, the owner, and not IBM.

Although Frank Lloyd Wright's chairs are often deemed uncomfortable, the distinction between his and Calder's in terms of comfort may be hard to identify. It isn't difficult to understand why Sandy's recliners did not catch fire. And the Calder children must have dreaded the iron-maiden toilet trainer.

Stabiles filled Sandy and Louisa's property on Painter Hill Road. *Discontinuous* (1962), *The Onion* (1965), *Polygon on Triangles (The Nun)* (1964), and other stationary sculptures were scattered around the expansive grounds. *Southern Cross* (1963), a red standing mobile—the largest object there—sat in a field between the road and the house.

Sandy did business at two foundries in Waterbury, the Segré Foundry and the Waterbury Ironworks. Outside Segré, other large-scale works, some as high as thirty feet, awaited assembly. Calder made no blueprints or drawings to instruct the foundry workers on how to build these monumental works of art. Instead he created tiny models, about a foot high. To build the sculptures to size, the workers disassembled the models and enlarged the components by means of projection. The large individual elements were then manufactured and reassembled, using the model as a guide. Sandy said that it took great courage at first to tell the foundries how big he really wanted the stabiles—huge, in fact—and the stabiles kept getting bigger and bigger as he kept creating them.

At the Segré Foundry, Sandy was particularly fond of "Chippy" Ieronimo, a fellow who was quick to catch on to Sandy's intentions. Sandy soon became Ieronimo's favorite assistant, keeping a watchful eye on the production of his work. The men at Waterbury became so adept at translating Sandy's models into huge stabiles that they once attempted to put together one of their own design. They built it out of scrap steel, always in great abundance at foundries. They proudly showed their stabile to Sandy, who was only mildly amused. He did not like imitators and was fiercely protective of his unique creations. To him, imitators trivialized the medium.

Arranged in the tall grass and under the trees in Roxbury were a number of stabiles of less-than-monumental size. Sandy must have been hungry when he named *Funghi Neri* (1960) (below) and *The Onion* (1965) (opposite).

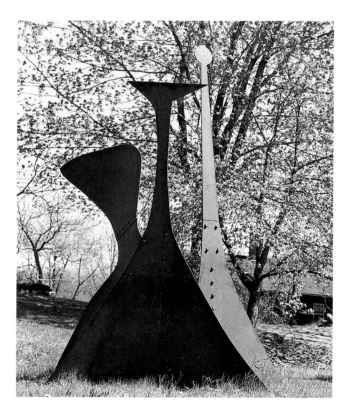

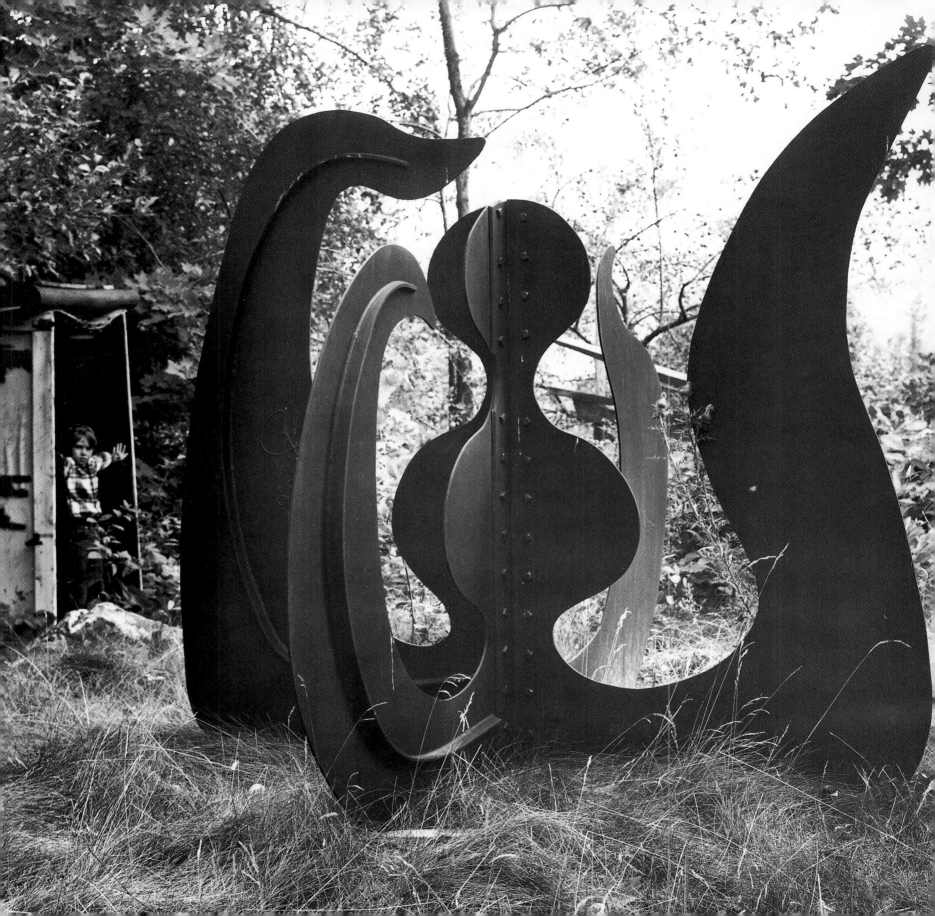

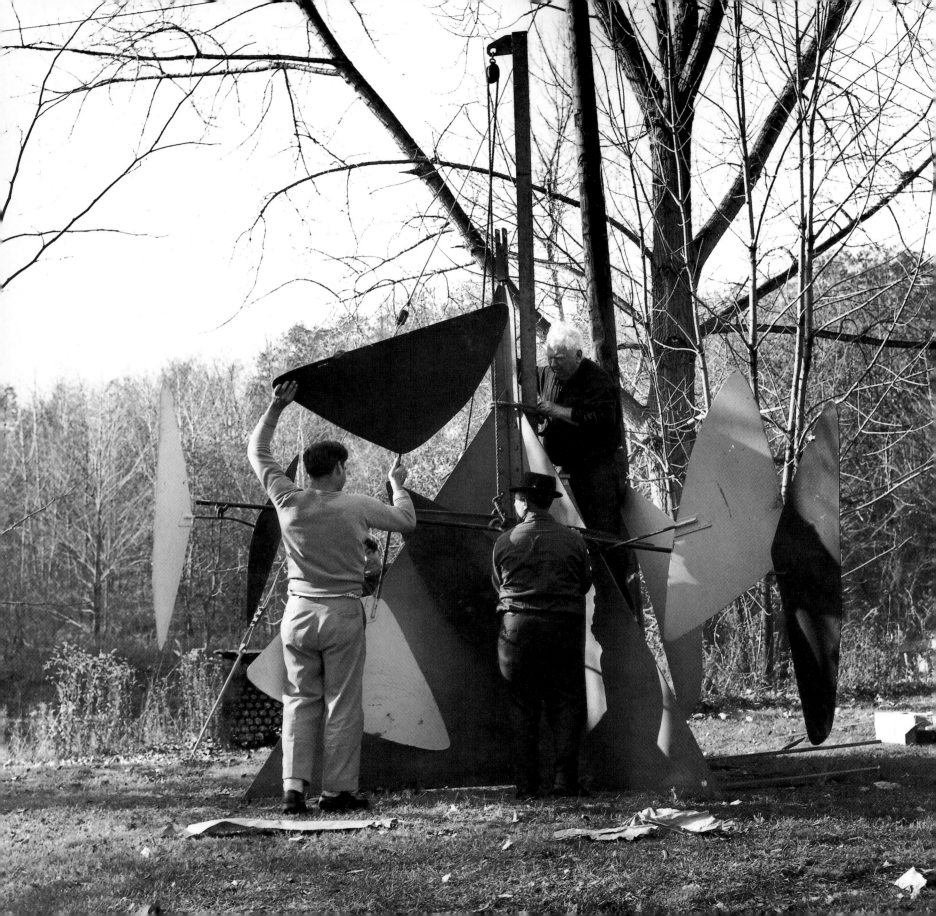

Sandy's art, although childlike in its exuberance, was a serious endeavor—not to be dismissed by writing it off as that. He knew that his public had expanded greatly but admitted jovially, *My fan mail is enormous—everybody is under six.* On one of my early visits, Sandy learned that I had been elected justice of the peace, so he fashioned a star for me from the top of a tin can. He punched a hole in it to attach it to my shirt. *Here, wear it with pride,* he said with a grin, and I still have it.

In the fall of 1963 Sandy and Louisa made plans to leave for France and their home in Saché, a small village south of Paris, near Tours. As a sendoff, my wife, Barbara, and our children—Susan, Marc, Ben, and Barbara—invited Louisa and Sandy over for a Mexican dinner at our house in New Canaan, not far from the Calders' Roxbury home. I made enchiladas and refried beans—having a direct line to a Mexican food business that my father had helped establish in Arizona, I could easily get the required ingredients. Mexican food was not common in Connecticut at the time, so, not knowing whether the Calders would like it, I warned them about the menu. They were game.

Sandy brought his circus movie to entertain the children. In the 1920s he had created a miniature circus made of wire, wood, paper, and bits of cloth. *Calder's Circus* had a full menagerie of animals, high-wire artists, tumblers, a lion tamer, and even a sword swallower. Living in Paris as a young artist, Sandy staged performances of *Le Cirque Calder*, as it was known there, to earn money and attract the attention of the bohemian art community. Performances, which usually took place in his apartment, were advertised and attracted enthusiastic crowds. He acted as the ringmaster; the music was supplied by a wind-up Victrola that some friend or, later, Louisa would play. In 1961 one of these performances was filmed by Carlos Vilardebo at the Calder home in Saché. My children, like most children then and now, were delighted by the film and Sandy's off-screen asides. The circus master directed his full attention to getting the greatest reaction from his audience. It did not disappoint him.

In 1965 a crew from the Segré Foundry led by "Chippy" Ieronimo (opposite, in the hat), came to Roxbury to install *Sandy's Butterfly* (1964). The artist played the enthusiastic assistant, doing most of the work. The black farmhouse (above) made a good backdrop for his *Lollypops* model (1962) and the mobile *Red Disc and White Dots* (1956).

With its mobile arm balanced on a four-legged orange stabile, *Southern Cross* (1963) dominated the Roxbury property (below and opposite). The open, spidery feet marked a departure from the black pyramidal bases that Sandy had used previously. He continued to make giant stabiles, but *Southern Cross* remained one of the few in this form.

Sandy and Louisa departed for France soon afterward, and I began to make plans to visit them in Saché. With the photographs released to me from *House and Garden* and the others that I had accumulated since then, I was convinced that I should put together a book on Sandy's work. No new books on Calder had come out since about 1943 (James Johnson Sweeney's monograph, which was revised in 1951), and it was time to bring him up-to-date.

House and Garden, which had decided earlier in 1963 that the story on life chez Calder was not for its readers, ironically made possible my first visit with the Calders in France, thanks to a two-week assignment in Ireland that I extended to a working foray into Saché. And the original feature was not abandoned completely. *Vogue* tried to make the idea fit its format but sent the proposal back to *House and Garden,* suggesting that the magazine assign a celebrity photographer—obviously not me—and turn it into a personality profile. The editor chose Inge Morath, who had married Arthur Miller after his divorce from Marilyn Monroe. But this idea was dropped until *House and Garden,* remembering that I had continued to document the Calders, asked me to submit what I had done. The magazine then hired Francine du Plessix Gray to write the text for a photo essay entitled "At the Calders," and this was published in the December 1963 issue.

A book on Calder seemed more and more like a good idea. In October my wife and I traveled to France to visit the Calders and to continue my quest to document them at home.

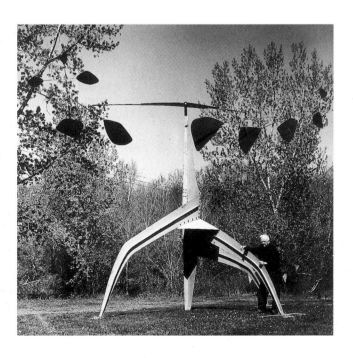

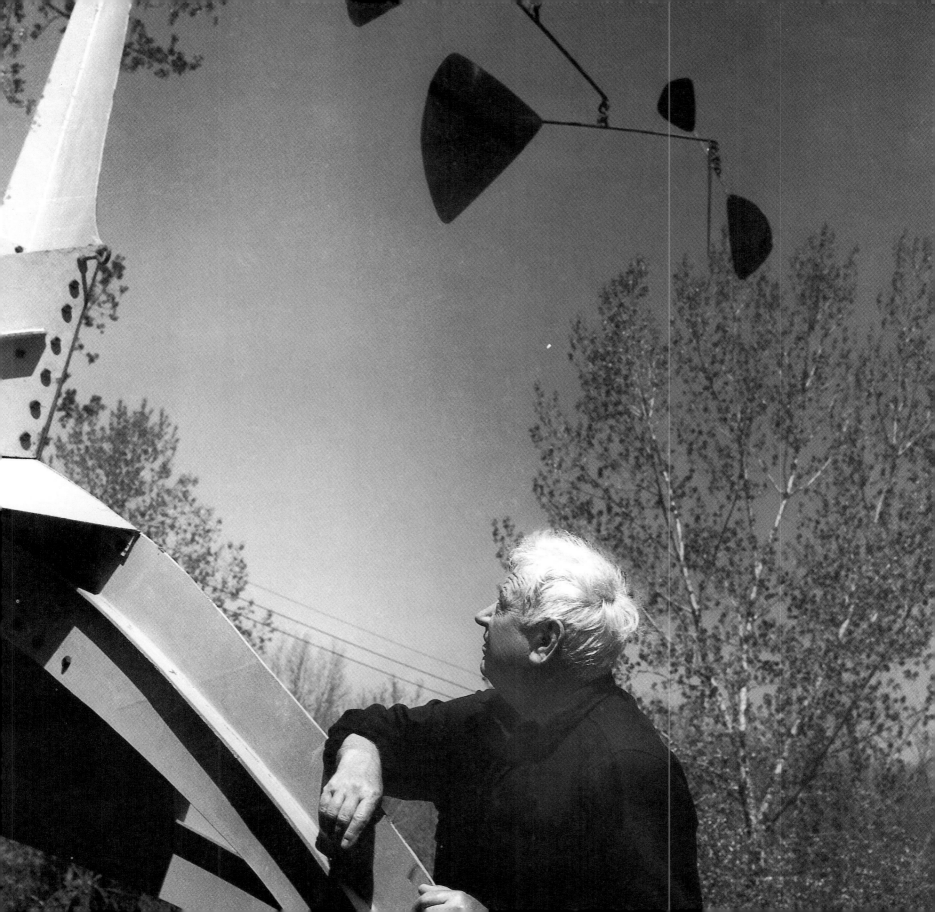

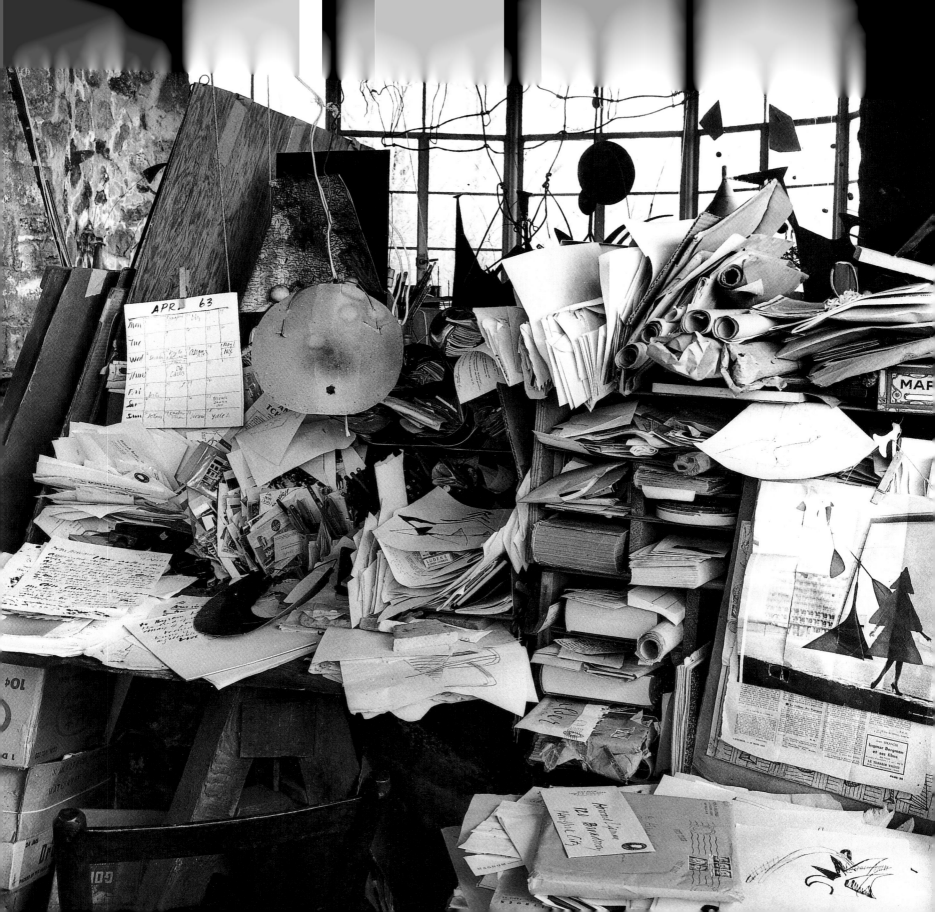

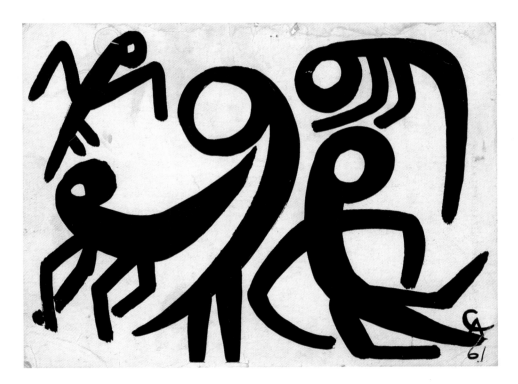

On the end of the studio where the silo once stood, Sandy created an office. Here calendars and schedules, notes and letters were intermixed in scattered and layered confusion. Sometimes he would drop everything and sit and answer his mail. A dutiful and loyal correspondent, he wrote letters that were always warm and often funny. His bold, slanted script, which appeared to be written with a crudely sharpened stick, seemed to race across the page.

Like the rest of the Roxbury studio, Sandy's desk near the silo end was a marvel (opposite). Although most of us can take comfort that our own desks are not so bad, Sandy knew where everything was. His visor, left atop the desk, reminded him of where he had left off. His familiar hand invited us along to France (right).

Lincoln Art Series: ALEXANDER CALDER

POST CARD

"HE CAN LIVE IN FRANCE ... WITHOUT ANY SENSE OF EXPATRIATE

GUILT AND WITHOUT BECOMING IN THE LEAST BIT FRENCH."

Selden Rodman

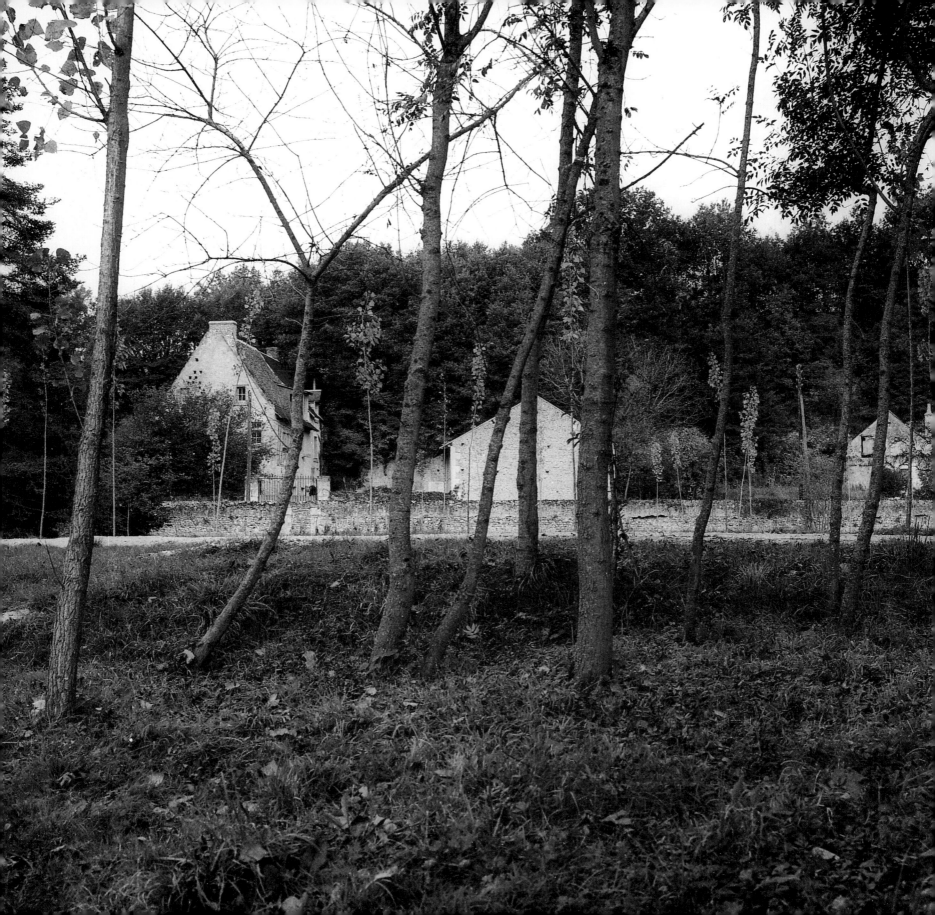

fter World War II the Calders had begun spending extended periods of time in Europe, particularly in France. They stayed in rented houses and on some occasions with old acquaintances, of which there seemed to be many. During one of their motoring jaunts through rural France, they found themselves in chateau country. Realizing that the brother of their friend Jean Davidson lived in the area, they decided to try to find him. Serendipitously, they ran into Jean himself.

The Washington correspondent for *France Presse,* Jean was the son of Jo Davidson, a famous sculptor in the same classical vein as Sandy's father, Alexander Stirling Calder. Once when he visited Sandy in Roxbury, Jean remarked to Sandy's mother, Nanette, that he greatly admired her son's work. *Oh,* she said, *but you should have known Stirling. He was a sculptor.* Years earlier Jean had tried to justify Sandy's sculpture to his own father, to no avail.

Tiring of life in Washington, Jean decided to settle in France, where his father had a country home. He purchased some property nearby—even he didn't seem to know how much—including an old mill in Saché with a long-past-functioning water-driven wheel. When Sandy and Louisa visited in 1953, Jean was busy converting the mill into a home. He was so enthusiastic about the project that he took the Calders around the countryside, trying to persuade them to buy a mill of their own. But Sandy had seen something he liked better: a seventeenth-century house that was a long-abandoned derelict. Surrounded by an expanse of grass and a stand of trees, it sat comfortably about a hundred fifty feet from the river Indre—and turned out to be on Jean's property.

Although little more than a ruin the first time Sandy first saw it, the two-story structure bore the regal name of François Premier. Built of stone, brick, and timbers, it had only a dirt floor and no plumbing or electricity. The windows were plugged with loose stones. To anyone else, it probably would have been a discouraging wreck, but not to Sandy. Jean still owed Sandy for some works of art, so the two agreed on an exchange—a few mobiles—and the deal was set. *I will make mobiles from cobwebs and propel them with bats,* he said optimistically when he accepted Jean's terms for the trade.

Buffered from the river Indre by a grove of trees, François Premier was a grandly named ruin that the Calders bartered from Jean Davidson, soon to be their son-in-law. The ancient house abutted a flinty rise and at one time had served as a spot for pressing grapes. Across from the front of the house was a farm implement shed, and beyond was another farm building awaiting artful conversion to Sandy's special needs.

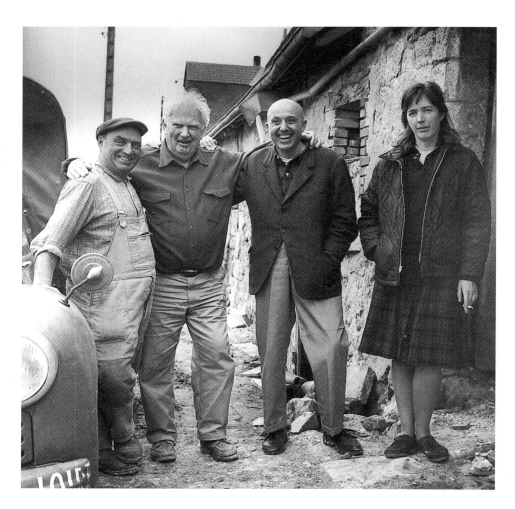

Jean Davidson, standing between his wife, Sandra, and her father, Sandy Calder (left), lived in a picturesque old mill in Saché that he had converted into a home (below). Sandy put Jean in charge of refurbishing his own historic house (opposite), which was typical of ones in the surrounding countryside. Soon after the Calders and Jean settled into their homes, Sandra and Jean were married and they moved to another house away from the river.

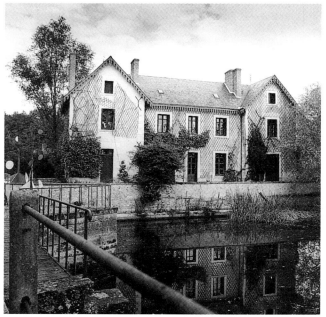

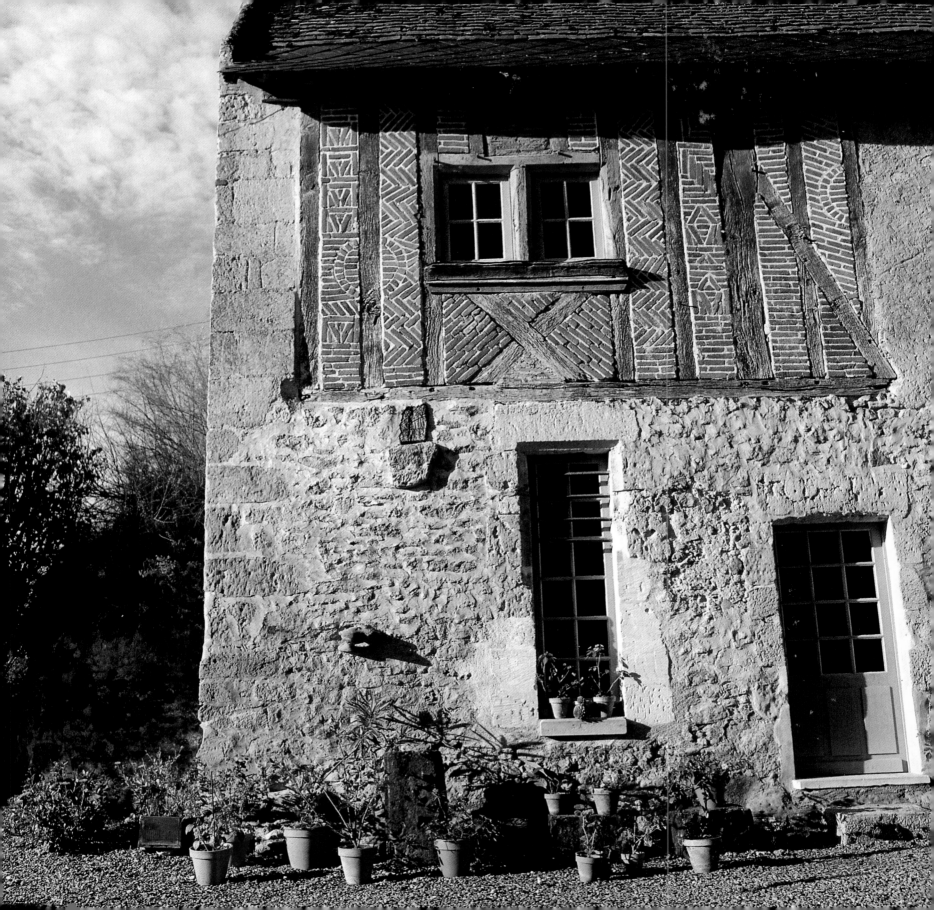

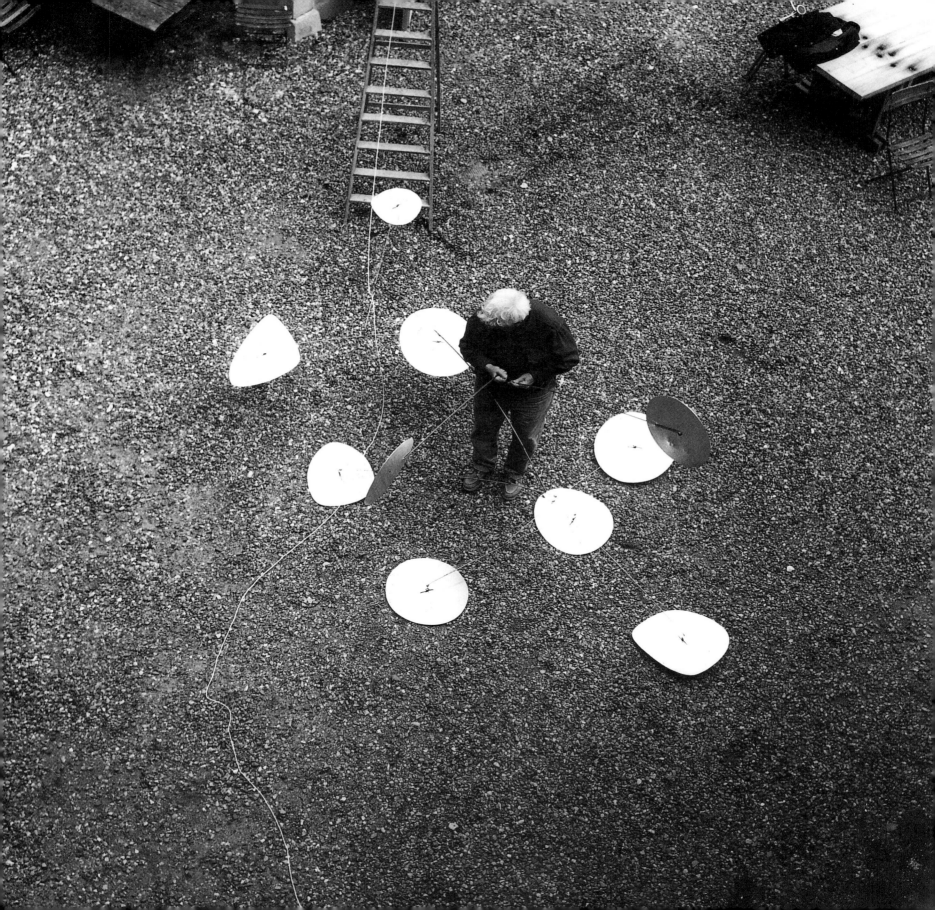

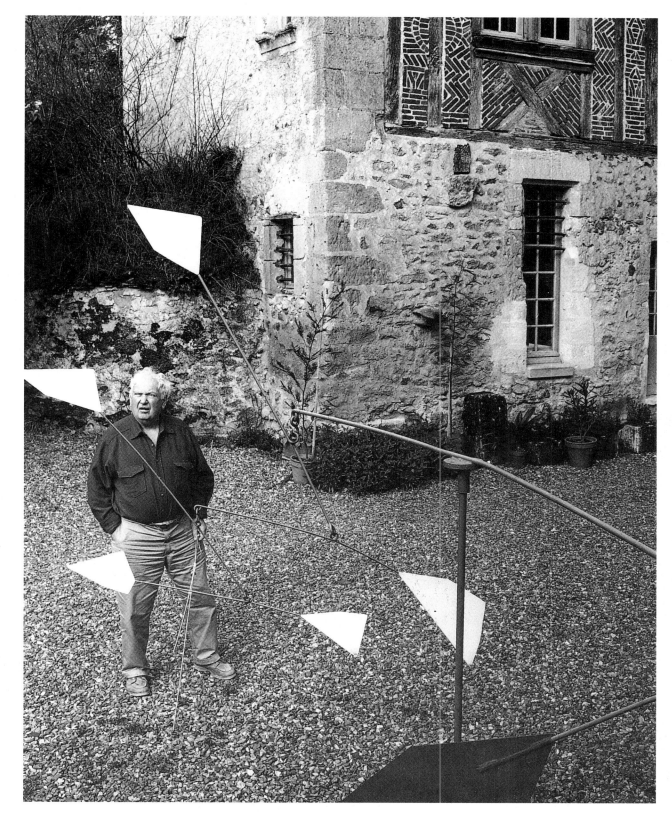

Sandy would string up a
new mobile between the
house and the maquette
studio, either to study it
or, more often, to paint
it. These two from 1964
and 1966 represent the
limit of the size he could
handle in the old imple-
ment shed. Beyond that
they were relegated to
a foundry. The maquette
studio did not have
enough space to unfurl
a mobile or to paint it.

Sandy and Louisa put Jean in charge of making some much-needed repairs to the house while they traveled to Beirut and the Middle East. Given the responsibility of making the dwelling habitable, Jean immediately saw to it that water and electricity were brought in. Amenities such as bathrooms and a kitchen sink then became possible. Except for the installation of tight doors and windows and tile to cover the dirt floor, little other effort was made to bring the house into the twentieth century. In customary French country fashion, the interiors were whitewashed and the ceiling was supported by a series of rustic, rough-hewn timbers. Aside from this, once the Calders moved in during the spring of 1954 the house was anything but typical.

The main floor was one long continuous room with a fireplace and living area at one end and a kitchen at the other. Throughout the space, mobiles hung in profusion, almost colliding. Sandy's gouaches, in bold primary colors, stood out as dazzling accents on the rough-plastered walls. Colorful hooked rugs, made by Louisa in Calderesque patterns, were scattered across the floor. The furniture, from local markets or preowned, bore little evidence of Sandy's carpentry—he was obviously too busy with other things now. Nevertheless, the house was as crammed with objects, artwork, cabinets, armoires, and other furnishings as their home in Roxbury.

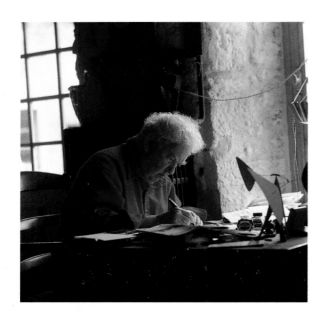

Once Sandy and Louisa moved in, they set about putting their inimitable imprint on François Premier. Much time was spent in the living area (left and opposite), but the kitchen at the other end of the ground floor was really the house's social center. The new tile floor ordered by Jean Davidson was soon covered with rugs that Louisa hooked from Sandy's designs. Local farmer's chairs and a plain sofa were covered with colorful throws from faraway places. Mobiles crowded the ceiling. Sandy even raised the hearth (pages 78–79) to make it draw properly.

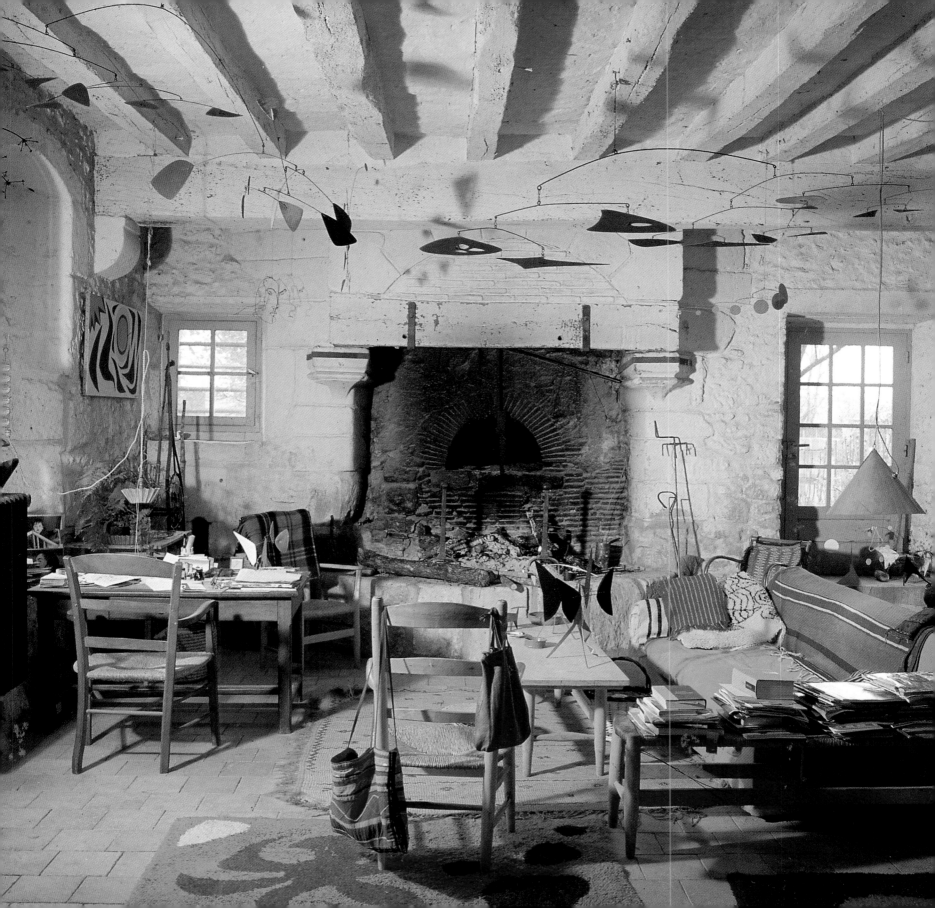

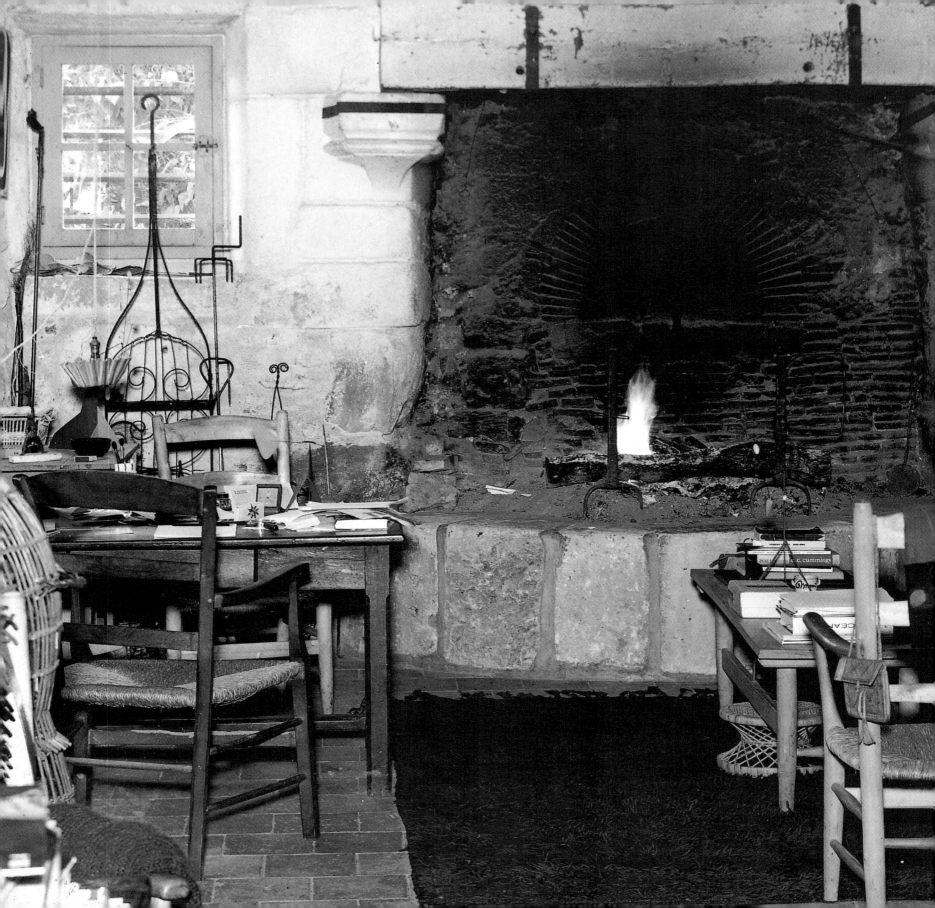

Sandy's ingenious candleholder of corrugated aluminum and beer-can bottoms (below) shared a corner with a bird of brass wire and a comb in the shape of a *figa*, a Brazilian fertility symbol, all from the 1940s. These helped fill the vast space along with objects as varied as Sandy's mobiles, reed trivets from local markets, and Louisa's rugs (opposite).

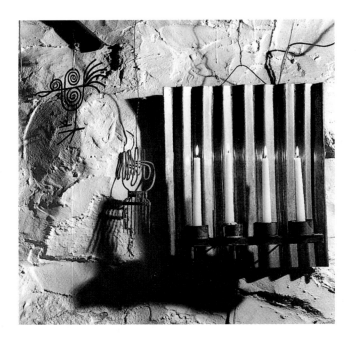

The kitchen, primitive by comparison even with the fairly rustic one in Roxbury, was built into the hillside that flanked the house. The stove was a minimal affair, and the oven didn't encourage Louisa's custom of daily bread baking, but they were in France, after all, where good bread was plentiful. The kitchen was crowded with items that Sandy and Louisa had purchased locally—woven reed trays, a loaf of bread displayed as a work of freeform art, and pots and pitchers. Pans, ladles, colanders, and sieves—perhaps twenty or thirty—hung from an iron bar across the opening that denoted the cooking space.

A table holding large jars and bottles separated the kitchen from the dining area, which consisted mainly of a long table that accommodated eight chairs. It could be enlarged to seat more if the occasion called for it, and it often did. A Chinese kite was suspended from the ceiling over the dining table, competing with a chandelier that Sandy had fashioned from a circle of metal gelatin molds. Coarsely woven fabrics, predominantly red, brightened the large room and served as backdrops for the different spaces. A bottle tree—an apparatus for drying empty, washed wine bottles—was in the far right-hand corner.

On the second floor, the Calders had a bedroom for themselves and room for guests. In stunning contrast to the living area, the bedrooms were stark and simple, minimal with a judicious use of color, like a well-designed poster. Louisa's throws adorned the chairs in the Calders' bedroom. An orange Moroccan carpet softened the red brick floor. I once saw three stacks of Sandy's favorite clothing in this room—one stack of half a dozen pairs of khaki pants and one each of red and blue woolen shirts.

Directly behind the house, adjacent to a gentle rise of flinty soil, was Sandy's "cave"—a wine cellar, cool and dark, that held what looked like hundreds of bottles of red wine. (I don't remember ever seeing a white wine at the Calders'.) In addition to the cave, a number of outbuildings were scattered around the property, each accommodating some aspect of Sandy's artwork.

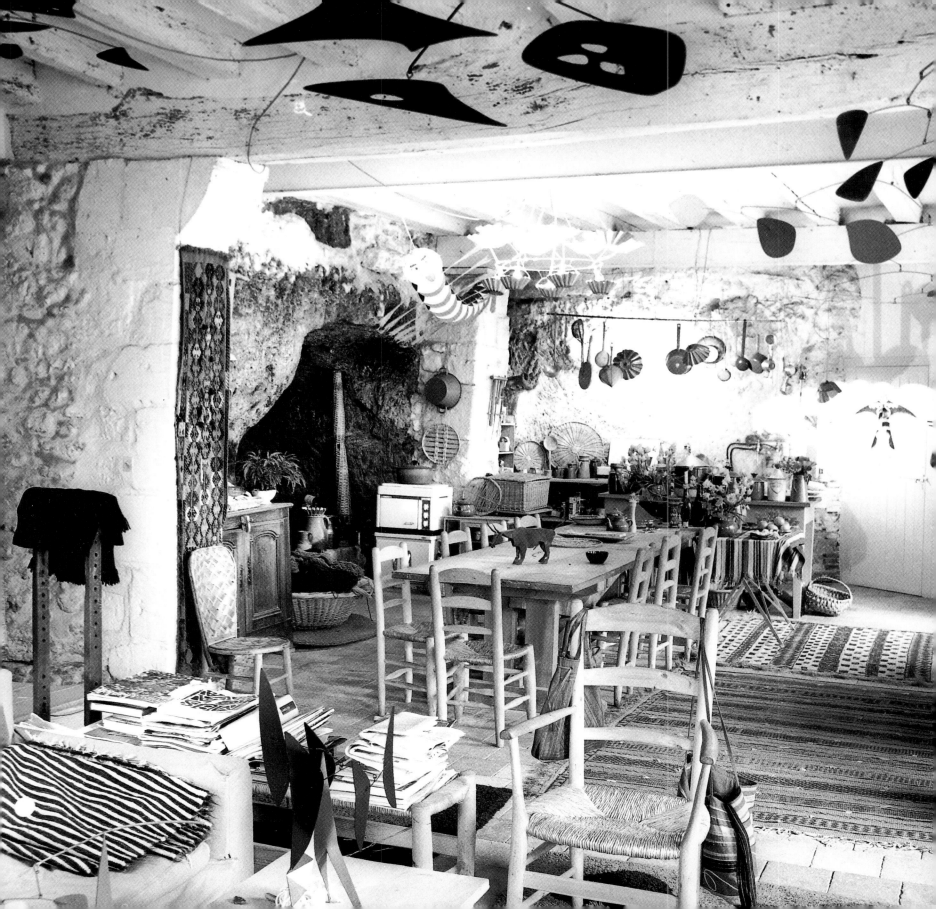

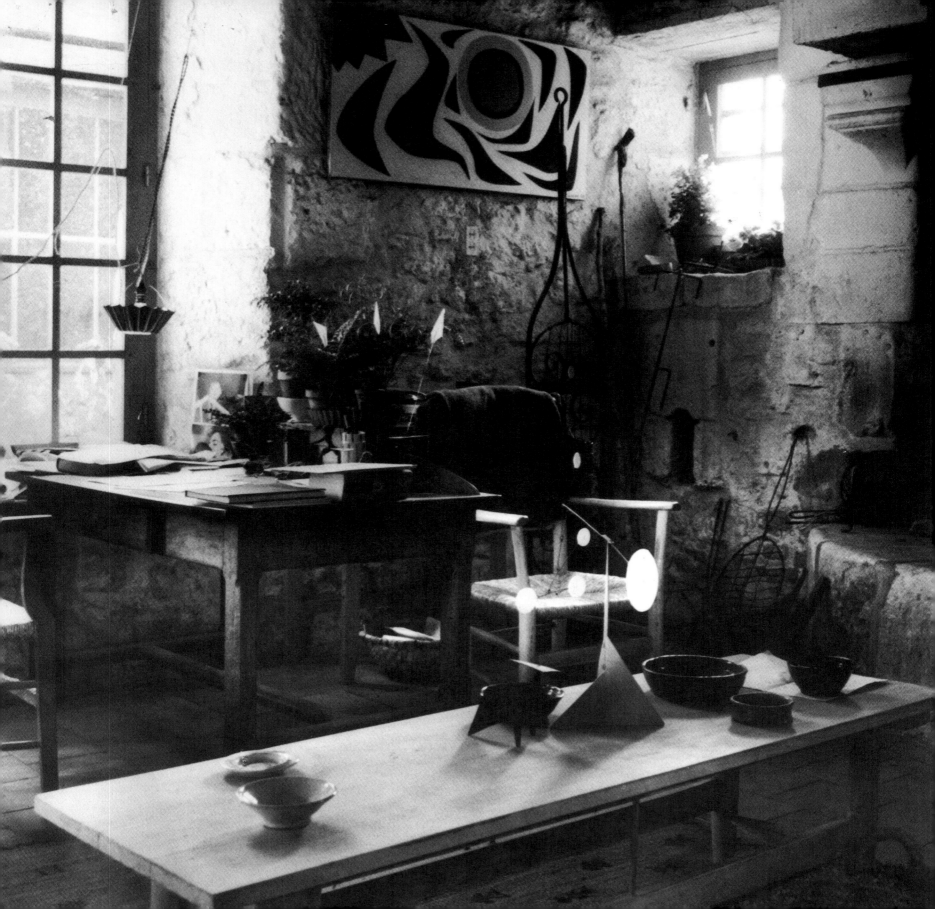

The outbuildings in Saché were all converted from wagon sheds or other structures on ancient farms and were constructed in the typical French country manner—stone and concrete with a tile or slate roof. Across the courtyard stood a modest building that Sandy used for making objects such as small mobiles, stabiles, and maquettes of future large stabiles. Closed in with factory windows and doors, the maquette studio also served as the overflow storage area for his gouaches. Another building located a short distance from the house was his painting studio. Sandy spent some time there each day, turning out a prodigious number of gouaches. But the most prominent building of all was the enormous stabile studio. This building, constructed in 1962 specifically for Sandy's large stationary works, dominated the landscape in its spot on a hilltop high above and behind the house.

When we came to visit him in Saché that fall of 1963, Sandy met my wife, Barbara, and me at the train station. I was dressed like all my fellow commuters in the Connecticut suburbs—in the typical uniform of gray flannel suit and wing-tipped Cordovan shoes worn by one and all streaming into New York City. My French getup also included a very unbohemian velour hat with a tiny feather in the band. I thought I looked pretty spiffy. Sandy shook my hand and gave me an enormous bear hug. That done, he snatched the hat from my head and flung it as far as he could. Calder disdained pretense and couldn't abide anything he considered sham.

Neither of us ever acknowledged the incident, and I never missed the hat. Yet the experience haunted me because of a similar occurrence thirty years earlier. I often worked in the summer for my father, a sign painter in Arizona. On a hot July day, while laboring on a sign atop the corrugated iron roof of a country store, I traded in my regulation painter's cap for a cool farmer's straw hat. The difference was remarkable. That afternoon, Dad dropped in unexpectedly. Approaching me from behind, he grabbed the straw hat off my head and tore it to bits. He fired me on the spot and sent me home on foot, twenty-five miles away.

Even though the two events were separated by three decades, it seemed odd to me that both men, who were about the same age, chose to focus on my hat. What were they trying to tell me? Obviously Dad was in a rage— he believed that I was being unprofessional by wearing a nonregulation hat. Sandy, more as a prank, seemed to be telling me to be myself. His playful lesson in Saché was far more powerful than my father's. My days of dressing like a banker ended that afternoon.

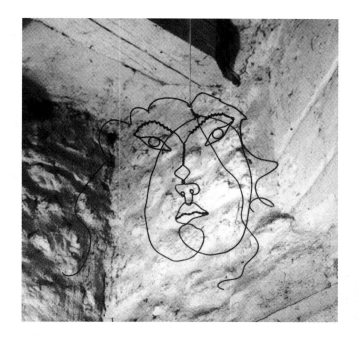

Sandy's writing table in Saché (opposite) was flooded with light from a window and a lamp formed from a gelatin mold. In the corner stood huge roasting grills, under a Calder painting that splashed color on the stark white wall. A wire portrait of Louisa (1931) floated from the rafters (above).

Although I didn't have time to paint *Teodelapio* (1962) in Spoleto, Italy (below), I was able to photograph it—as Sandy asked me to when I visited him in Saché. Upstairs there, the Calders' bedroom was simple yet in character (opposite). The tapestry *Black Head* (1962) hung over the bed, and one of Calder's early paintings crowned the fireplace.

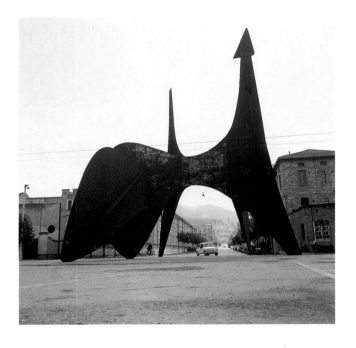

At François Premier we stayed in one of the Calder guest rooms, but because of a tight schedule, this first visit to Saché was brief. Before we departed, Sandy gave me a list of some of his major works in five European cities that he insisted had to be photographed and included in my book. Fortunately, my trip to Europe was financed in part by *House and Garden* as well as *Architectural Forum,* and I was prepared to devote two weeks to traveling to outlying locations on the Continent to document Sandy's work. I was off to Sweden, Denmark, Belgium, Holland, and Italy to continue tracking Calder. In addition to the list, he also gave us a gouache.

As we were just about to go out the door, Sandy asked one more thing: *How long will you be in Spoleto?* When I replied, *Just long enough to photograph "Teodelapio,"* he seemed disappointed. *It needs painting,* said Sandy of the immense sixty-foot-high stabile from 1962 that towers over the train station.

Over the years I returned to Saché a number of times, witnessing the daily rituals and habits that the Calders developed in their French abode. Whenever the postman arrived, for example, Sandy or Louisa or both of them would greet him grandly at the door with a hearty handshake and a show of gratitude, simply for having delivered the mail. Sandy assured me that such ceremonies were imperative to maintaining good relations with the local artisans, merchants, and civil servants.

When Sandy was working in Saché, he would drop his hammer or wire cutters around noon and call out to me: *Let's go get something to eat.* Quite often this was simply several slabs of bread, one or two kinds of cheese, a piece of sausage, and of course red wine. Occasionally Louisa served leftovers. *Ah! It's reappearing garbage,* Sandy would say with a crooked smile. *Oh, shush, Sandy,* was Louisa's reply. Lunch was not defined in terms of a given period of time—not a half hour or an hour. Usually it was a gracious, relaxed interlude, limited only when there was pressure to finish some work, keep an appointment, or go with Louisa to the market in nearby towns.

Louisa took care of the house, planned the meals, and shopped for them. But in Saché, Louisa had her own agenda apart from Sandy's. She made distinctive contributions to the look of their home. Each room was abundantly graced with hooked rugs, all executed from Sandy's designs. Other handiwork bore Louisa's own imprint, her sense of color and whimsy. Kind, gentle, and completely unflappable, she was often the peacemaker for Sandy, who would sometimes explode without thinking of the consequences.

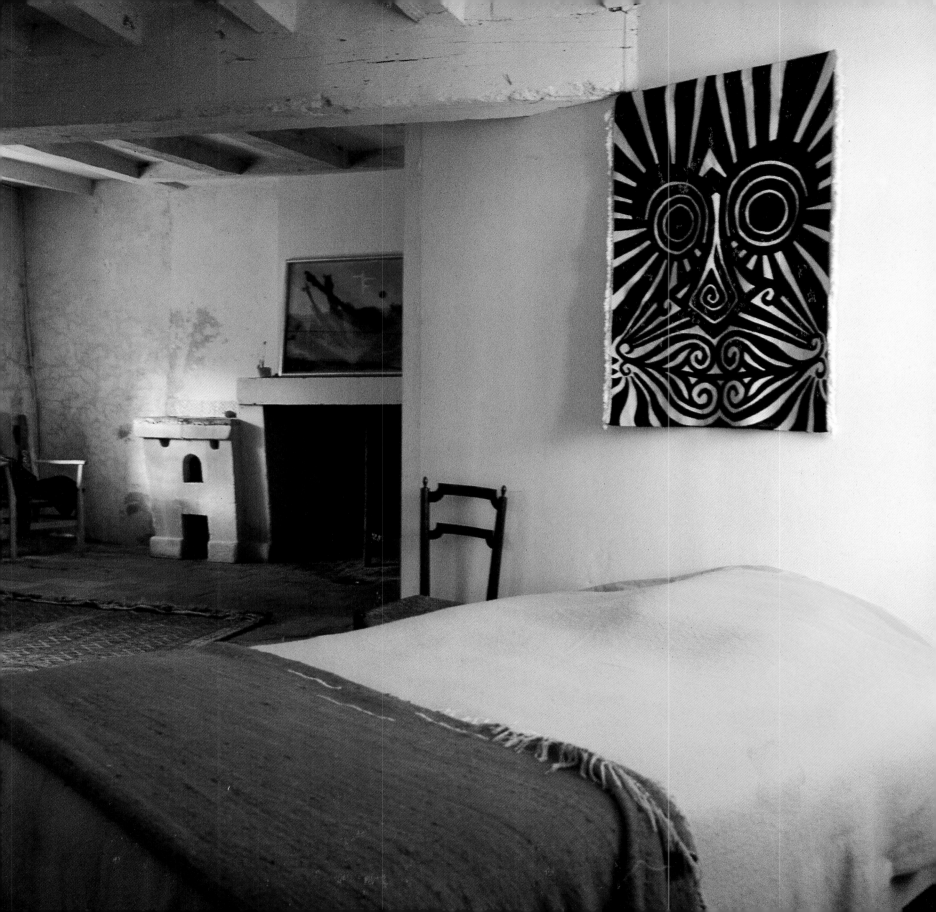

Using the same technique as his gouaches, Sandy designed some glazed porcelains in 1969–72 for Sèvres—a striking departure from his handcrafted kitchen implements (right). I don't recall that the Calders ever used them. Their kitchen in Saché was as Calderesque as it could get (opposite). A loaf of local bread vied for attention with pots, pans, and crockery.

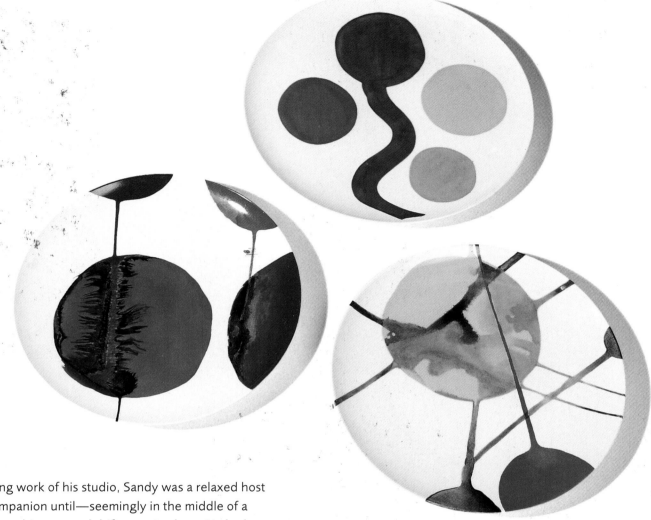

Away from the all-consuming work of his studio, Sandy was a relaxed host and an engaging dinner companion until—seemingly in the middle of a conversation—he would close his eyes and drift away to sleep. He had an uncanny way of shutting down everything except his ears and a good portion of his brain. Although he appeared to sleep, nothing escaped him. When it was least expected, Sandy would open his huge eyes to full aperture and respond either comically or angrily to his surprised guests.

This happened once to a poor unsuspecting soul at a large dinner party who had been placed in the seat of honor next to him. She was engaged in conversation with her dinner companion when, to her dismay, he looked as if he had fallen fast asleep. Indignant, she remarked to the other guests, *I was placed here because I was told he was a delightful dinner companion, and all he has done is sleep.* At this, Sandy's eyes popped open and he bellowed, *I wouldn't have gone to sleep if you hadn't been such a colossal bore!*

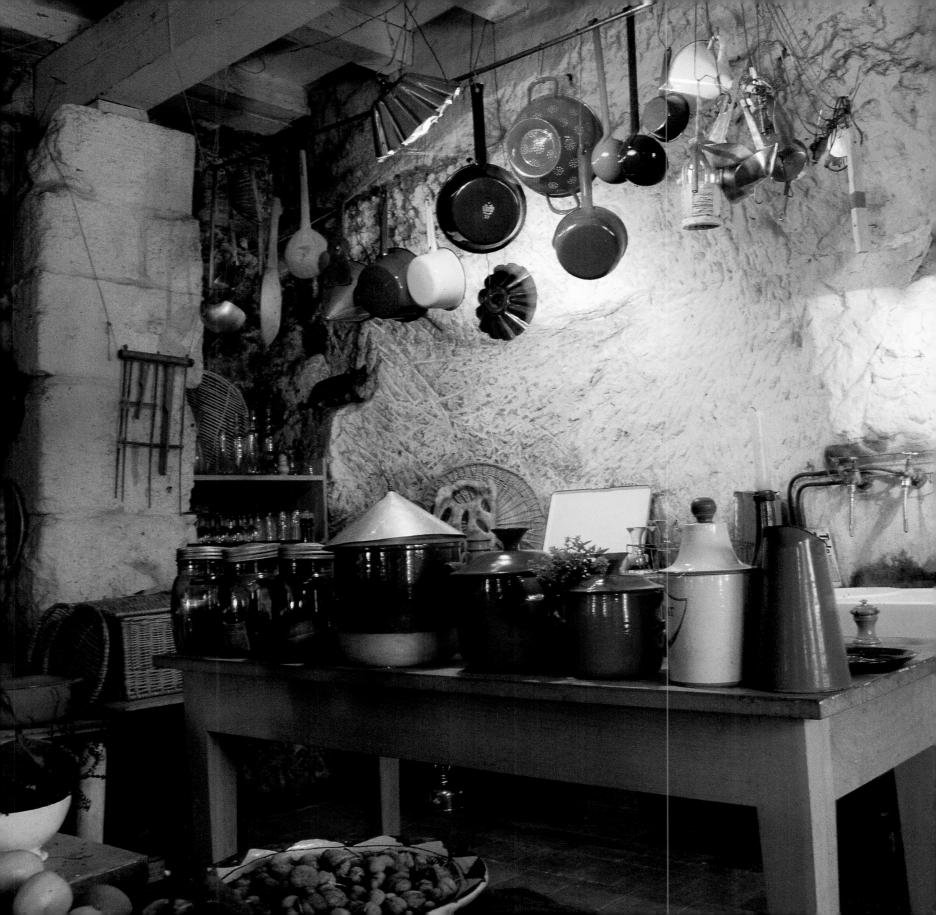

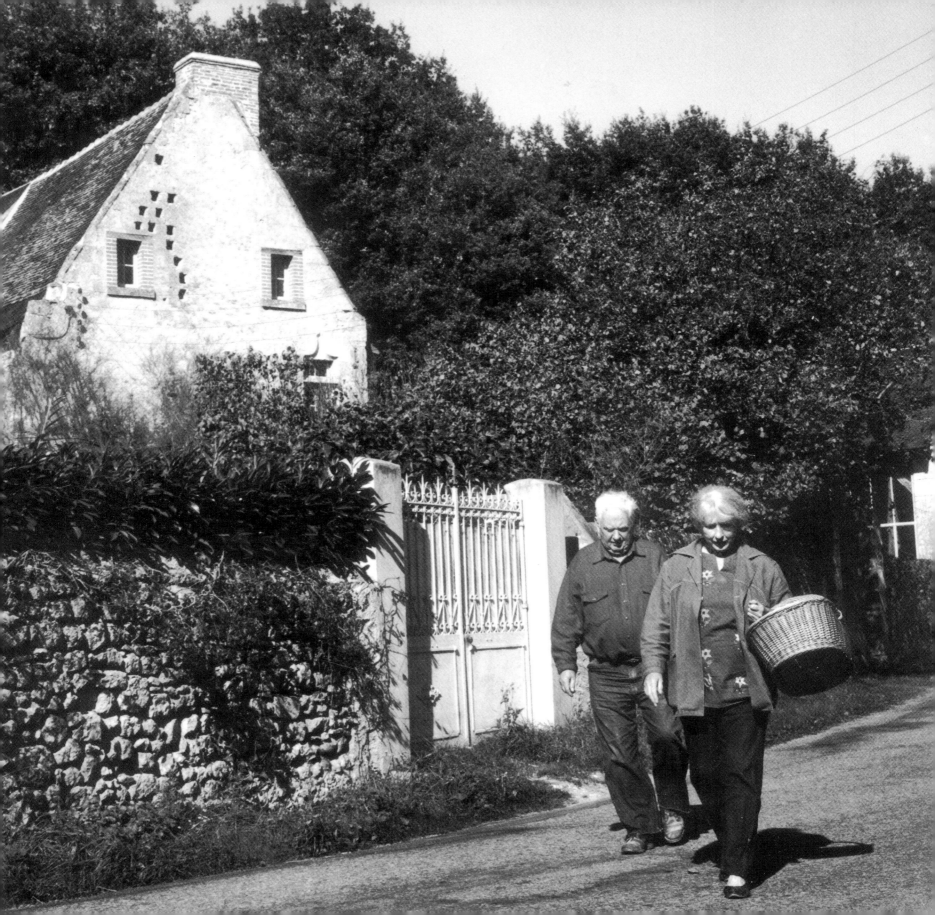

When Louisa did the shopping, Sandy usually went along to assist. They both loved the French countryside, the village markets, and the people. Their marketing trips were an enjoyable chance to break from the routine at home, where Louisa liked to indulge her passion for cooking. Lunches were uncomplicated, however: a good coarse bread, cheeses, a salad of greens, and the ever-present red wine. In France, the wine was either regional, from the Loire valley, or Bordeaux. Dinners were more adventurous. Among the family's favorites were leg of lamb and roasted potatoes. Louisa had a great liking for basil, garlic, and olive oil and prepared a rice dish subtly flavored with them. They appeared again in her *pistou,* a thick country soup. Louisa served us paella on our first trip, and she later taught me three French words—*omelette fines herbes*—and then proceeded to show me how to make one.

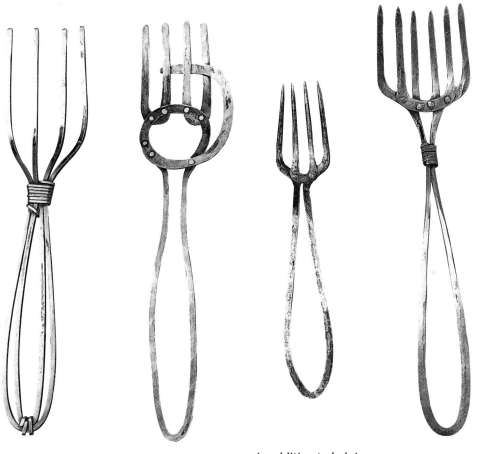

In addition to helping Louisa shop, Sandy liked to make utensils as the need arose. Among the silver forks he fashioned was one (second from left above) with a thumb hooked into the tines— another *figa,* imploring fertility in Brazil.

With all the work they had to do, neither one used a hired helper. If Sandy had only hinted that he might consider an assistant, he would have been deluged with apprenticeship requests. But would he have been a good teacher? Geniuses usually aren't. Jean Davidson, who joined the Calder family by marrying their daughter Sandra in 1955, continued to assist the Calders after they settled into their house. Later on he helped acquire land for the big new studio on the hill and supervised Sandy's detailed plans for it.

No matter how busy they were, both Calders would drop everything and give their whole attention to their French grandchildren, Jean and Sandra's Andrea and Shawn, who lived nearby. Expertly and enthusiastically, Sandy would make a pull toy from wire and beer cans or a hopping bird from a coffee can, and of course he would gladly draw any number of animals on request.

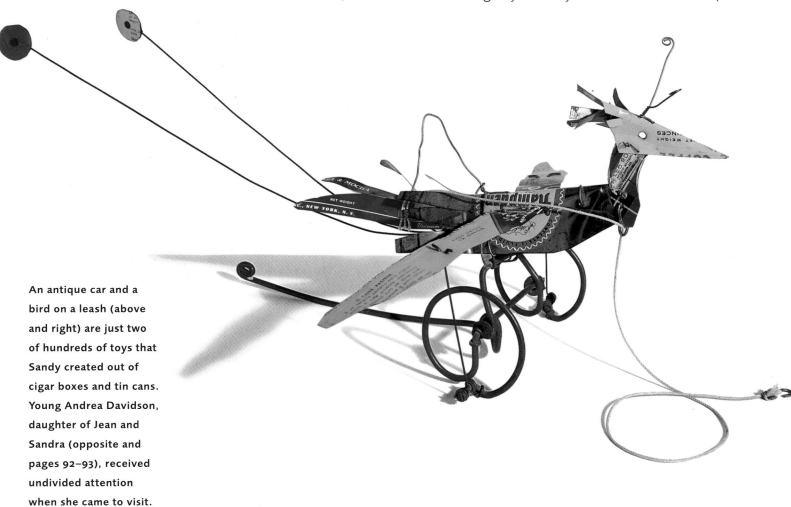

An antique car and a bird on a leash (above and right) are just two of hundreds of toys that Sandy created out of cigar boxes and tin cans. Young Andrea Davidson, daughter of Jean and Sandra (opposite and pages 92–93), received undivided attention when she came to visit.

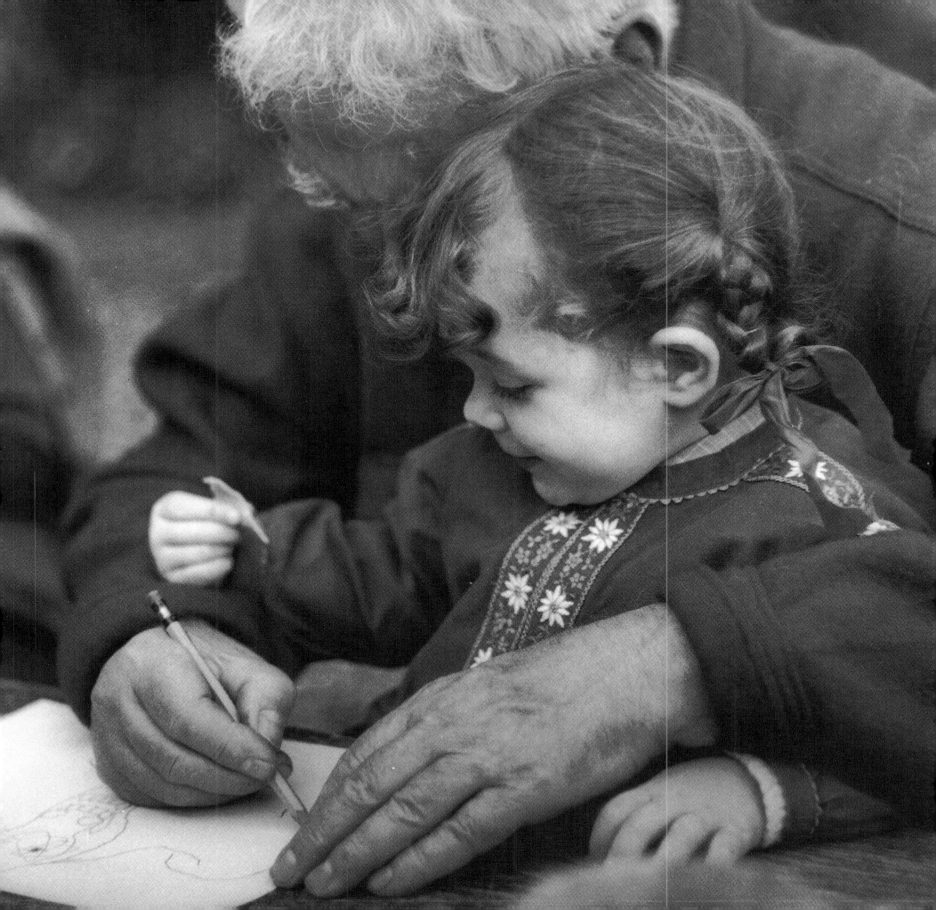

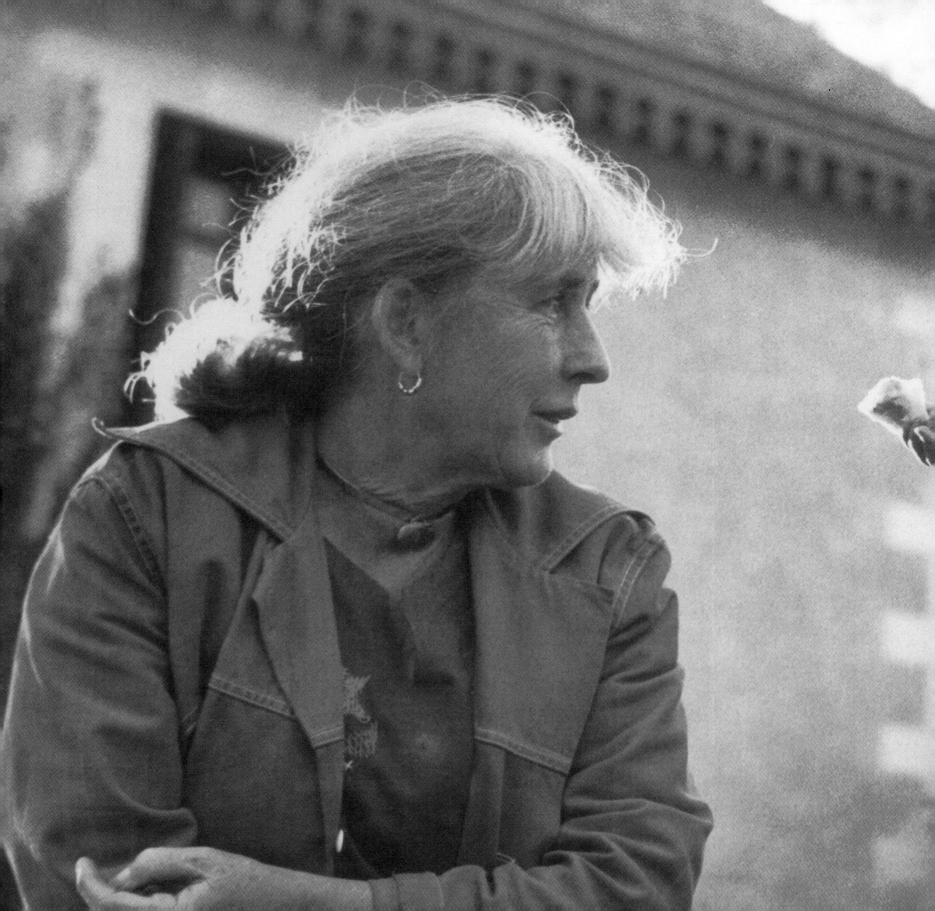

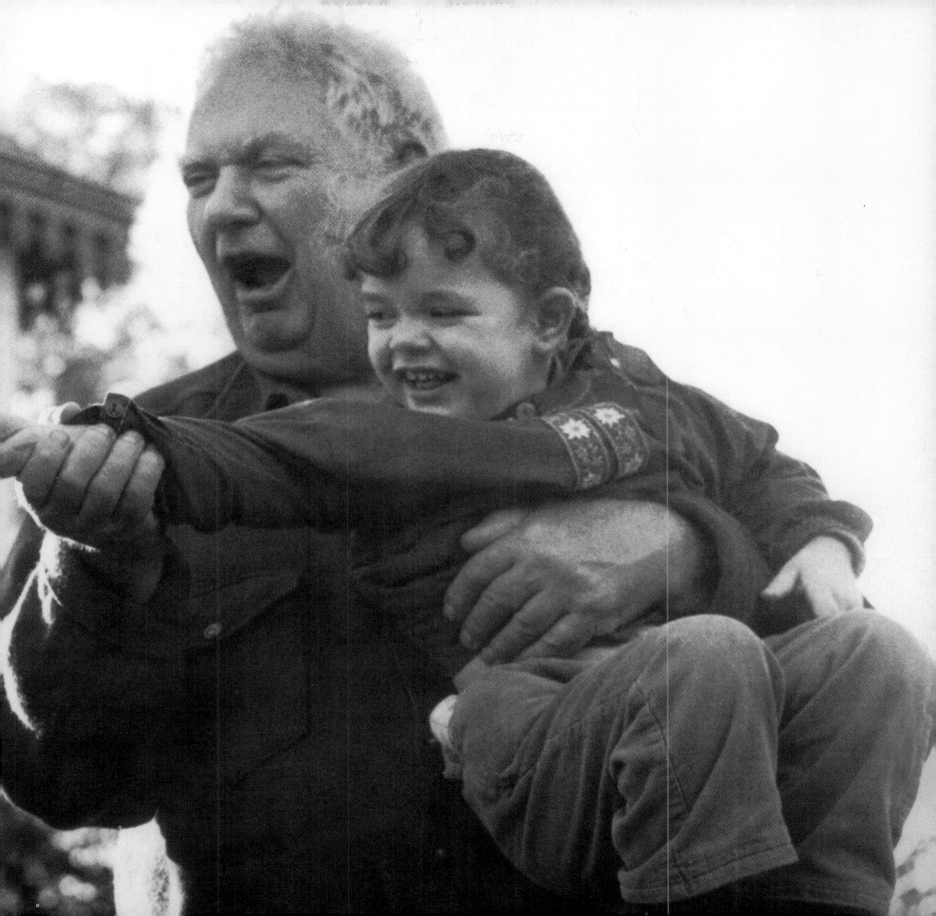

"MR. CALDER BUSTLED ABOUT LIKE A FATHER WHO HAS JUST WRAPPED

TOYS FOR THE CHRISTMAS TREE, SEEKING WOOD AND WIRE TO PLAY WITH."

E. Szittya

ainting or fashioning metal into unique shapes, Calder was intensely lost in his creative efforts. Alone in his studio, the working side of his personality came to the fore. Starting with a coil of wire or a sheet of metal and seemingly without exertion, he would begin the process of cutting, snipping, bending, joining, and balancing. Only he knew where each endeavor would take him. Sandy's large, pudgy hands seemed to caress the elements in which he worked. Sometimes he would handle pieces so tiny that they seemed almost lost in his grasp. Absorbed in his work, he hand-drilled holes in circles of metal, fitted and bent wire through the openings, shaped the work, and tapped it so precisely and neatly that imitators, whom he loathed, were confounded by the mastery of his skills.

In his studios he was engrossed—quiet and distant to the extent that, although I kept my distance, at times I felt like an intruder. He would look away from his work only to locate a heavier-gauge wire or to reach for a stronger pair of snips. If our eyes met, he wasn't always responsive. He would look away and go on with his work. If he got tired or lost his train of thought while working on one project, he would quickly move to another that had been interrupted before. He was soon absorbed in the delayed project, picking it up with fresh vigor.

I don't remember ever seeing Sandy refer to a sketch for a mobile or anything else in any of his studios. Some doodles were around—ideas may have sprung from these. And perhaps his small models were doodles in metal. Sandy also probably never set out to make anything in particular, such as a horse stabile. Texas clients in fact once commissioned him to design a horse. When it was finished, they went to look at it and were quite taken aback. *That doesn't look like a horse!* they exclaimed. *Well,* answered Sandy, *it probably isn't a horse.* End of subject.

Sandy's large studio in Roxbury had served him well until his work demanded more hands and machines than he could manage himself. He painted there and made mobiles there until they got so large that they required the efforts of several metal workers. The studio evolved to meet his needs, but it eventually reached a state of complete saturation. Anvils on tree trunks, large rectangular tables teeming with tools and vises, wooden boxes that became new work stations, stored paintings, unfinished maquettes—everything just narrowed the footpaths from station to station.

A short distance away from François Premier stood Sandy's small maquette studio. Until he converted it for his own use, adding large expanses of glass, it had been a shed for farm implements. He painted his small mobiles and stored his overflow of gouaches here.

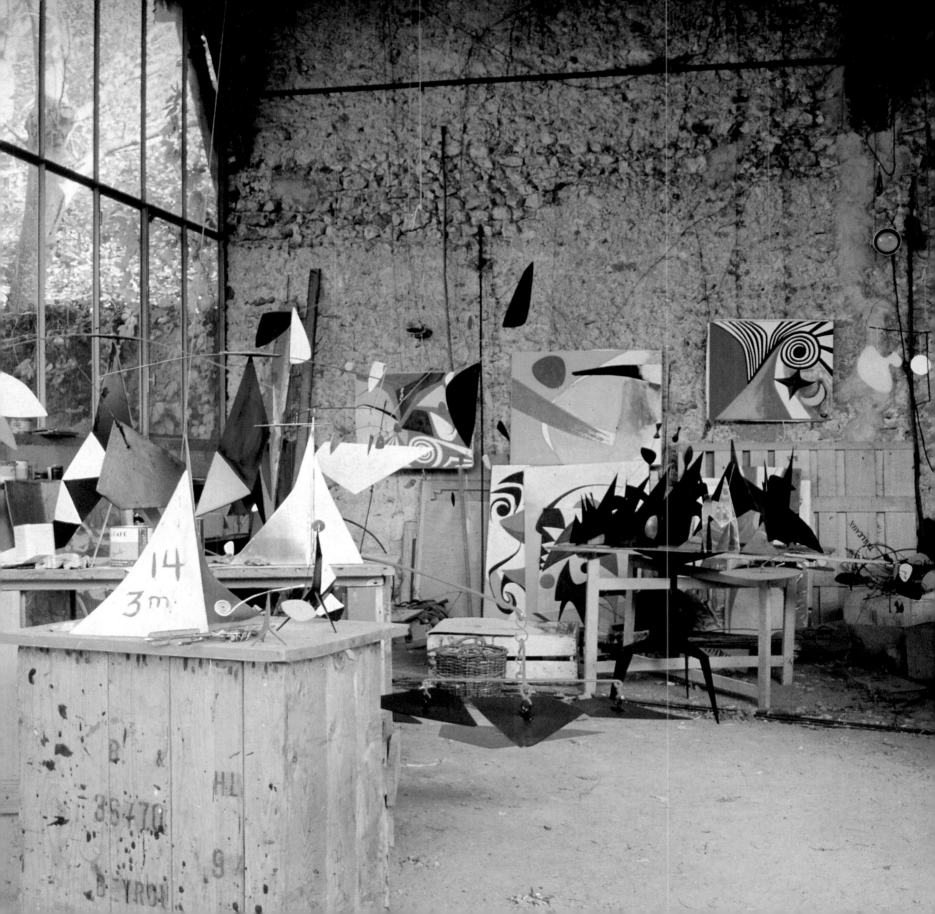

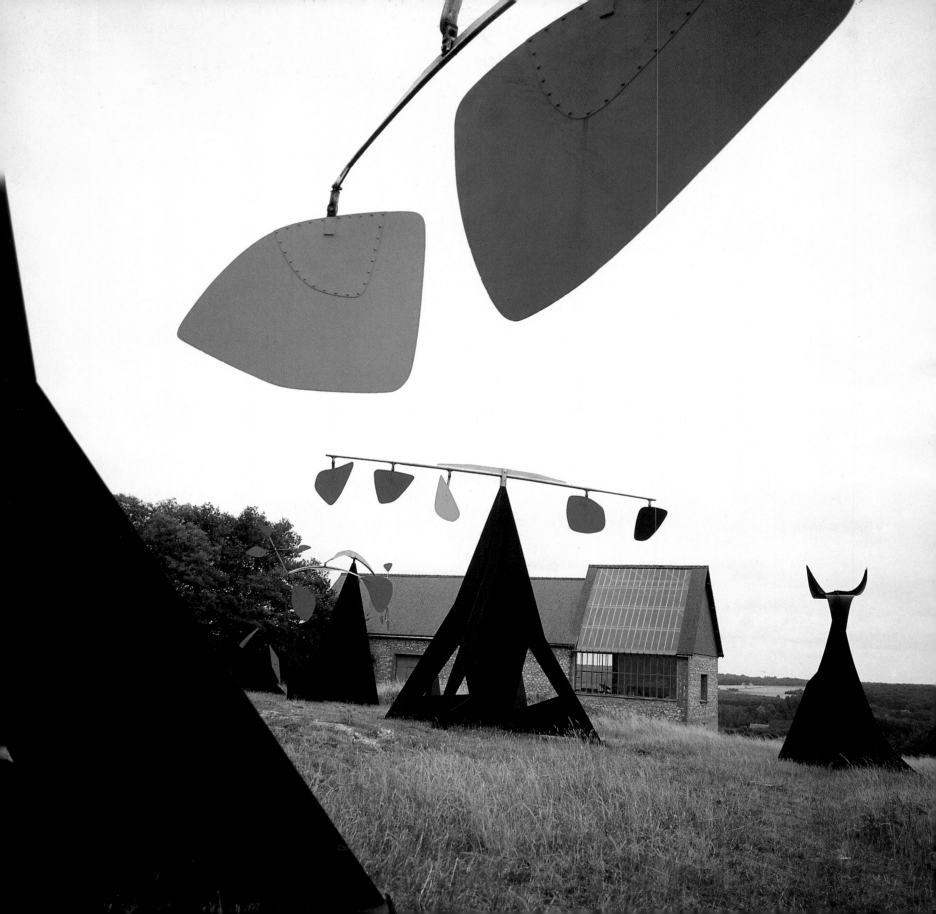

And Sandy didn't wait for commissions. As soon as he conceived an idea for a large stabile, he contracted with a foundry to manufacture it and paid for it himself. Because the foundries in Connecticut and France were eager to make his works, they were produced faster than they sold. A space large enough to store them securely, out of the elements, became a necessity.

The large hilltop studio in Saché grew out of these needs. Unlike his workplace in Roxbury, which was a marvel of tools, supplies, and work stations, Sandy's Saché studio served more as storage space than as a workroom. Down the hill he already had a small workshop across from the Calders' house, François Premier, and a painting studio nearby. His gigantic stabiles, some of them weighing as much as twenty-five tons, were manufactured by a foundry in Tours, the Etablissements Biémont, from Sandy's small models, so the studio became a way station in the process of creating and selling his art. Here Sandy's stabiles were tested for structural integrity and then dismantled for shipment to some distant exhibition around the world. His output was so prolific that almost as soon as the studio was finished in 1962, it became so crowded that the overflow spilled outside, making a startling display on the hill, much as his work did on Painter Hill Road in Roxbury.

Stored in the French countryside outside his big new studio, Sandy's huge stabiles created a dazzling composition of movement and hues (opposite and right). Additional Calder works guarded the studio doors (pages 100–101): *Bucephalus* **(1963), named for the horse of Alexander the Great, beside** *Tamanoir* **(1963).**

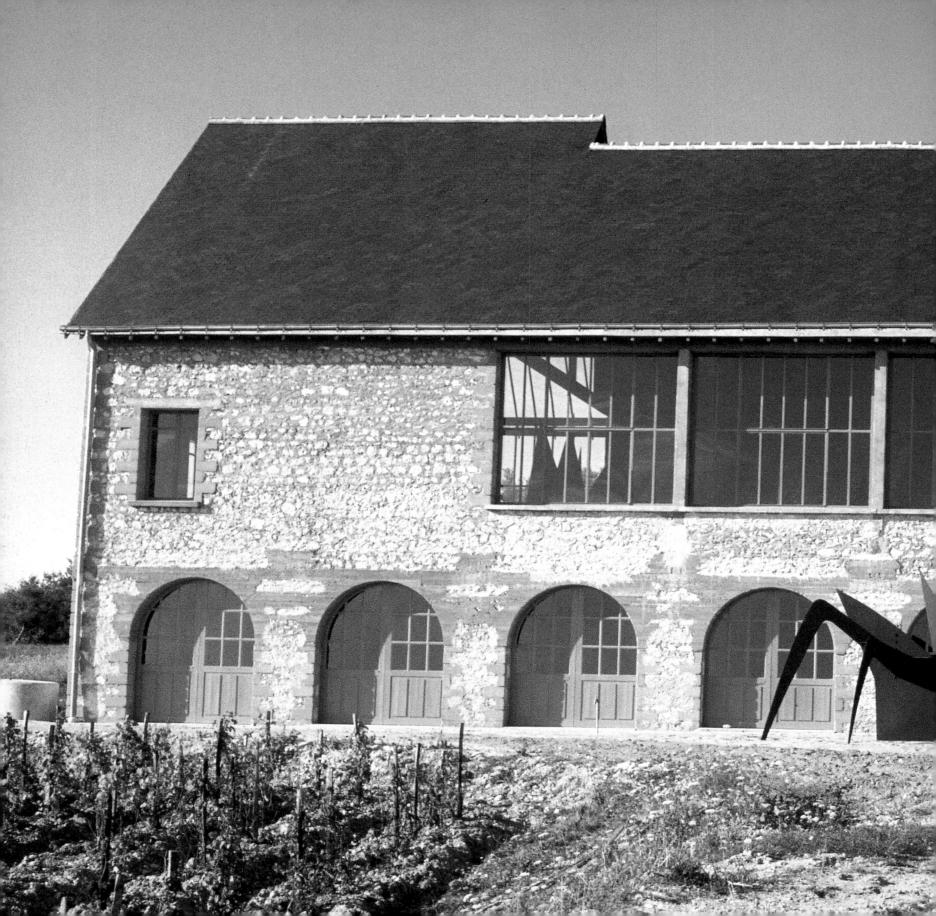

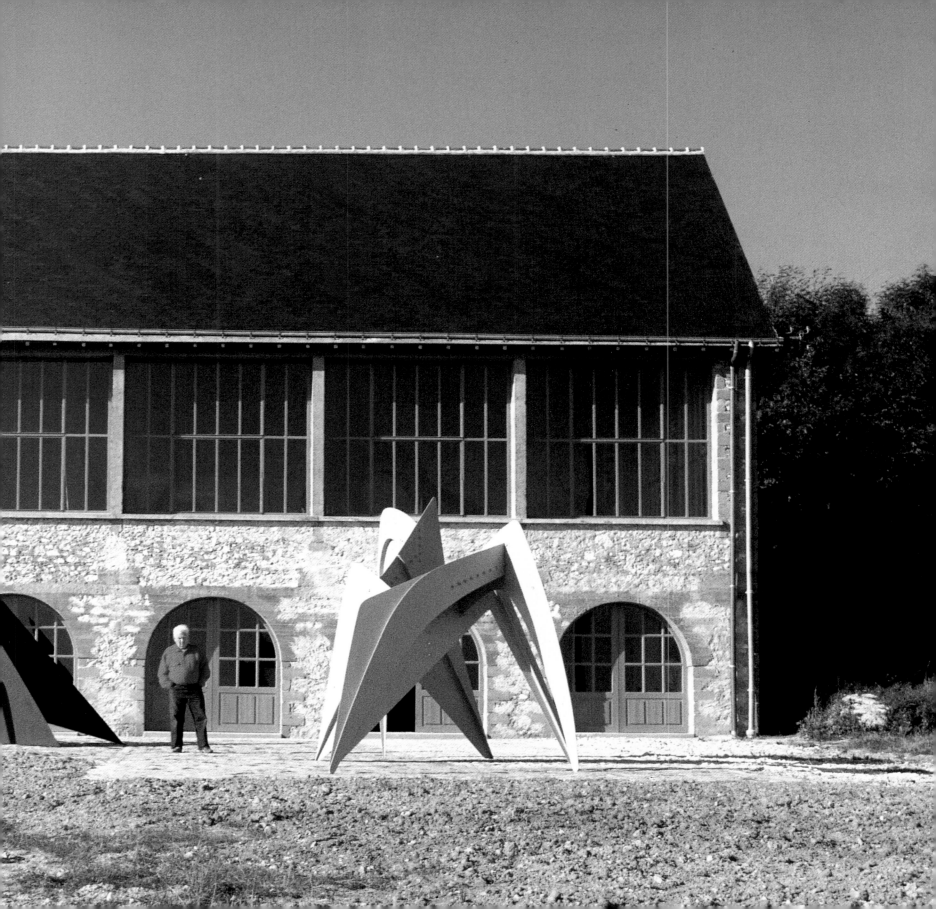

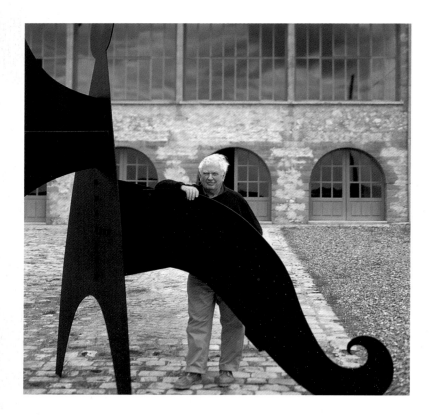

With its curled toe,
Sabot (1963) served as a
Calder signature on the
country landscape (left).
When Thomas Messer
of the Guggenheim
Museum traveled to
Saché in 1964 to arrange
the Calder retrospec-
tive, he and Sandy
pored over notes and
studied gouaches,
stabiles, mobiles, and
everything else that
could be considered for
the show (opposite).

The building was immense, about eighty by forty feet, with a peaked ceiling tall
enough to hold the largest Calder works. The walls were unpainted concrete
and stone, the floors wood, and the gabled roof shingled. On the north side
were six sets of ten-by-twelve-foot windows that lighted a large, open room.
The opposite wall was solid, except for a doorway big enough to admit the
stabiles when they were delivered. Below was another storage room. For the
dozen years it was in use, the studio saw constant traffic in and out.

One of the first stabiles to be stored here was *Guillotine for Eight,* completed
in 1963 by the Biémont foundry. This was not a commissioned work, but it
eventually made its way to New York City, where it adorned the rotunda of the
Guggenheim Museum for a major Calder retrospective in November 1964.
Thomas Messer, the director of the Guggenheim and organizer of the show,
arrived in Saché in April 1964 to go over Sandy's prodigious output. They
measured *Guillotine for Eight,* the exhibition's centerpiece. Every tangle of
wire, every box that might contain a long-forgotten or ignored canvas or an
unfinished experiment was opened and examined. The selection process was
serious and intense. They spent long hours making lists and arranging to locate
and borrow works owned by others, determining shipping schedules and
packing needs. I followed along to record this historic event.

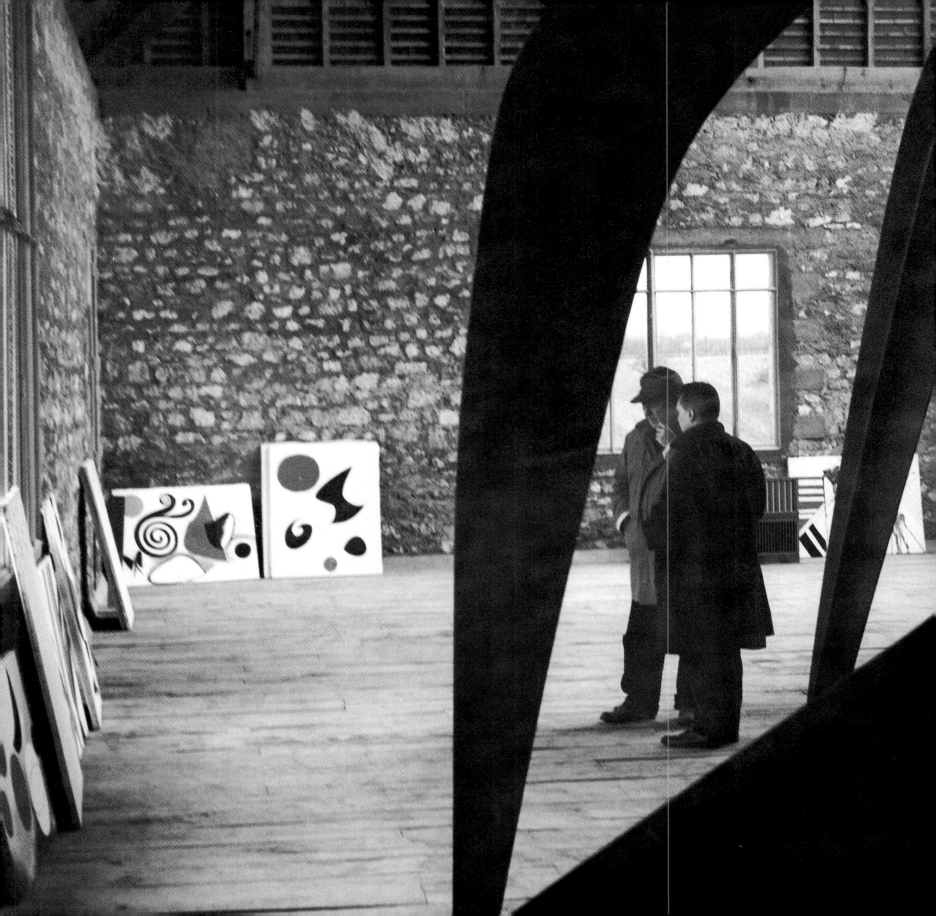

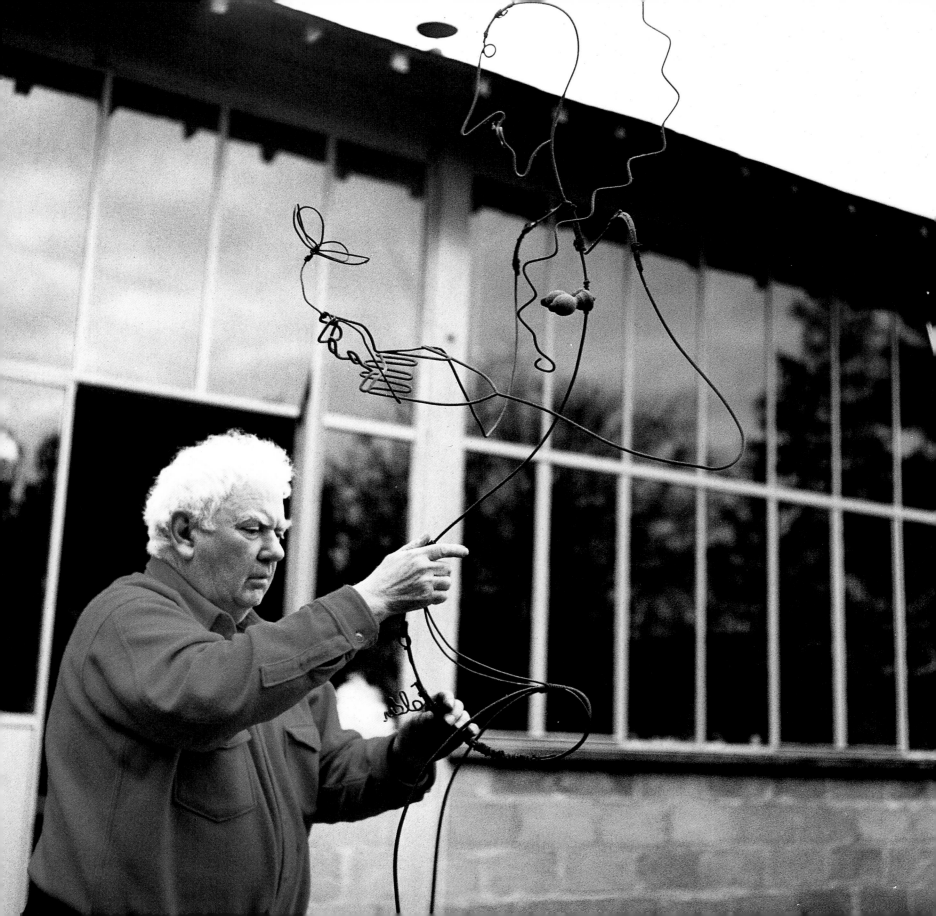

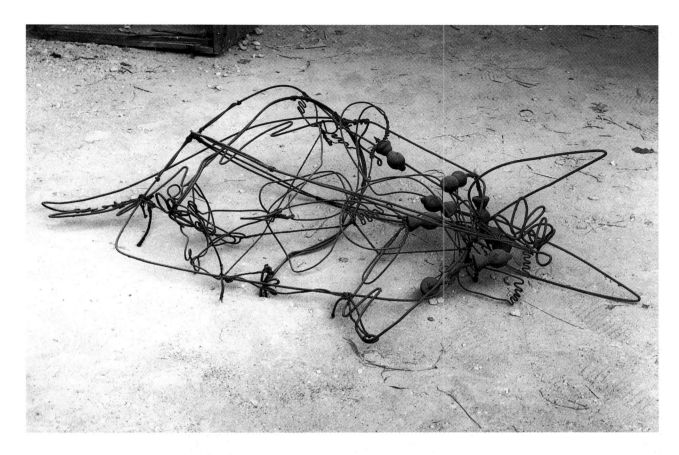

I t was in his quest for objects for the Guggenheim show that Sandy found an early wire sculpture of a maiden with a flower called *Spring*, made in 1928 and exhibited at the Society of Independent Artists in New York City as well as at the Salon des Indépendants in Paris. For thirty-five years it had been coiled up in a warehouse as a bale of wire, along with *Romulus and Remus*, another wire creation from the same year. As I stood by with my camera, Sandy unfurled the jumble, bringing it back to life for the Guggenheim. *This has the freshness of youth*, he said, obviously delighted. *Of my youth*.

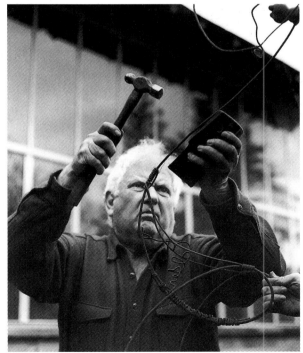

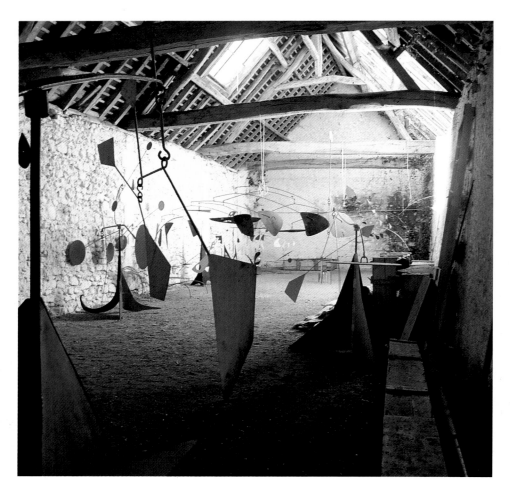

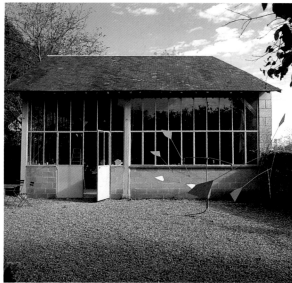

On display in the annex to his painting studio (above) and in the maquette studio (right), Sandy's models and mobiles resembled a three-dimensional work by his good friend Joan Miró. In July 1976 (far right) Sandy paused to tackle some neglected work in progress.

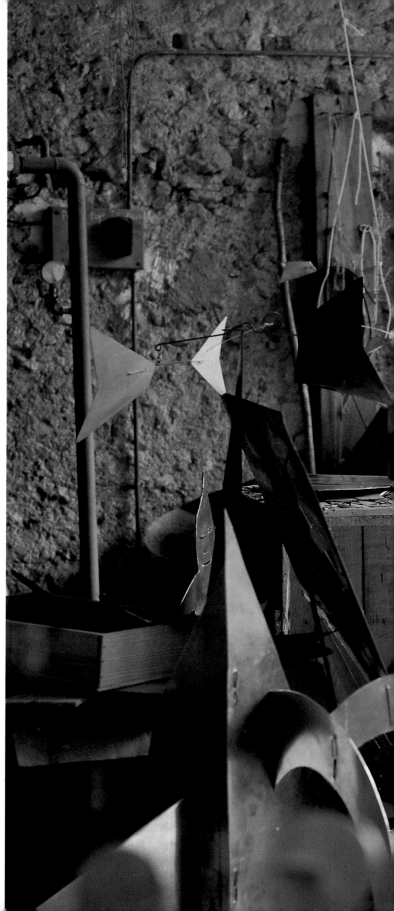

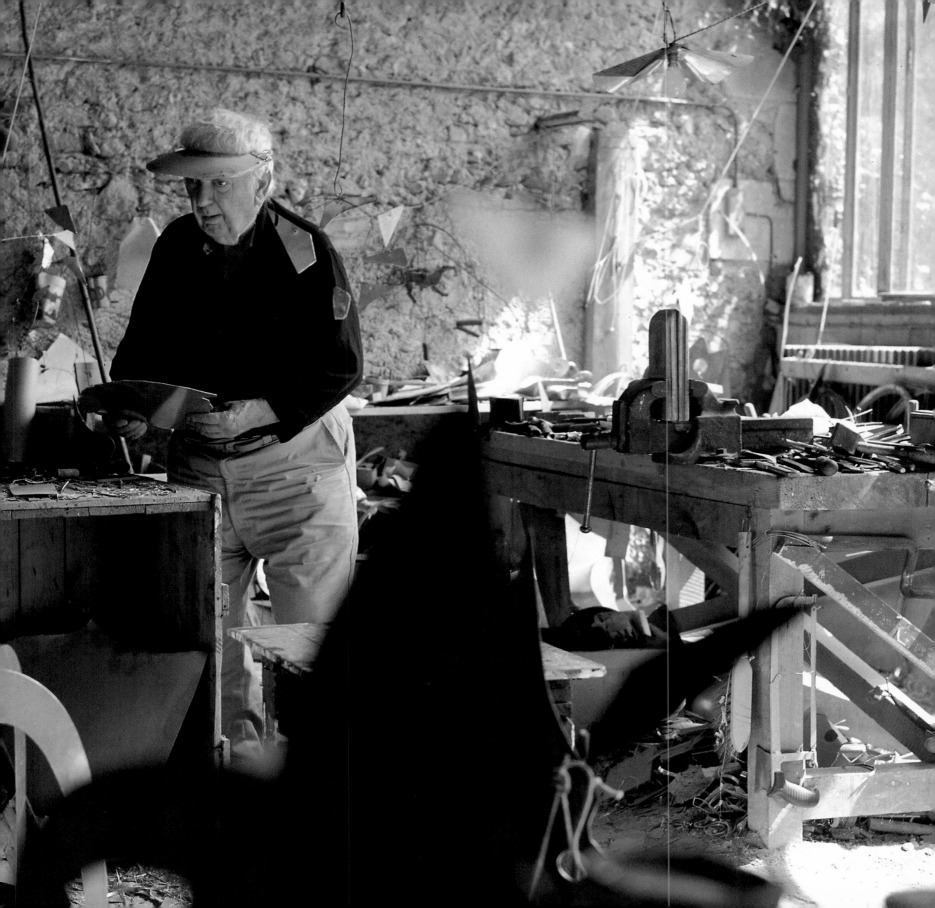

A conscientious and quick correspondent, Sandy used a relatively uncluttered table (below) to respond with an economy of words scrawled across sheets of plain white paper (he was not given to formal stationery). Carrying out a seemingly impossible task (opposite), he painted a small mobile—his large, powerful, pudgy hands dwarfing the tiny pieces.

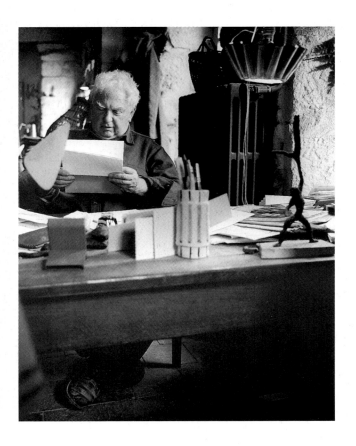

Sandy occasionally painted an oversize gouache on an easel in the big studio in Saché, but generally he created these opaque watercolors in the painting studio located about a hundred yards south of François Premier. Also of stone and concrete, this smaller studio looked as if it had been a residence at one time. Sandy did little to change his *gouacherie* except to bring in boxes and crates, on which he placed his paper. Stored mobiles hung from the ancient timbers in the gabled roof. A skylight cut into the roof provided additional light.

Small gouaches were created in an unconventional way, with Sandy leaning over a crate or a box to paint. Across a sheet of paper he would direct a large amount of watercolor, which dripped and created a series of parallel lines. Sandy then rotated the paper and added some blobs of color to make lines crossing the first set. He studied the results of this spontaneous design to let them suggest the next application. The color racing across the tilted paper might conjure up weird human shapes or "beasties." If the result was crosshatching, Sandy would fill in the ensuing squares with different shapes or just color. Whatever the outcome, they were unmistakably Calderesque—not much different from his early mobiles made of found objects.

His third studio in Saché, a small workplace for mobiles, was located directly across the courtyard from the house. It was nothing more than an implement shed when Sandy enclosed it with ready-made windows and a sliding door, securing it from the weather. Made of stone and concrete with a shed roof, the studio had two or three stations on which Sandy could work—little more than upended crates for his necessary equipment: coils of wire, hammers, snips, and aluminum. In this maquette studio he also created models for his large stabiles. On occasion models were made in Roxbury and brought to France for manufacture at Biémont in Tours.

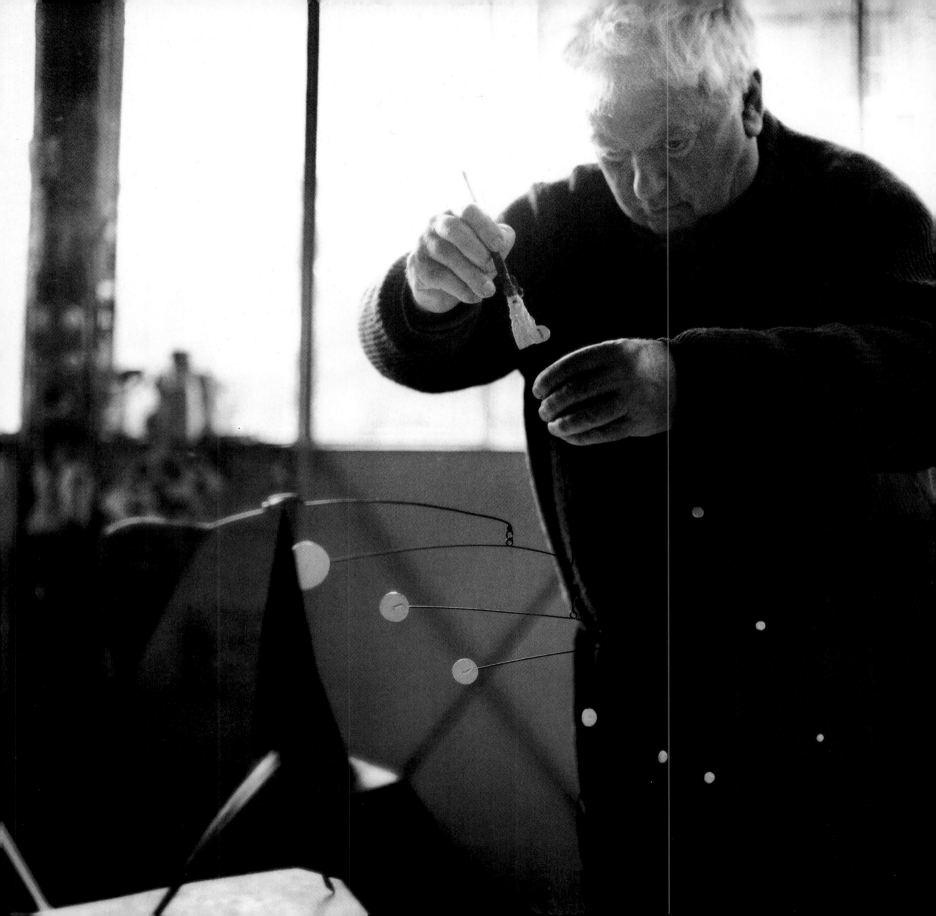

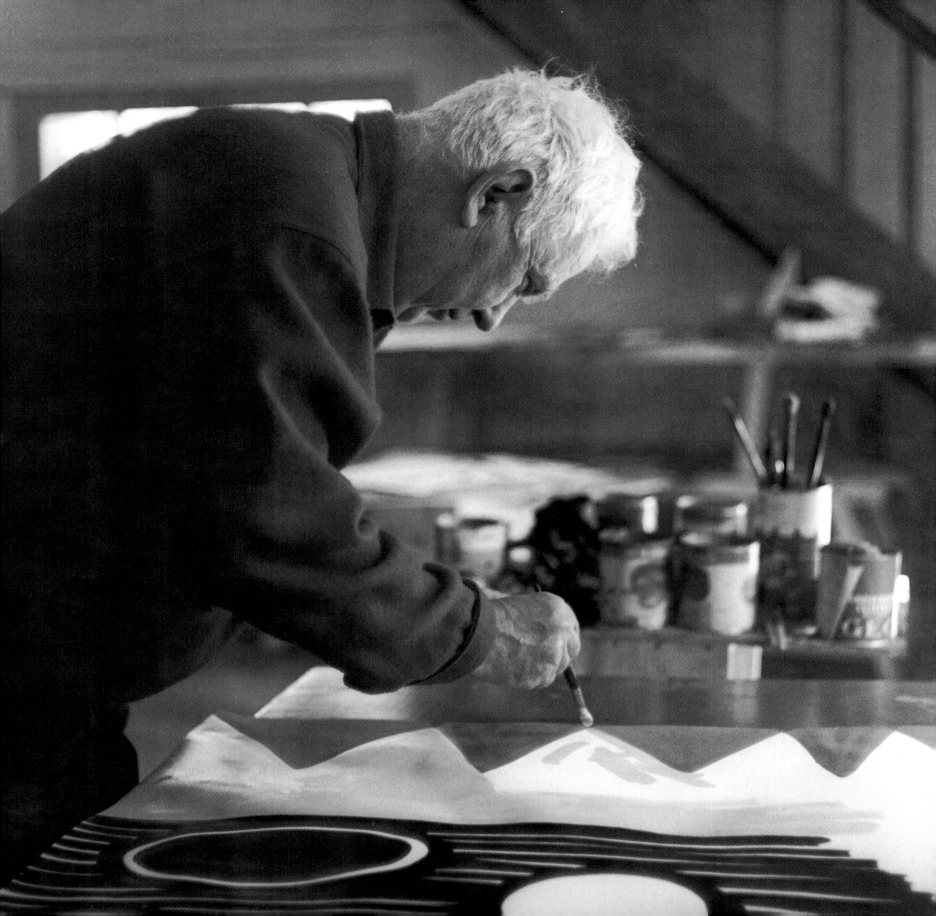

From the day I met him in Roxbury, Sandy's speech was slurred. It was an awkward thing to question him about, so only later did I learn from Alexander Rower that his grandfather had long had Parkinson's syndrome. When Calder painted, his left hand—which held the paint jar—would tremble. But, miraculously, the shaking would stop and the hand would become steady as soon as he moved to replenish the paint on his brush. In *Calder's Universe*, the playwright Arthur Miller observed, *If anybody could understand what Sandy Calder was saying, I would have cast him as God. As it is,* added his former neighbor in Roxbury, *I take him on faith.*

When Sandy painted gouaches, he often allowed ribbons of color to run down his paper. These "beasties" from 1965 were some of the weird figures he devised.

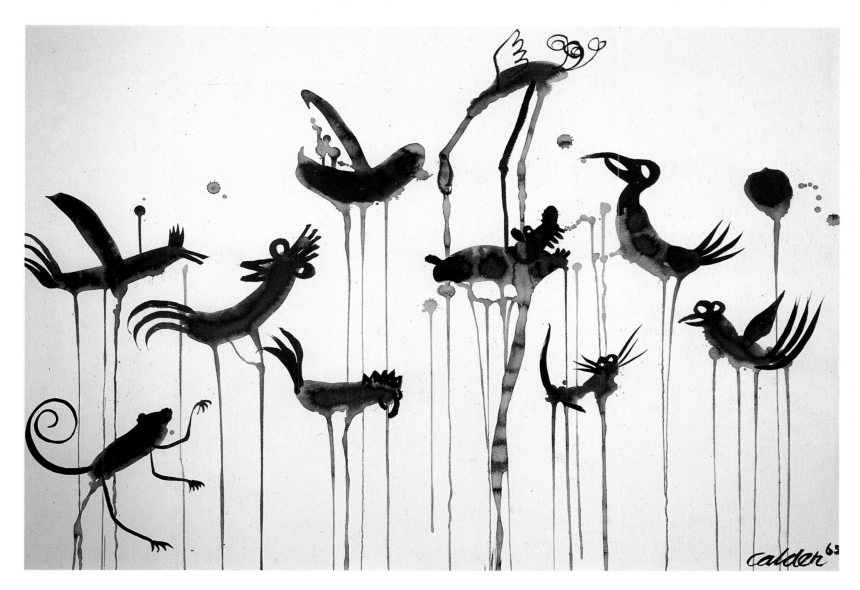

Calder 65

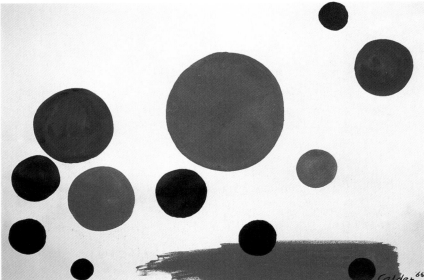

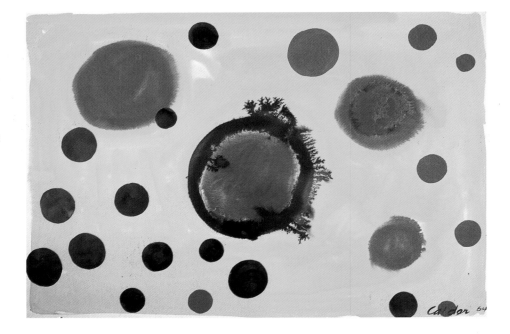

Sandy and I usually broke for lunch when metabolism called or work came to a stopping point. One lunch break was laced with great quantities of wine. As my eyes began to droop, I remember thinking I was glad that Sandy was twenty years my senior. Surely he would need a nice, long siesta after such a lunch. But then he rose from the table and said, *If you want to photograph me painting, grab your camera and come with me!* I staggered behind him to his odd-looking Citroën. Without bothering with roads, Sandy revved up the car and proceeded directly down to the painting studio. We crossed plowed fields and open ditches in a teeth-rattling ride. Shaken, but glad to be alive, I waited for him to decide that he was not up to painting—but in vain. He painted gouache after gouache. He painted so many so fast that in a very short time an impressive pile was stacked up. He asked me to help myself. I pulled three out of the stack. When I told him that I was having trouble making a choice, he said to take them all.

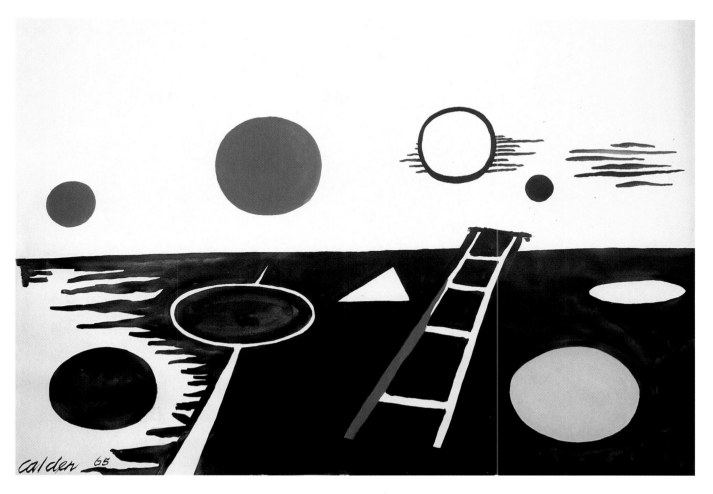

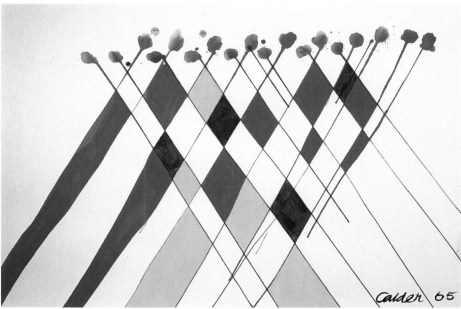

Using circles of different sizes and colors, Sandy composed hundreds of gouaches, such as *2 Bolides Bleus* (1965) (opposite top) and *Black Ringed Blue et Alia* (1964) (bottom). He occasionally wet the paper, allowing colors to spread in unpredictable directions. Sometimes Sandy had a title in mind when he started. *Echelle de Miró* (1965) (above) means *Miró's Ladder.* An untitled painting from 1965 (left) emerged from two runs of colors that he then cross-hatched.

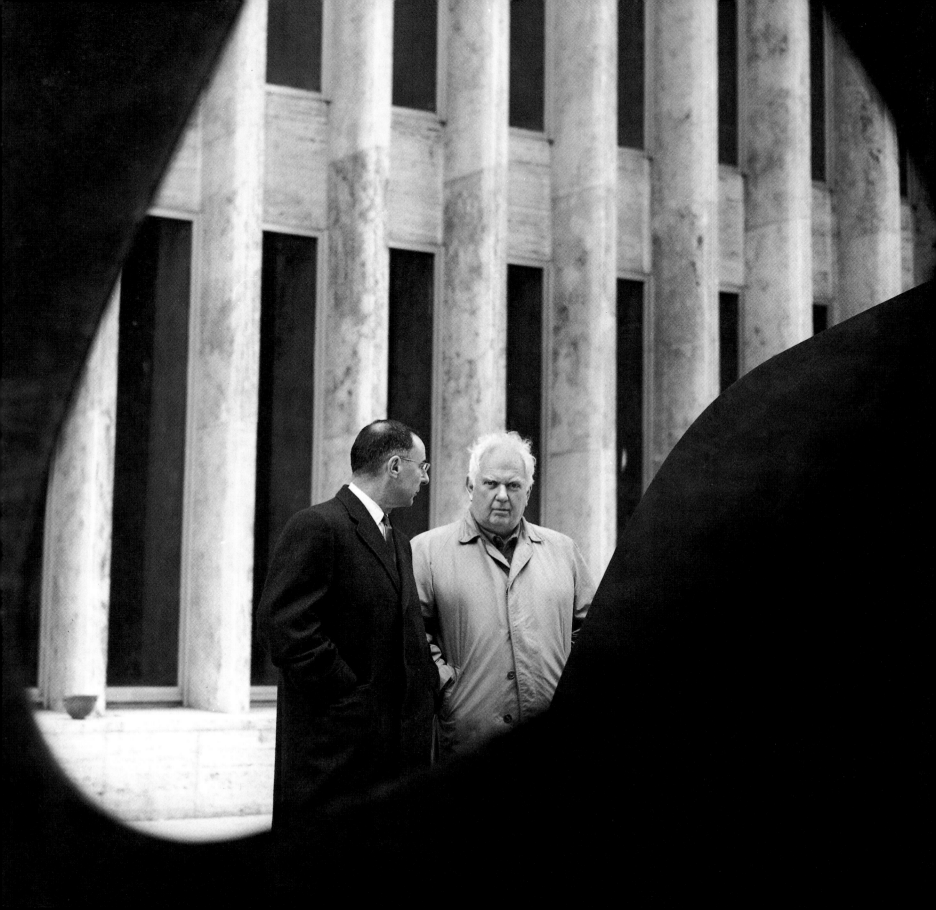

Sometimes we would visit the foundry so that Sandy could check on works in progress. As many as six stabiles might be under construction at any one time. Not just *Guillotine for Eight,* but *Le Guichet (The Box Office)* (1965), now at Lincoln Center's Vivian Beaumont Theater in New York City, *Bucephalus* (1963), *Polygon on Triangles (The Nun)* (1964), and others were taking form there (all happily completed in time for the Guggenheim show even if not commissioned for it). We would stay an hour or two, whatever Sandy needed to give instructions. These were not intense visits; Sandy often regaled the workers in French while I stood by taking photographs, wishing I understood them.

Occasionally I gave Sandy a progress report on my book about him. Armed with introductions from him to museum curators and officials in Denmark, Belgium, Sweden, Holland, and Italy, I was in the process of gathering photographs for it. Although I didn't know it at the time, he himself was at work on his autobiography. On January 15, 1965, a year after I began my book, he undertook work on his, dictating it to his son-in-law Jean Davidson without my knowing it. He was secretive about it until he was well enough along that he felt comfortable competing with me. He would call to ask me how I was coming, perhaps pacing himself with my own progress. Often he would ask me to photograph what he called "goodies" just for him, which I gladly did. Although I didn't know these were for his own book, I wouldn't have refused in any case. We were friends.

Both books, both entitled simply *Calder,* came out at exactly the same time, in 1966, mine presenting only two of what would eventually total thirteen years spent documenting Sandy's life, work, and homes. Sandy later told me that he began to refer to my book as *the enemy book.* But I couldn't have put mine together without his blessing or help. I now wonder why it didn't occur to me to collaborate with him—one book combining my photographs and Sandy's words would have been stronger. One reviewer, in fact, made that point when he said that Sandy's book *(Calder: An Autobiography with Pictures,* Pantheon) was *all fun and no art.* My book *(Calder,* with H. H. Arnason, Van Nostrand), he wrote, was *all art and no fun,* which I had to agree with.

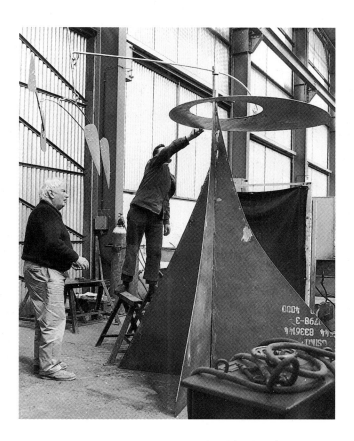

Outside Lincoln Center (opposite), Klaus Perls, Sandy's long-time dealer, was framed with him in *Le Guichet* when it was installed in 1965. The same year Sandy also closely watched the fabrication of a stabile at the Biémont foundry in Tours (above).

"IT WAS IN THE FIELD OF PLAY HE WAS MOST AT HOME AND MOST FULLY

ALIVE: PLAY WITH SHAPES, COLORS, LINES, MOVEMENT, FORMS."

James Johnson Sweeney

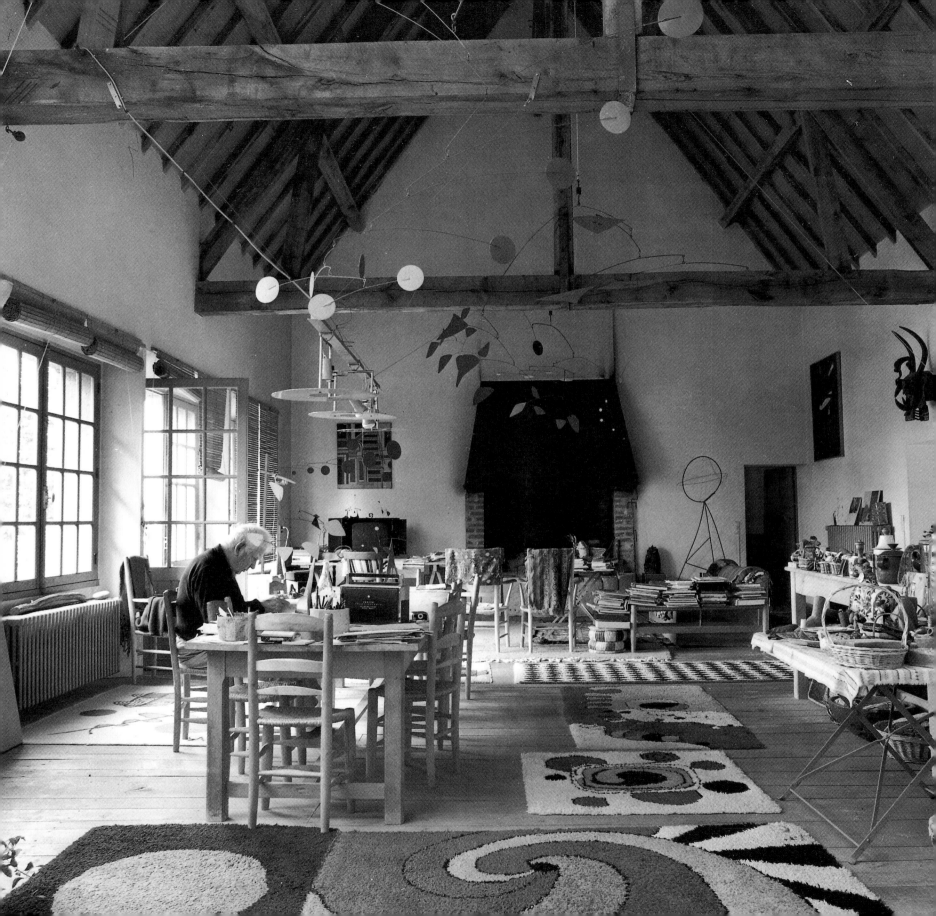

n December 1972 a postcard arrived at my home in New Canaan, Connecticut, announcing the Calders' move to a newer and grander house in France: *We have a new shack,* Sandy wrote, *very fancy.* By way of inviting me to visit, he added simply, *We'll be seein' you.*

The Calders and I had visited together at exhibitions and gallery openings in and around New York City and at their home in Roxbury in the late 1960s, but not until Sandy was asked to paint a second Braniff International plane, appropriately named *Flying Colors,* in late May 1975 did I have the chance to travel to France in hopes of seeing the "new shack." My years of frequently flying to Europe on assignment ended abruptly on February 1, 1968 (along with most of my income), when an article about my opposition to the Vietnam War appeared on the front page of the *New York Times.*

As the only dove on my local draft board, my antiwar views aroused the indignation and anger of many of my neighbors, who thought that I should be removed from the board. Even the New Canaan weekly newspaper led a campaign calling for me to resign. Such a controversy did not escape the notice of *House and Garden*, my chief source of employment. The senior editor let the word go out that I was not to be assigned any more work and removed my name from her list of freelancers, abruptly ending my twenty-year career with the magazine and about three-fourths of my income. Although I later learned that the publisher did not share the editor's views, the order to blackball me stood. But I did not resign.

At last—a vast and airy space large enough to display all their art without collisions (opposite). Louisa's hooked rugs were almost too precious to step on. The daily newspaper absorbed Sandy in July 1976, when I accepted his invitation to see their fancy new abode (right).

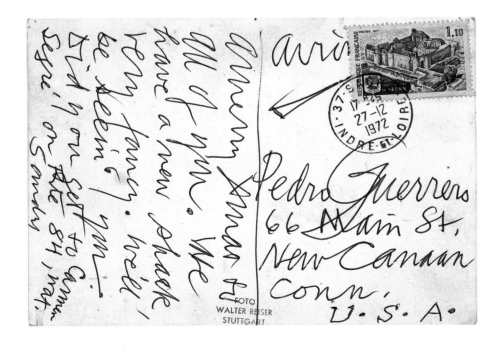

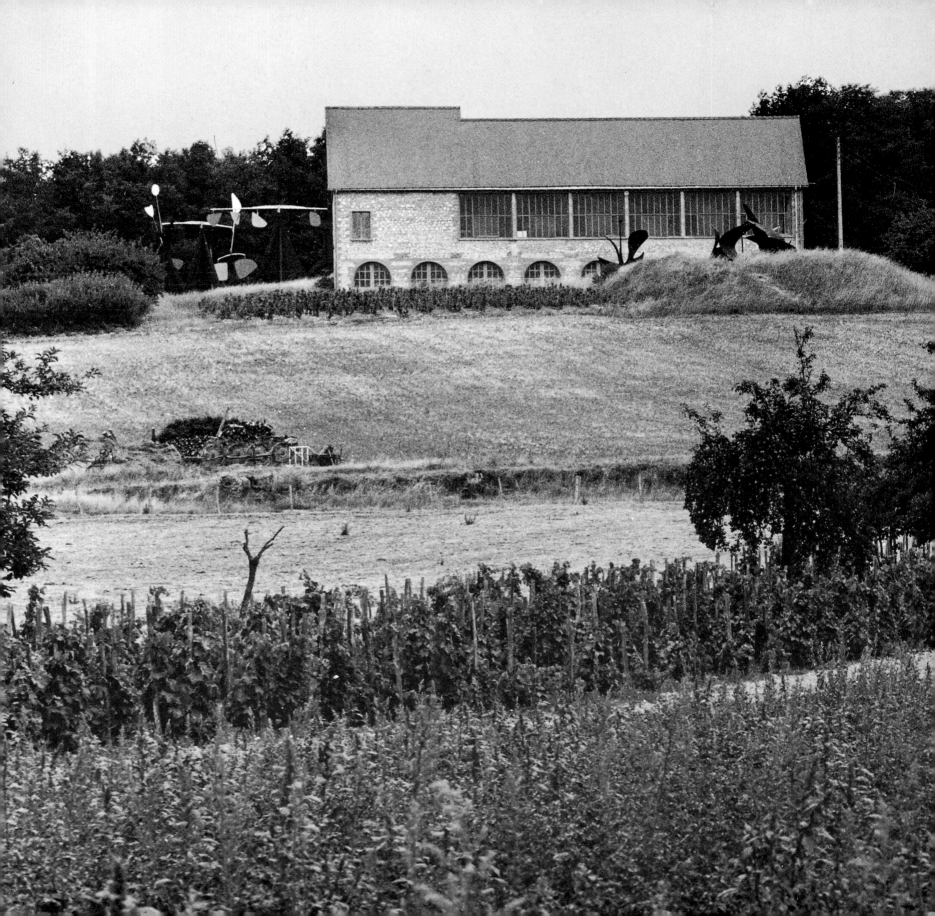

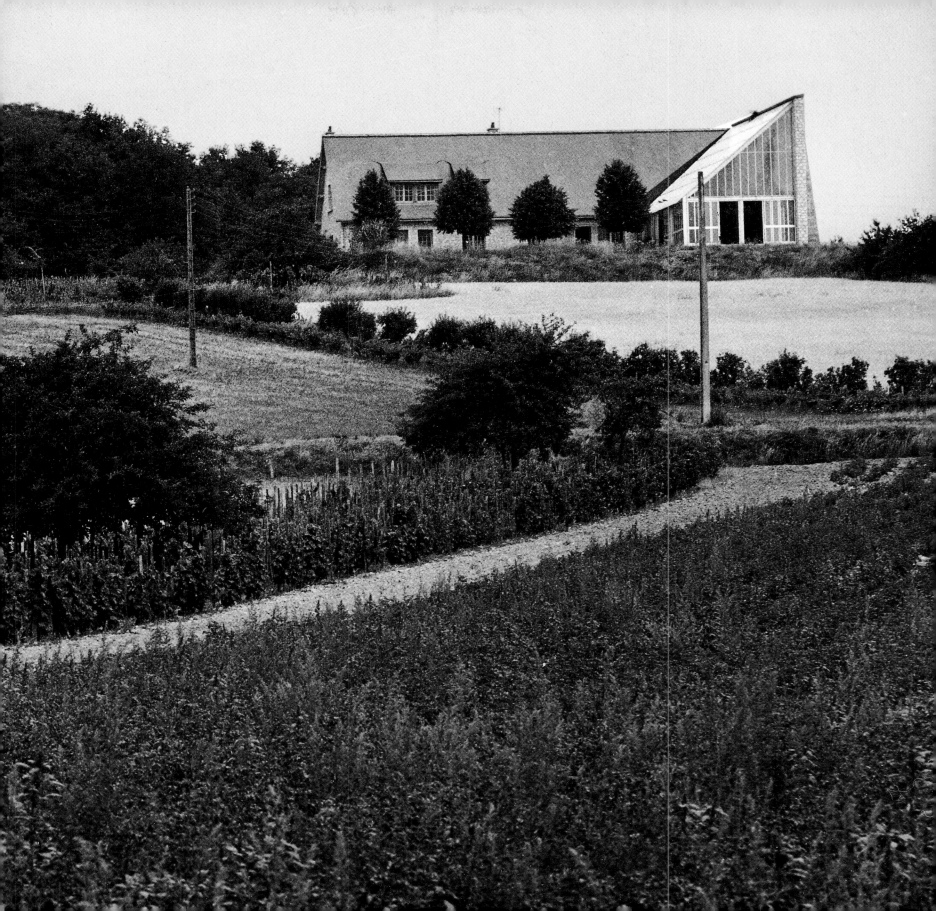

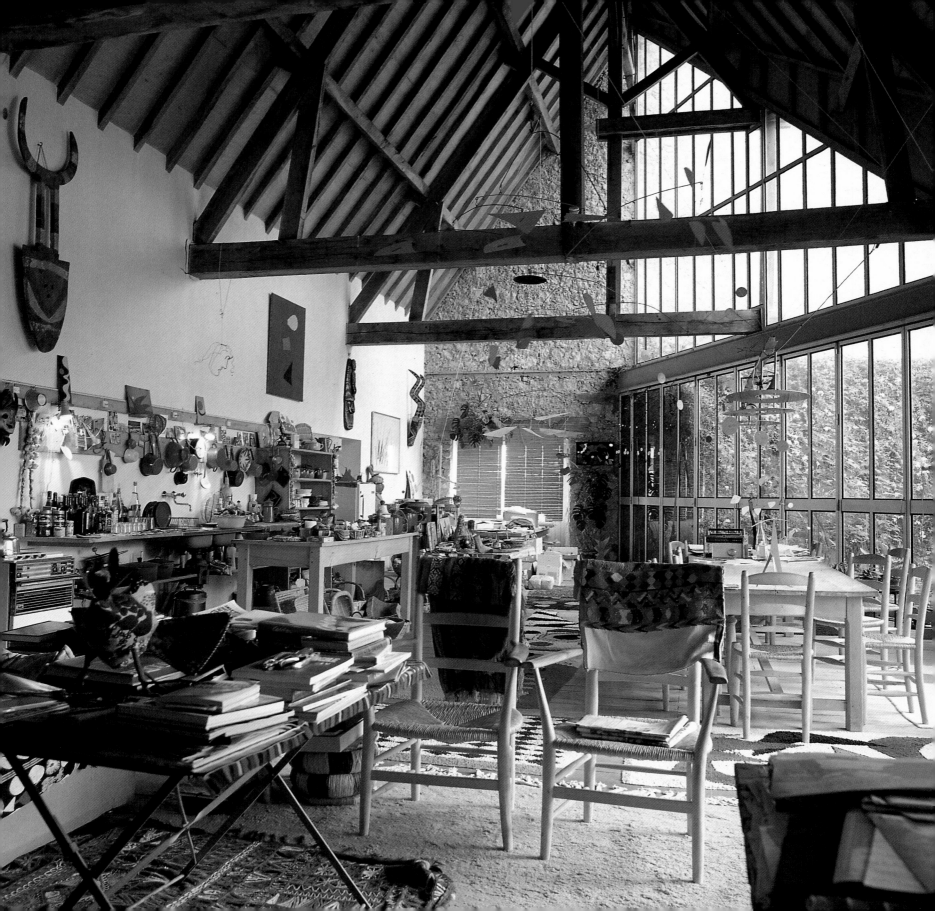

The new studio and the new house (pages 120–21) stood with dignity on the ridge. Inside, the living room (opposite) opened beyond the dining table onto a greenhouse for Louisa's other passion, plants and small trees.

The *New York Times* article caused nothing but problems for me with *House and Garden,* but it brought the opposite reaction from the Calders. After reading the story of my plight in the *International Herald Tribune,* Louisa and Sandy immediately sent a letter from France wishing me well and congratulating me for my stance. Other letters of support came from their daughter Sandra and son-in-law Jean Davidson. Although *House and Garden* fired me for my antiwar views, the magazine, of course, had been my entrée into Calder's world.

Both Sandy and Louisa were also vehemently opposed to the war. Little in the world escaped the Calders' notice even in their remote location in Saché much of each year. They provided a haven there for young Americans who had fled the United States to avoid going to war. When the Calders were back in the States, they marched on Washington in 1966 as the chairpersons of Artists for SANE (the Committee for a Sane Nuclear Policy) and took out a full-page advertisement in the *New York Times* urging readers to dedicate themselves to peace. The Calders also helped where they could to promote the election of like-minded candidates for state and national office. Then in 1972, on the grounds that President Richard Nixon's conduct of the Vietnam War was unconstitutional, Sandy and Louisa joined others in calling for his impeachment. Their proudest moment, they told me, was making Nixon's enemies list.

Even though I saw Sandy in Paris in May 1975, the visit to Saché was not to be. The Calders were not staying in France. Exhibitions elsewhere kept them from their French home and dashed my hopes of continuing the documentation. The next year, impatient to finally photograph the house and at the urging of a publisher who had expressed an interest in a new book of my Calder work, I wrote Sandy and Louisa and received a warm invitation to come. But again my plans were thwarted, this time with far more serious consequences: in May 1976 a fire destroyed my house and took my wife's life.

The Calders sent their condolences and urged me to keep my plans to visit them in Saché. As a distraction for both myself and my nineteen-year-old daughter Barbara, we flew to Paris that July. My niece Marina Jaimes came along to keep Barbara company while I worked. Louisa had written to say that they had room for only one overnight guest, so arrangements were made for us to stay at an inn in Azay-le-Rideau. Sandy and Louisa met us at the tiny station in Saché and drove us to the "new shack."

Sandy was seventy-two and Louisa sixty-five in 1970 when they moved into this first house built to their own specifications. Placed about sixty yards from Sandy's large studio on the crest of the hill, the new house was dry and airy—the antithesis of the family's old abode. Being close to the river, François Premier had been continuously damp. It was left behind to become a guest house, its contents moved to higher ground.

The new home and the studio, compatible in design and size, dominated the hill yet didn't appear out of character with the older buildings in the countryside. Around them was rolling farmland, mostly small enterprises of truck farms, vineyards, and orchards. Flinty hills surrounded the flat lowlands of the Loire valley. Below, the land had been carved into small parcels, some only a few furrows wide. Sandy had to purchase land from fourteen owners to create a property large enough to hold the studio and later the house.

Constructed according to regional custom of native stone and concrete and built to Sandy's plans, Saché II had two stories, a high, pitched roof like others in the area, and a long bank of twenty-foot-tall windows that invited sun in to cheer its occupants. A greenhouse formed an ell to the side. More than enough space was allowed for the collections of artwork and other items that the two purchased on their many travels. It soon took on the look of having been a Calder house since the beginning of time. As in the old house, the cooking, dining, and living areas were combined in one long, bright room. A bedroom was on each of the two stories.

Louisa's rugs (below) gave the "new shack" its zest. With her greenhouse beyond and a bank of three of Sandy's specially designed lighting fixtures, she didn't want for a place to read (opposite).

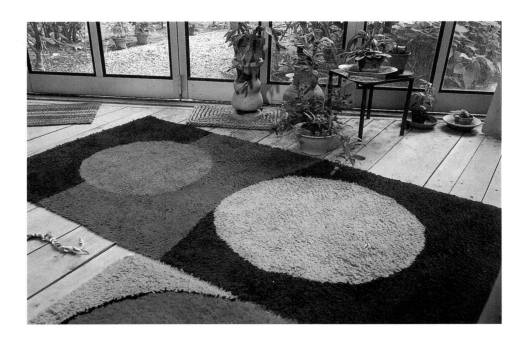

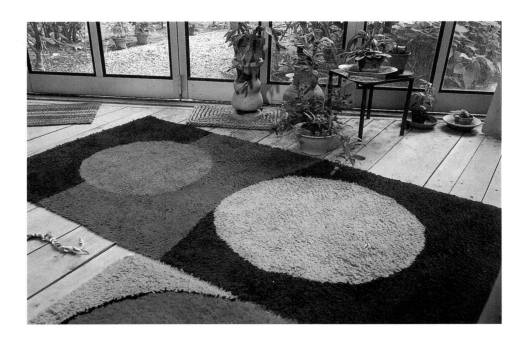

1 2 4

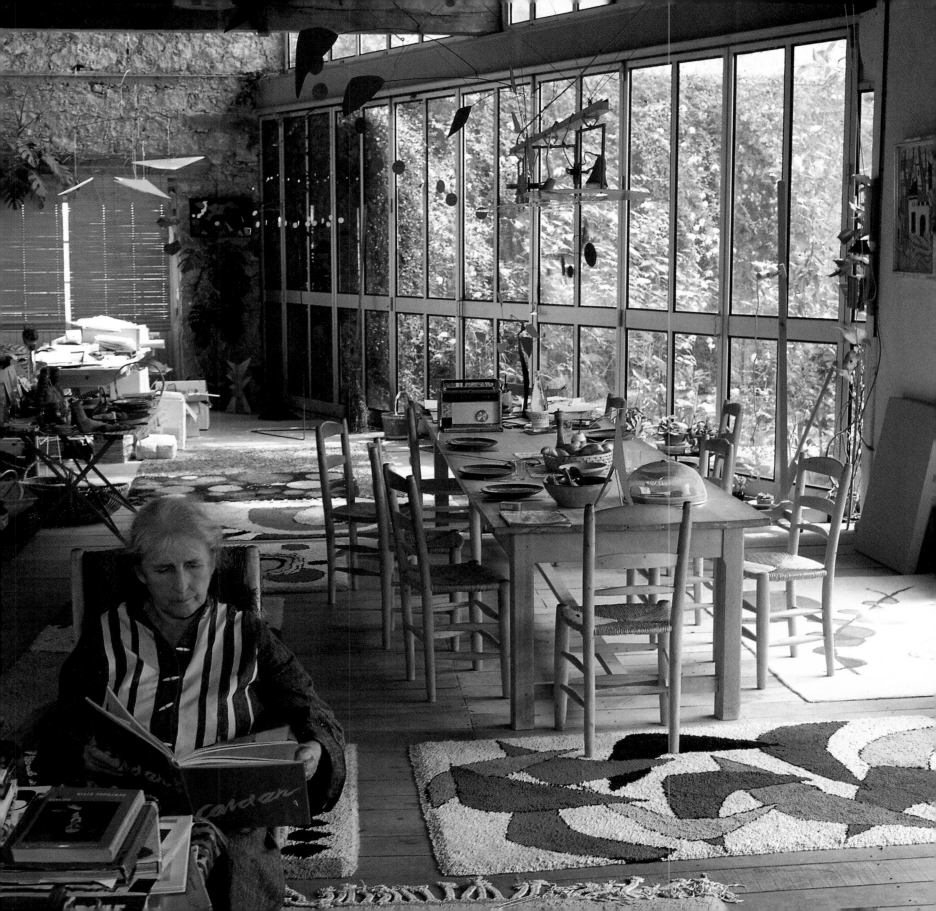

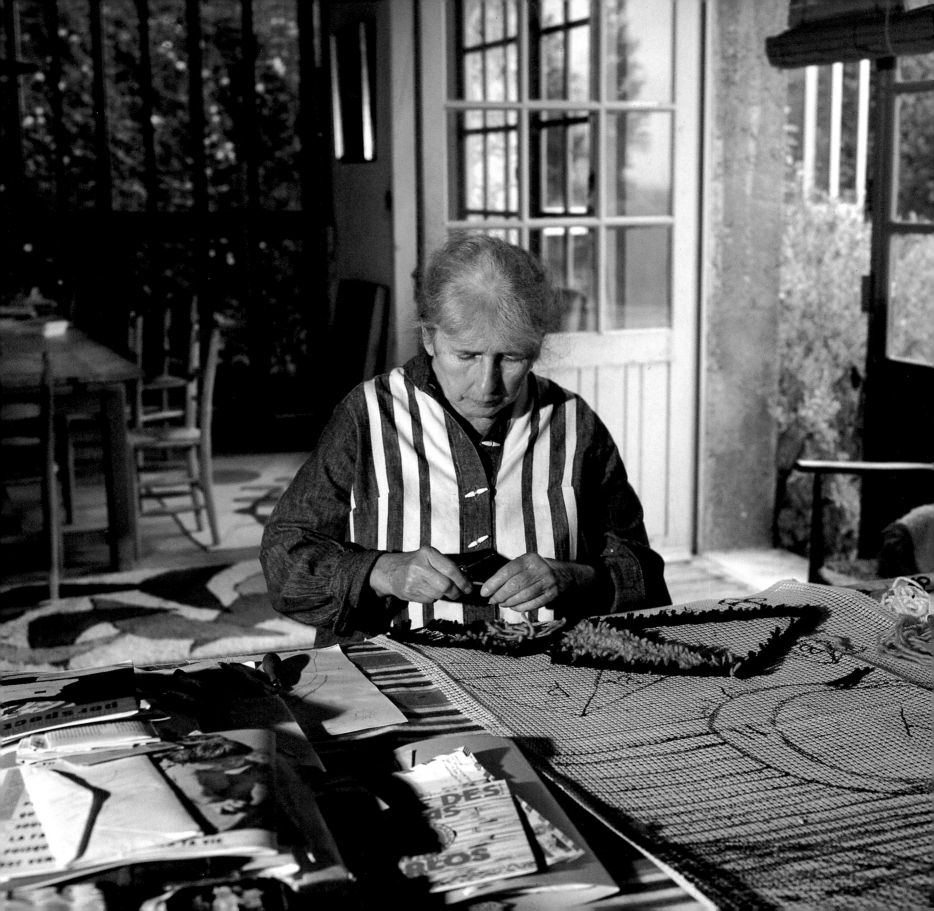

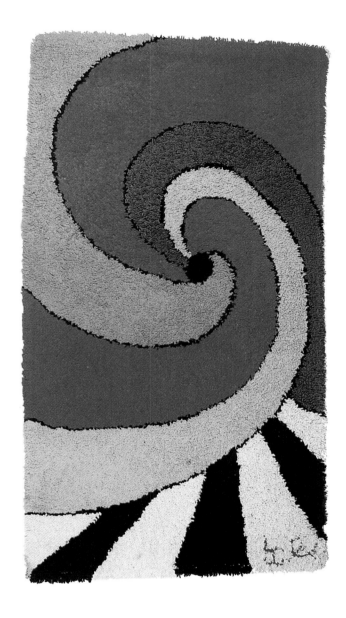

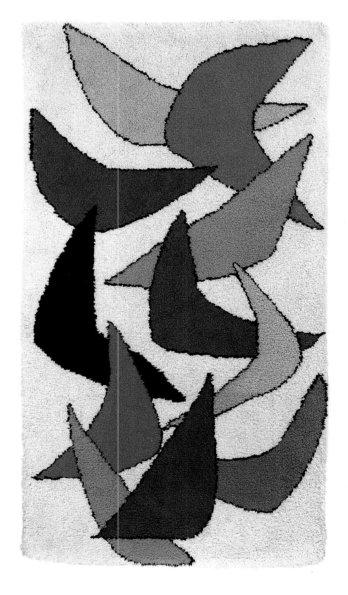

*T*o hook her colorful rugs, Louisa would select one of Sandy's designs and he would enlarge and transfer it onto her working base. Her output was prodigious despite taking care of Sandy and their domestic needs. The floors in Roxbury and Saché were almost wall to wall with patterned rugs, such as *Spiral* (above left) and *Boomerang* (right), both from 1972. And she had enough to give to friends.

Dominating one end of the living area was a large fireplace surrounded by an informal arrangement of sofas and chairs where Sandy and Louisa relaxed or entertained. In the center, adjacent to a row of windows, stood a long dining table, accommodating at least twelve chairs. Opposite the windows, a long wall harbored all the elements that made up Louisa's spacious, open kitchen— an electric stove, a double sink, a refrigerator, and a work table covered with exotic baskets, utensils created by Sandy, and other colorful objects. Above the utensils hung a brilliant painting by Joan Miró and a selection of African masks and fetishes. This large, well-equipped, and modern space was everything that the primitive kitchen in François Premier was not.

The ceiling in this generous room soared to nearly thirty feet above the dining area, perfectly suiting Sandy's mobiles—they hung down and twirled lazily with the slightest breeze. For once there was enough space to avoid collisions. The walls, again recalling their first house in Saché, were whitewashed. All the color came from the artwork and an almost seamless array of Louisa's hooked rugs and a selection of Near Eastern carpets that adorned the wooden floor. The brilliant blue, red, and yellow yarn warmed the bright space.

The kitchen reflected Louisa's needs and her passions for cooking and collections—baskets, crocks, pots and pans, ladles and bowls. Over-looking all were two African masks, the 1931 wire sculpture of her, and a painting by Miró.

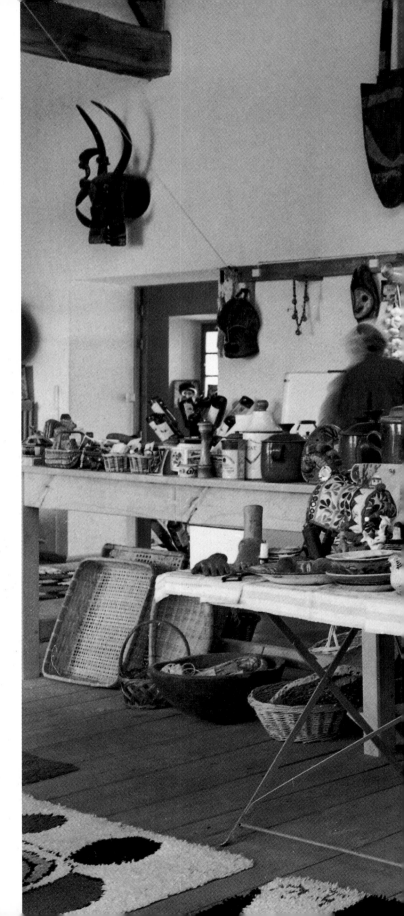

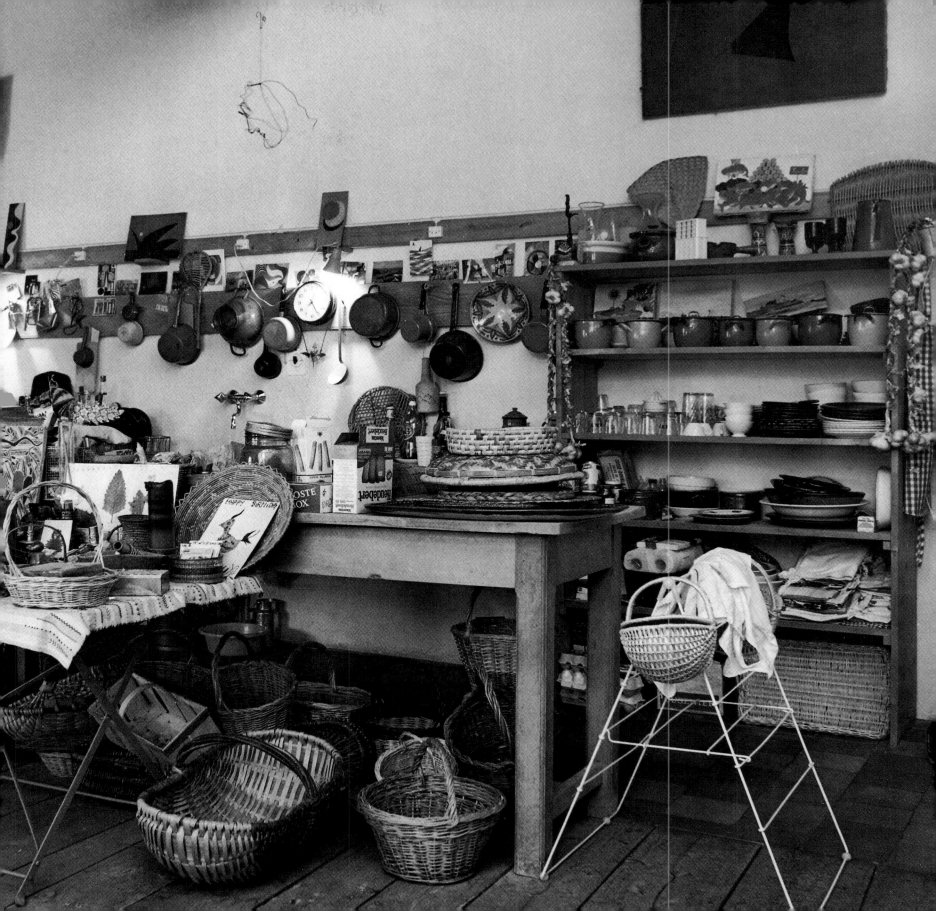

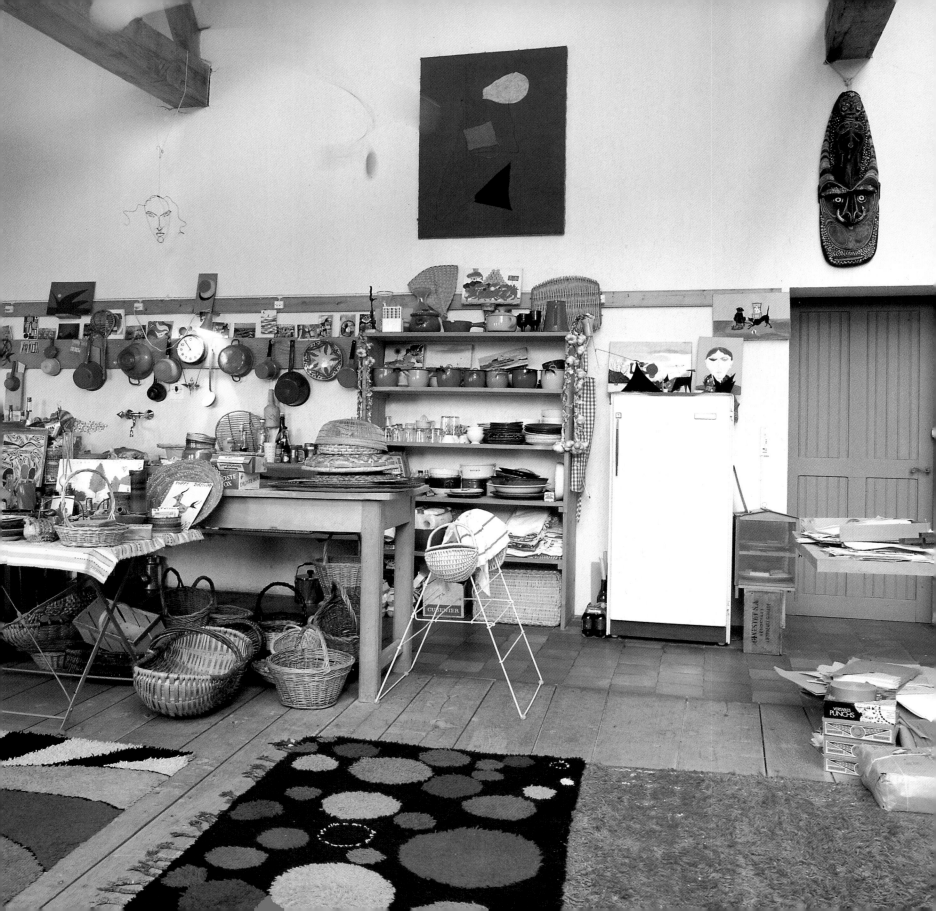

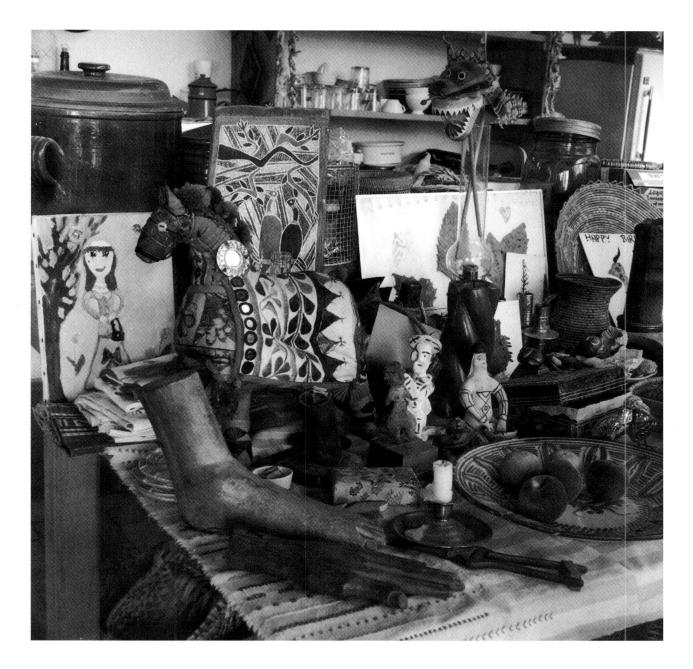

Even with its distinctive French and Calderesque look, the kitchen was fully equipped with modern amenities such as a refrigerator (opposite). A locally bought folding table held the eclectic array of objects purchased by the Calders in their travels—fetishes, candlesticks, pottery, and baskets (above).

Behind the kitchen, a doorway led to a large corridor where Sandy's gouaches and oil paintings were stacked against a wall in great abundance. The bedroom on the second floor was reached from this corridor, as was a special room in the cellar set aside for Sandy's billiard table. He loved billiards and invited anyone interested to join him in a game, although he once became annoyed with me when I failed to live up to his expectations of a worthy opponent. *You're no damn fun,* he snarled, throwing down his pool cue in disgust. He could function better than I with any amount of red wine and didn't recognize the need to grant me a handicap.

Settling into the new place, the Calders more and more made Saché their principal residence. After they had been there two or three years, they decided to stay in France for an entire year, making Roxbury their second home. Occasionally they would come back to the States just to see their dentist, usually in the fall—a well-heralded visit resulting in much socializing.

Following a path defined mostly by hooked rugs, one passed through the corridor leading to the basement and the second-floor bedroom (right) and into the most important room of the house (opposite), the all-purpose living-dining-and-kitchen room, poised under a ceiling hosting a swarm of Sandy's mobiles.

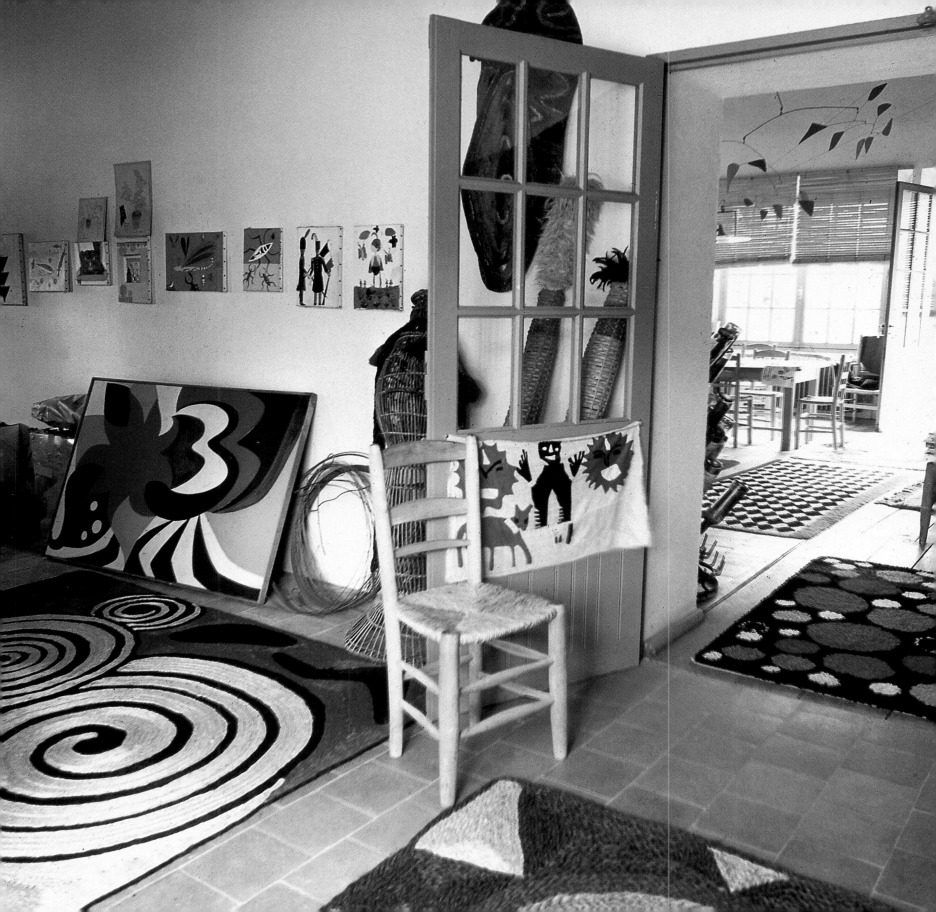

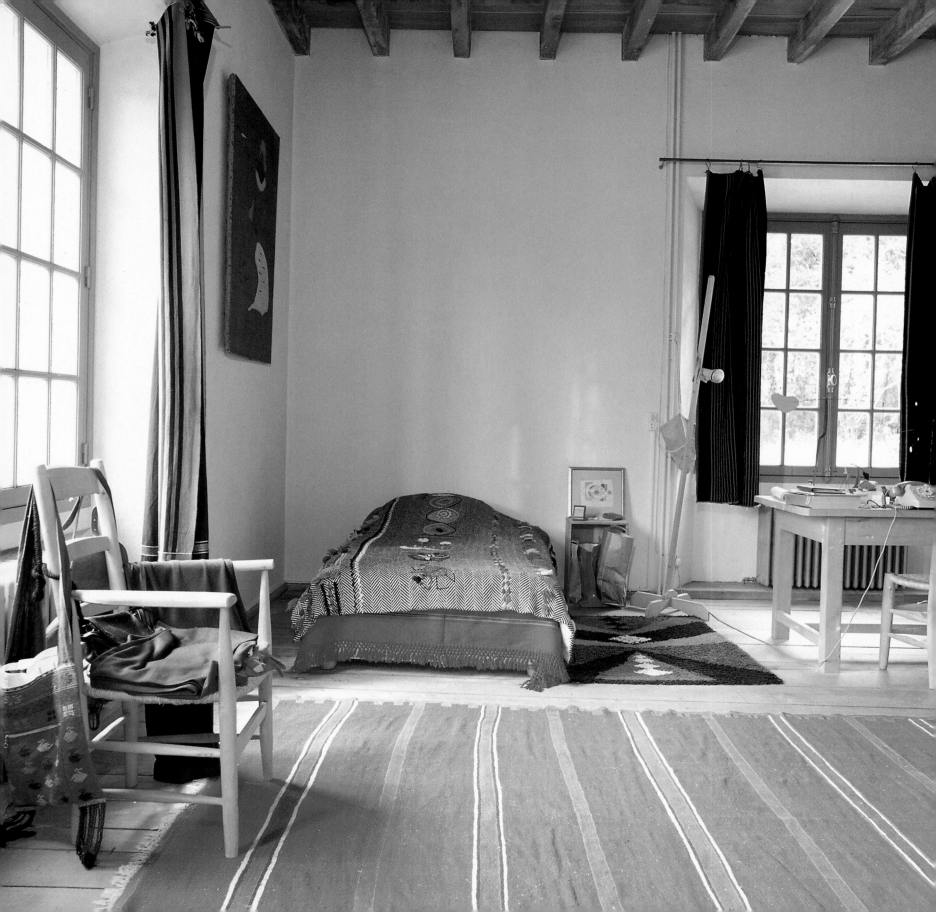

The Calders' bedroom
(opposite) was stark—
they spent little time
there. The furniture
was simple and local,
most of it carried over
from the abandoned
François Premier. A
propped-up Miró paint-
ing graced the bureau
(right). As usual, fabrics
and textures enlivened
the space perfectly.

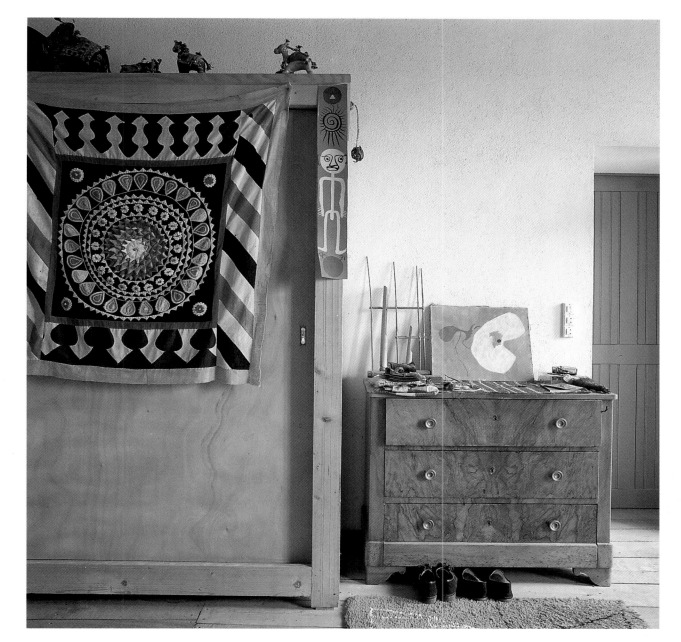

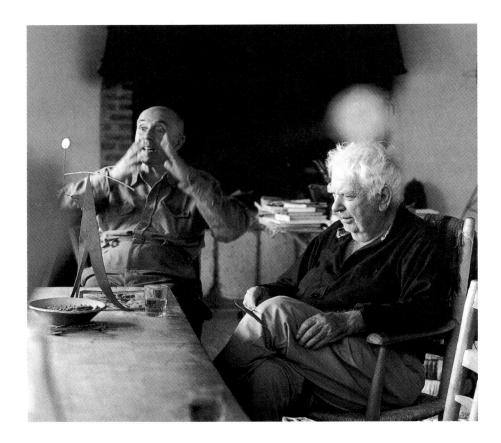

Jean Davidson (above) was always a fine companion, not to mention a chauffeur to Paris when the Calders needed one. Sandy kept abreast of world events by devouring the newspaper daily (opposite).

Their daily routine had not changed much. Louisa still cooked all their meals, and Sandy was now only a few feet from the large stabile studio and a neck-breaking, Citroën-fueled dash across unplowed fields to the mobile and painting studios. In the house Louisa had a permanent and airy spot in which to hook rugs, and Sandy could spread out his morning papers, neither encroaching on the other's space.

The demands on their time on both continents continued, but the constant whirl of travel and the hubbub seemed to energize them. Paris was only a two-hour drive from Saché—less if Jean Davidson was driving. And Paris in those years became more central than New York City to Sandy's needs. Lithographers, the Galerie Maeght, and the airport were the hub for his spreading domain.

At the end of our visit in July 1976, the Calders were planning to leave for a short trip within Europe. In the fall they would return to the States for a major new retrospective of Sandy's work at the Whitney Museum of American Art in New York City. It turned out that this was to be my first and final visit to this glorious house and that my photographs would be the last to document the "new shack" as Sandy himself saw it for the last time.

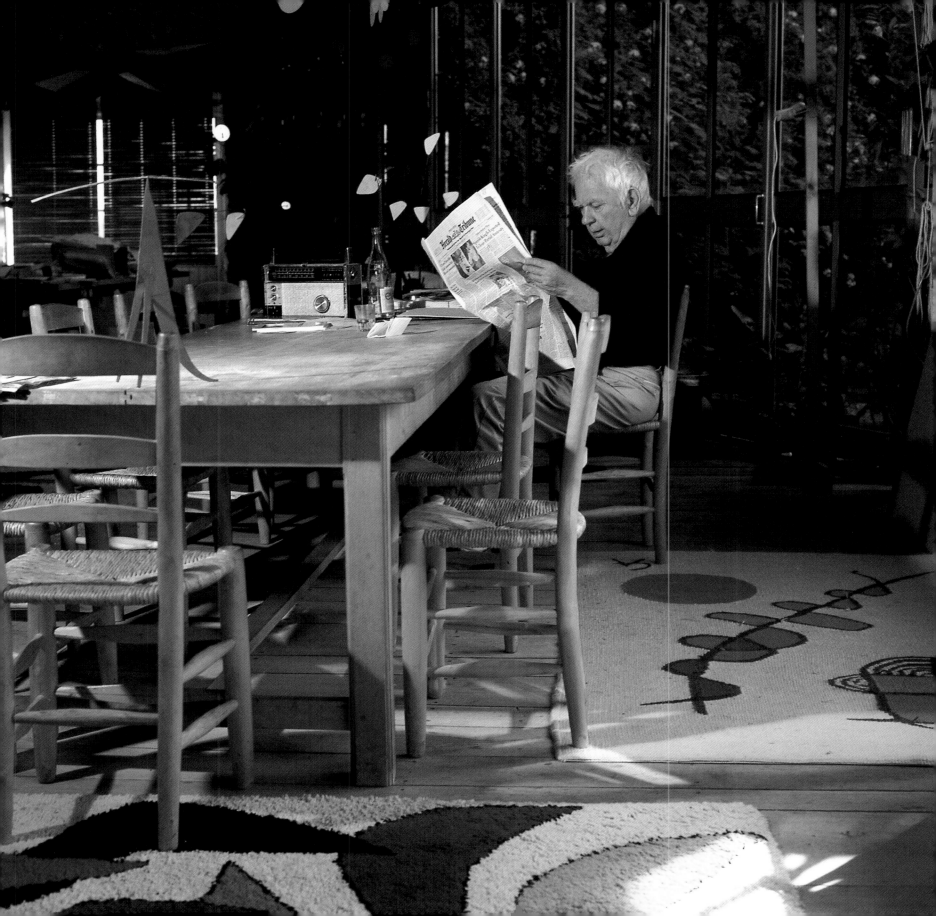

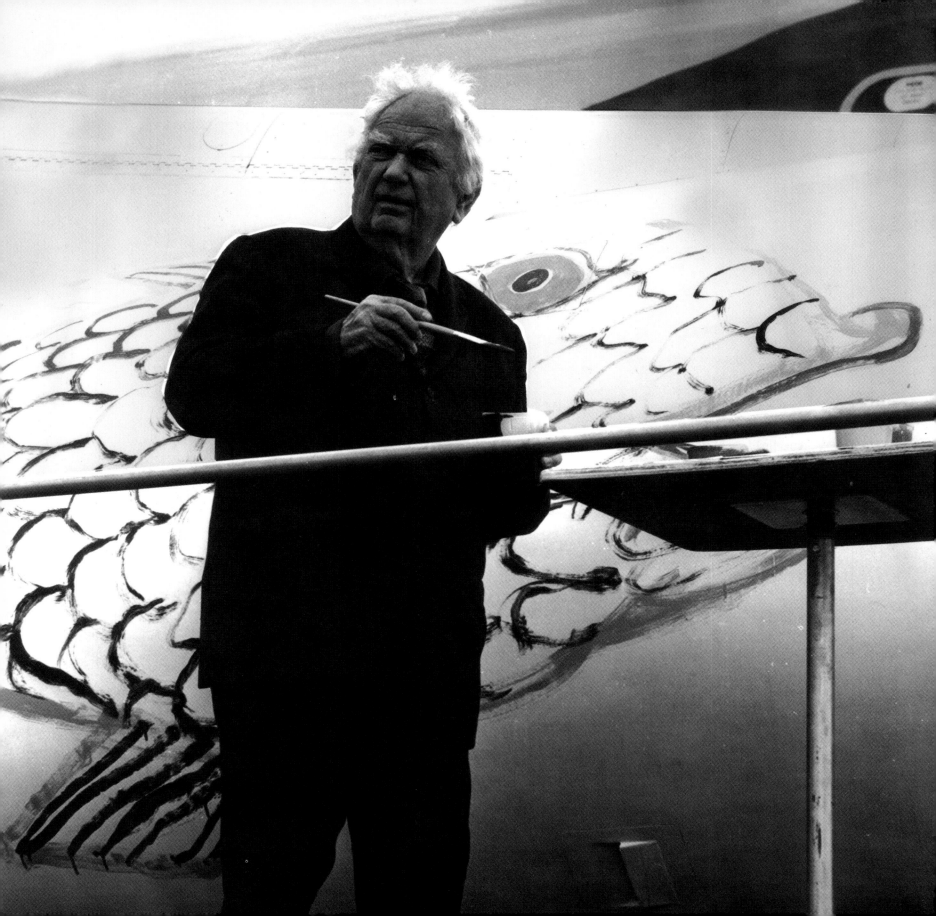

Flying Colors Calder

Mustering my resources and taking advantage of a bargain flight—sponsored by Braniff International and the Whitney Museum of American Art—I had flown to Paris to take part in the May 1975 festivities celebrating Sandy's final Braniff plane, held at Le Bourget airport during the Paris Air Show. We "Friends of the Whitney" and passengers on that privileged flight clustered against a cyclone fence to see Sandy paint flying fish on the engine covers of a DC-8. The rest of the Calder design—great waves of undulating colors— had been spray painted some other time and place.

I hadn't had time to inform the Calders that I was coming to Paris and that I wanted to travel from there to Saché to see the "new shack." So it came as a complete surprise to Sandy to see me trying to fit my camera lens through the restrictive wire openings in the fence. He climbed down from the elevated platform on which he was painting and, after his customary bear hug, personally opened the gate to allow me unobstructed and unlimited views of his work. When he was done, we all took off in the plane, with colors flying, to see France from above.

The Braniff *Flying Colors* were the ultimate Calder mobiles—heavier, more expensive, but certainly the highest of all of Sandy's great constructions. One flew to South America, the other to Europe. The planes outlasted the company, however. Braniff ceased to exist in 1980, and the former flagships were repainted or scrapped by the new owners.

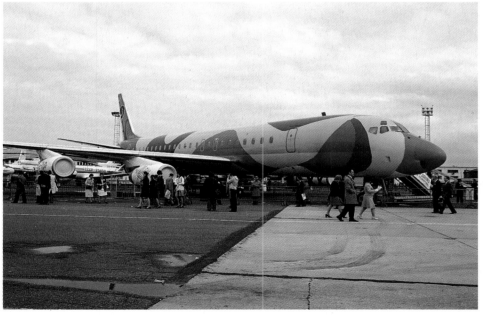

"SANDY THE MAN, THE FRIEND, HAS A HEART AS BIG AS NIAGARA.

CALDER THE ARTIST HAS THE FORCE OF THE OCEAN."

Joan Miró

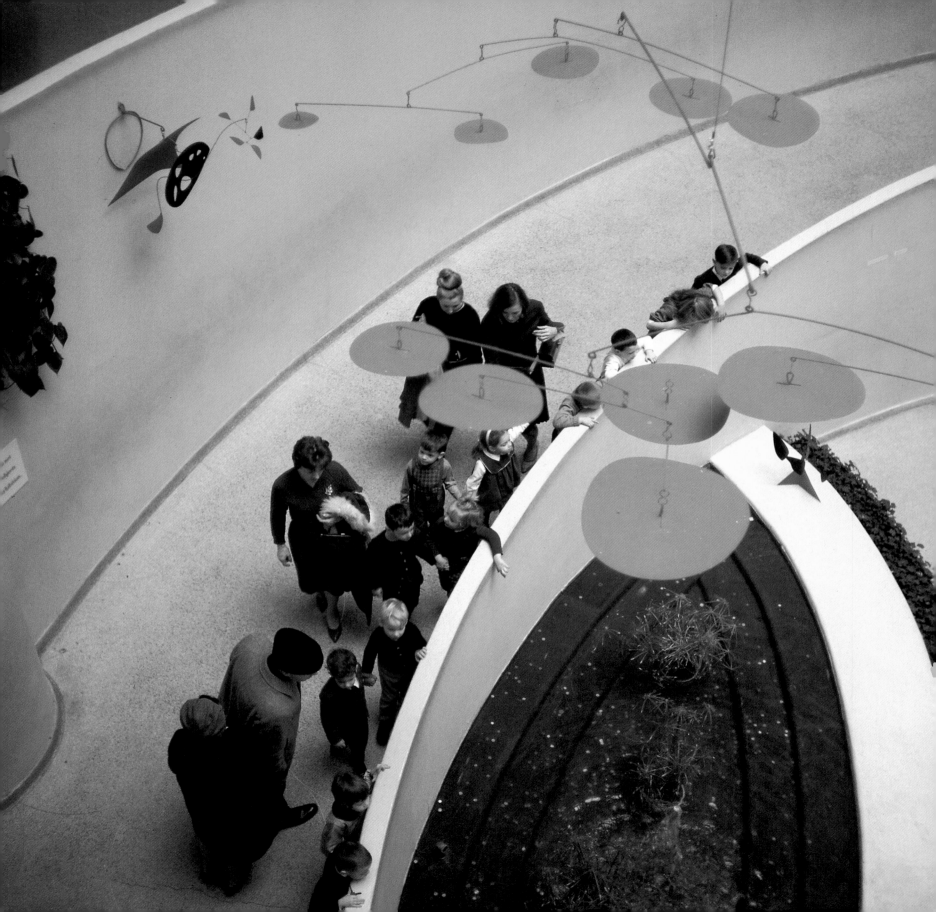

Frank Lloyd Wright allegedly once asked Alexander Calder to design a mobile for him, but Mr. Wright asserted that he wanted it made of gold. *I will make it out of gold,* Sandy is said to have responded, *but I'll paint it black.* Although the story may or may not be true, it underscores the difference in their characters—Mr. Wright, the aristocrat, and Sandy, the blacksmith.

The two were certainly aware of each other even if they never met. Calder no doubt would have been put off by Mr. Wright's regal airs. Sandy's impatience with pomp wouldn't have allowed him to see the humor in the architect's intentional theatricality. That Mr. Wright admired Calder's work is apparent, however: when he chose one object by a living artist to adorn the entrance to an exhibition house put up in 1953 on the site of the future Guggenheim Museum in New York City, it was a Calder mobile *(The Moon and the Loop).*

Eleven years later, in 1964, Sandy opened a retrospective of his work at the finally completed Guggenheim Museum—the 1959 building that was the crowning achievement of Mr. Wright's later years. By then, he had been dead for five years. But surely he would have approved of this Calder retrospective in his museum. Sandy, though, said he never thought much of the spiraled Guggenheim, calling it an *ice cream cone of a building.* He nevertheless went about hanging his hugely successful show with enthusiasm and glee. In fact, the space was perfect for his needs, and he knew how to manipulate it— like Mr. Wright, space was Calder's medium.

Sandy's career was catalogued in the imposing rotunda and on the encircling ramps from November 1964 to January 1965. A huge but graceful mobile thirty-five feet long—probably the largest of its kind at the time—hung from the center of the rotunda's art glass ceiling. *Ghost* (1964), as it was called, was the only major work specifically designed for the show. Painted white to blend into the museum, it hovered gently over Sandy's giant stabile *Guillotine for Eight* (1963). This mammoth black construction could be seen unobstructed along with other Calder works from the very top of the ramp, from every angle moving down, and from up close on the main floor. A mobile appropriately named *Red Lily Pads* (1956) dangled over the pool on the museum's main floor, revolving in the breeze. Smaller mobiles were suspended from the ceiling of the sloping ramp and swam lazily and true, moving in the draft created by the migrating crowds. Some mobiles were hung low enough so that children could blow on them or push them gently—a travesty to the staff. Sandy's wire sculptures danced on pedestals. Paintings and tapestries dangled on wires. Several large stabiles graced the outdoors. It was a celebration of color and motion.

At the Guggenheim in 1964 children—among them mine—delighted in *Red Lily Pads* (opposite) and other mobiles. Ben Guerrero (below) added his own wind drafts, to Sandy's joy and the curators' horror.

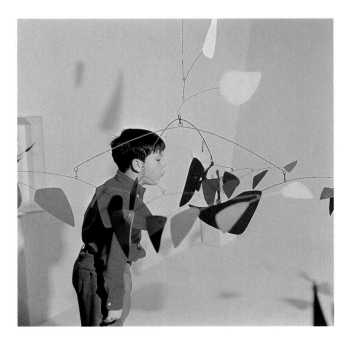

1 4 3

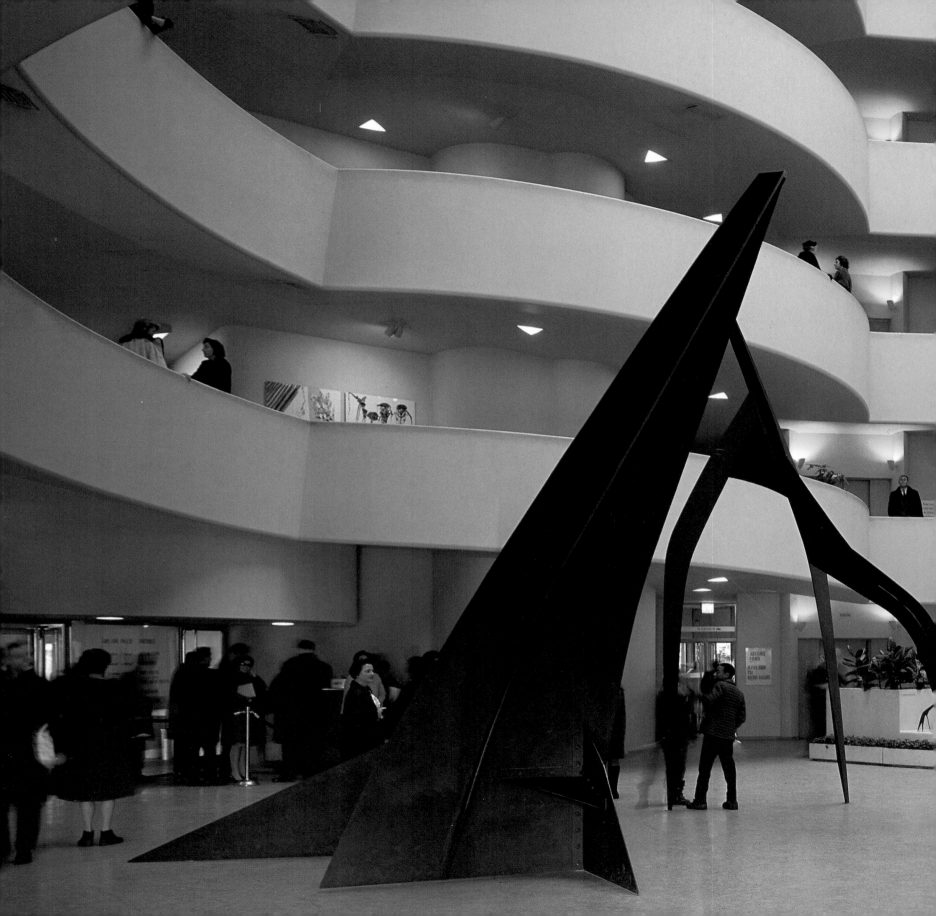

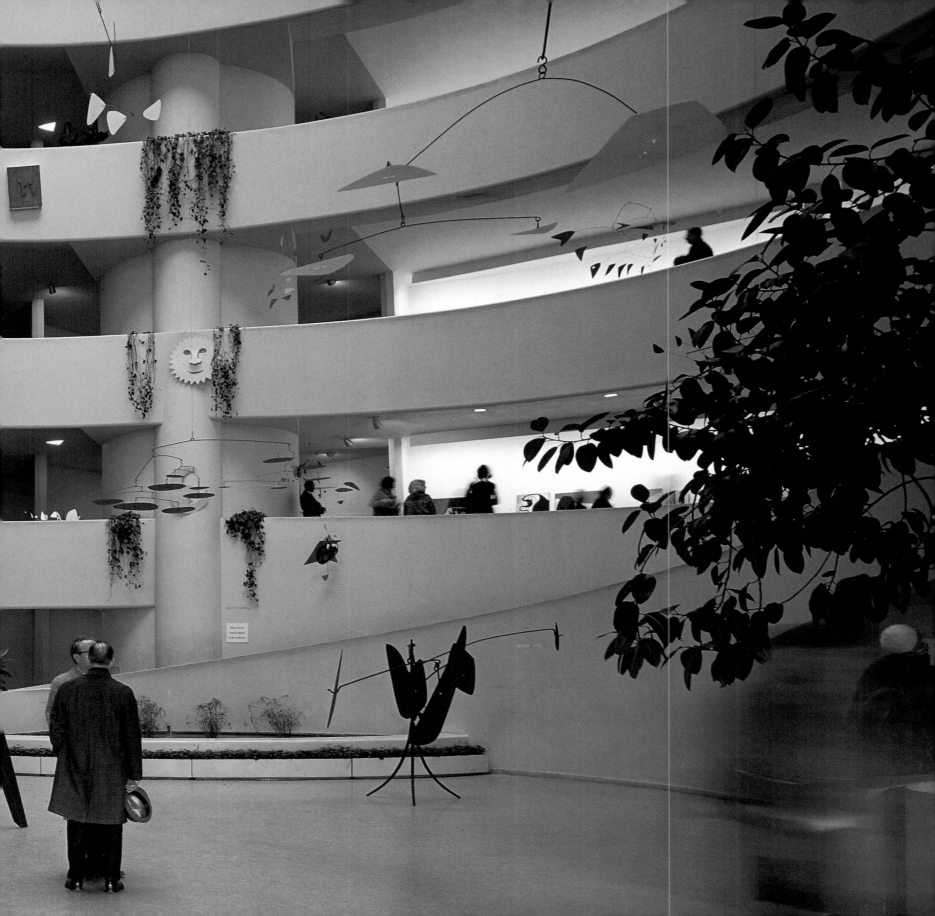

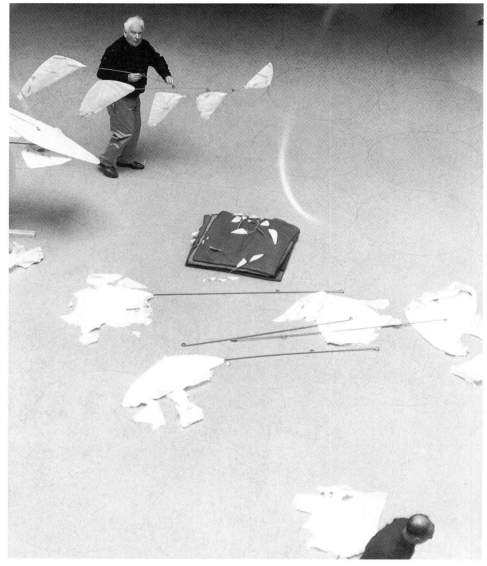

While preparations for the Guggenheim exhibition were under way, one staff person—working from Polaroid photographs of objects scheduled for installation—would ask Sandy: *And what is the name of this?* (Museums want titles on everything.) Sandy would walk over to where the item was stored and come back with something from his mother lode of fanciful names. *That we will call "Knobs and Curlicues,"* he replied, anointing his 1963 stabile. A red metal figure from 1945 would be *Portrait of a Young Man.* Asked the staffer: *Are you just making up those names now?* Sandy retorted, *Do you know a better way?* The names usually stuck, and Sandy never changed them.

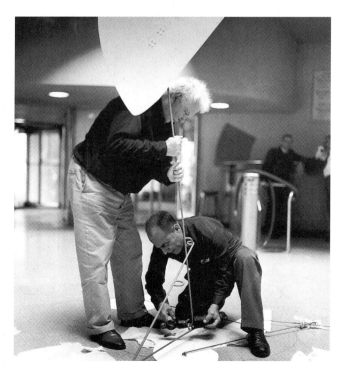

Sandy may not have liked Wright's design for the Guggenheim building, but he saw the advantage in being able to circle his works—especially the central duo, *Guillotine for Eight* and *Ghost*—from every possible vantage point (pages 144–45).

"Chippy" Ieronimo came from the Segré Foundry in Connecticut to help the artist install *Ghost* in the rotunda (left and above). Sandy instructed me not to *forget to take "Guillotine for 8" from above . . .* , so of course I did (opposite).

146

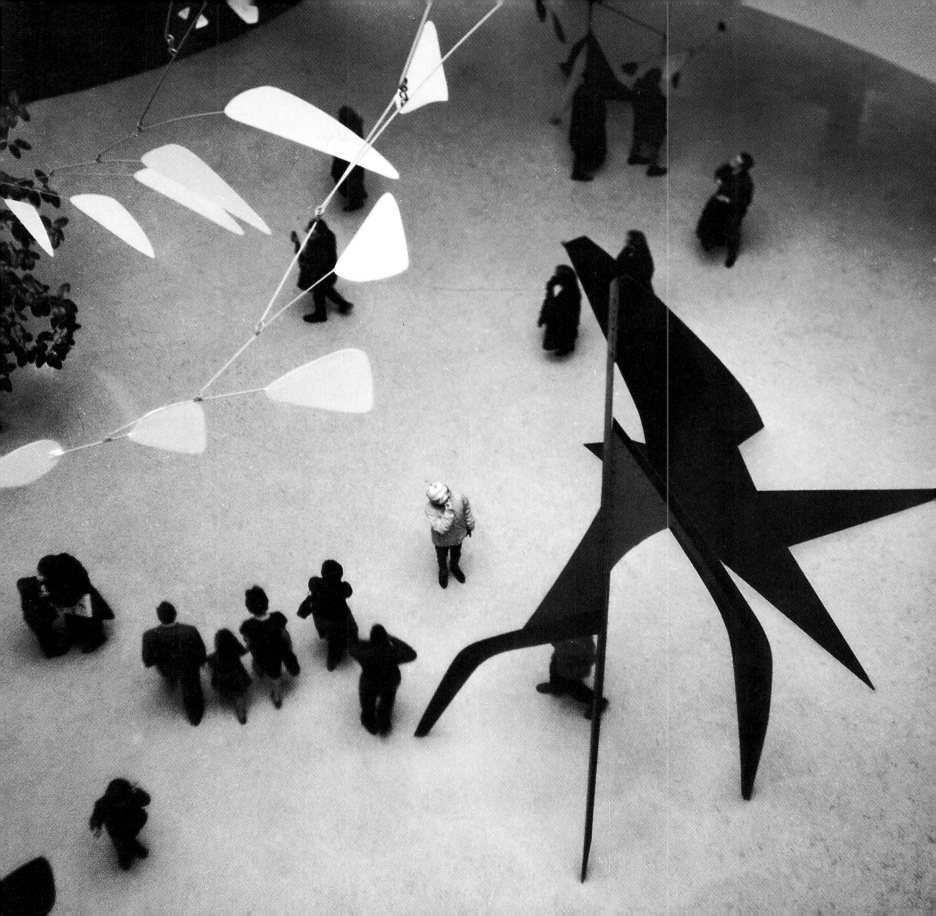

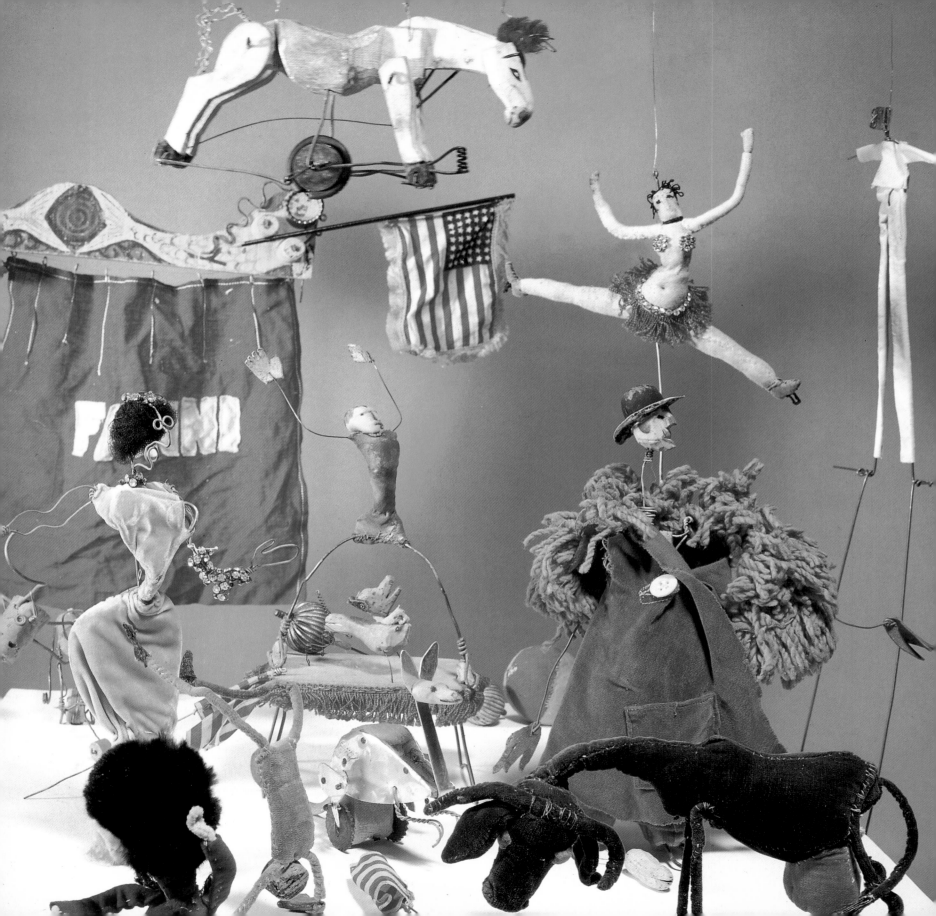

Adults and children both went home convinced that they could create Calders—it all looked so easy. The retrospective must have created an instant shortage of wire clothes hangers in many homes; it did in ours. After New York, the show made more Calder devotees as it traveled to the Milwaukee Art Center, Washington University Art Gallery in St. Louis, Des Moines Art Center, Art Gallery of Toronto, and, with changes, to the Musée National d'Art Moderne in Paris.

For the last retrospective in his lifetime, "Calder's Universe," held at New York's Whitney Museum of American Art from October 14, 1976, to February 6, 1977, Sandy assembled his famous circus for one final show. It was a highlight of the entire exhibition. By this time he had maintained the circus for nearly fifty years. Each performer, each animal in this world of wire was fully articulated—each a tiny gem of creativity—from the lasso-twirling cowboy to the man with a broom and shovel to clean up after the horses, camels, and elephants.

Sandy had long been fascinated by the circus, beginning with a 1925 visit to the Ringling Brothers and Barnum and Bailey Circus in New York City. Day and night for two weeks he drew pictures as a freelance artist for the *National Police Gazette* of the circus acts, moving from one vantage point to another to get the best views. The vivid scene, reinforced when he followed the circus to Florida, served as inspiration for his three-dimensional work.

Calder's circus was continually added to over the years until it grew from two suitcases of wire and paper performers to finally fill five. Performances were repeated in the States or anywhere he might be for any length of time, but his best reception was always in Paris. On the night before their wedding, Louisa and her family were treated to a special showing.

After the film of the circus was made in 1961, Sandy had rarely had time to put it together himself. The Whitney retrospective was a special occasion, however, and called for his personal touch. A case on the main floor was created just for it. Sandy, by then seventy-eight, arranged and rearranged the tiny characters, seemingly thrilled to be doing so. Balancing the miniature pieces in his big hands, he was completely absorbed in his work.

A half century after Sandy started creating his cast of circus creatures—assembling them and then storing them in several suitcases after each performance—he unpacked and positioned his unique circus in a special ring for "Calder's Universe" at the Whitney Museum of American Art in 1976 (opposite, below, and pages 150–51).

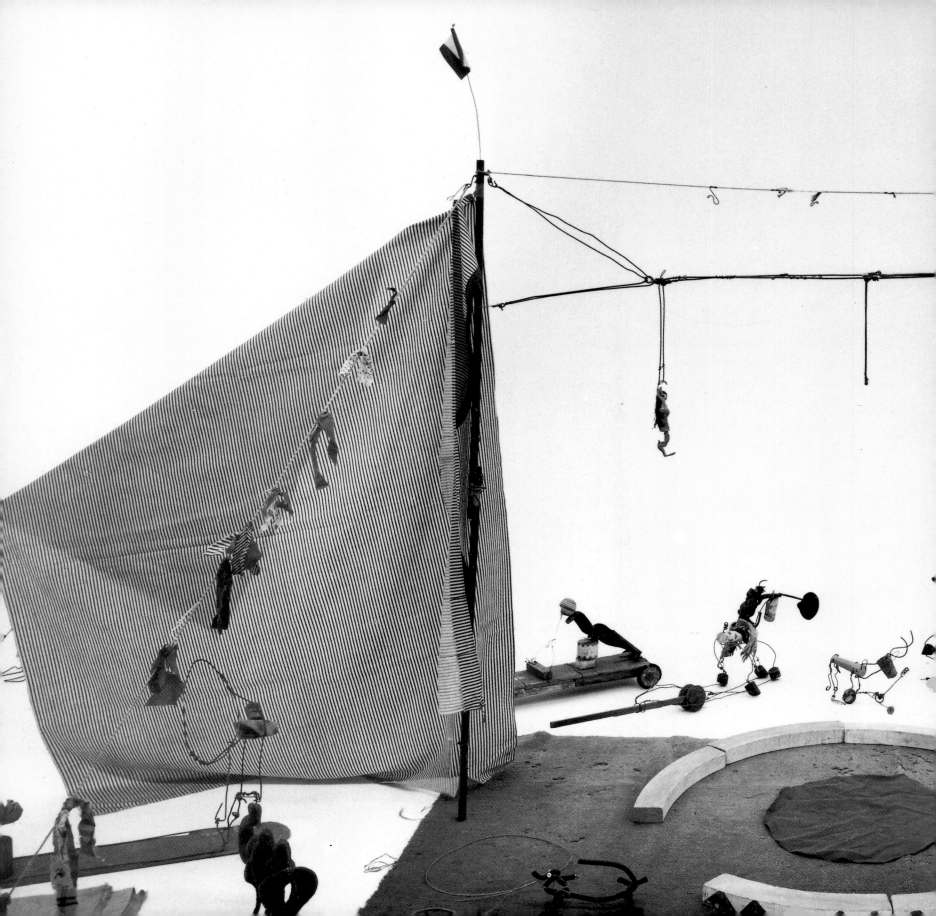

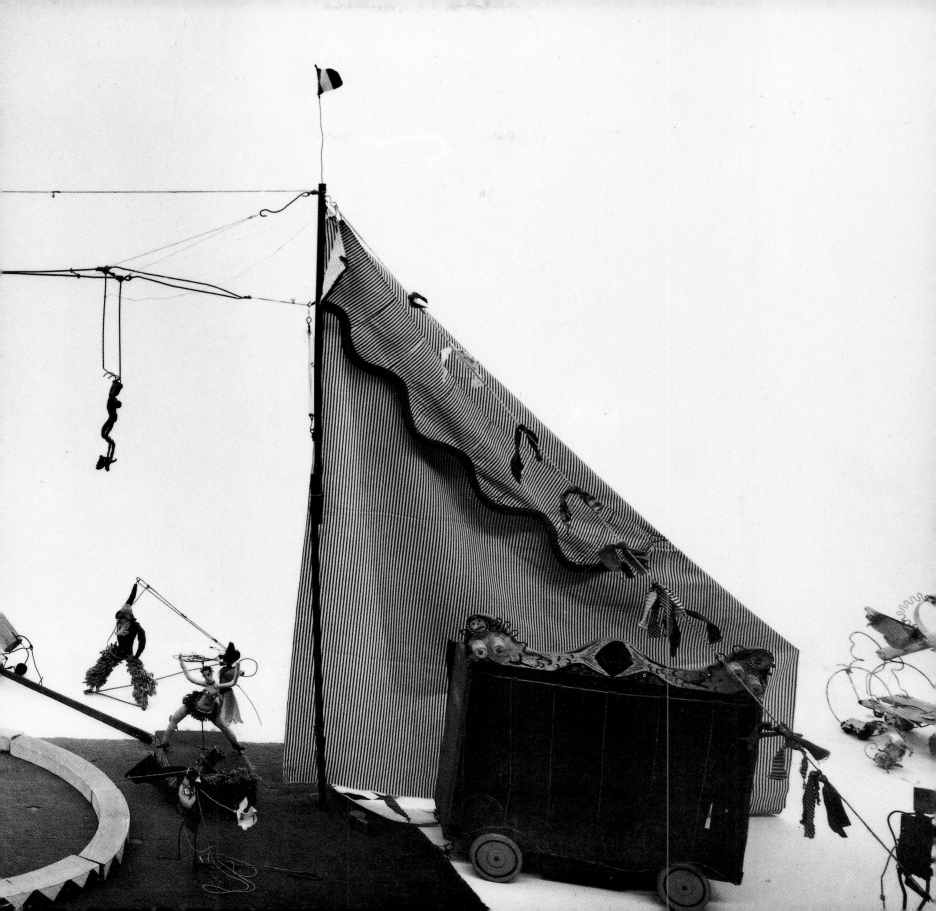

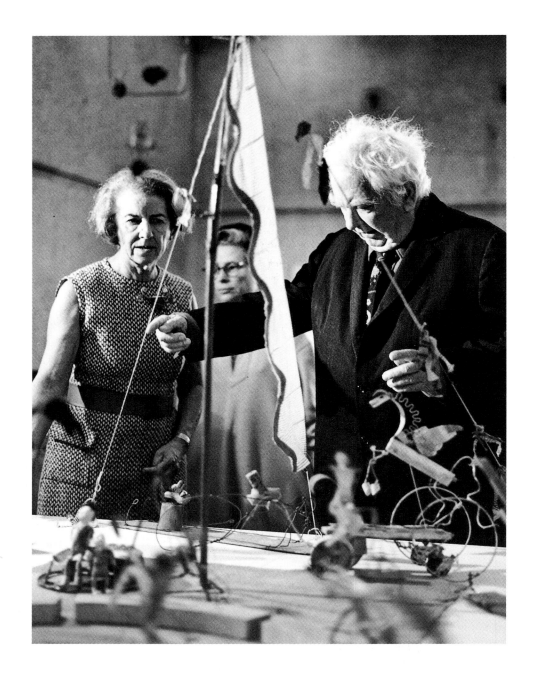

ean Lipman, editor of *Art in America* for thirty years, considered Alexander Calder *the most important American artist of any time.* She and her husband, Howard, president of the Whitney Museum for many years, were devoted collectors of Calder works and donors as well who made gifts to museums around the country. Among their major donations was Calder's *Le Guichet (The Box Office),* given to Lincoln Center in 1965. Connecticut neighbors of the Calders, the Lipmans visited them there and in France, where Jean remembers that he was known as "Monsieur Caldare" (accent on the last syllable). Jean and Sandy met probably for the last time at the 1976 Whitney retrospective in New York City, where I saw her listening intently to her friend of many years as he explained the intricacies of installing his famous circus. She compiled the show catalogue, *Calder's Universe,* which carried the same title as the exhibition. With its recollections from scores of friends and art critics, and even some photographs by me, Sandy considered it to be the official new book about him.

The opening of the Whitney show was the usual crowded, happy mob of people eager once again to be regaled by Sandy's joyous works. The basement-to-roof display of Calder creations in every medium brought together some of the art world's luminaries and the Calders' closest associates and friends—Georgia O'Keeffe, in from New Mexico; Louise Nevelson, Marcel Breuer, Virgil Thomson, John Cage, André Kertesz, Norman Mailer, and Arthur Miller; Klaus and Dolly Perls, his dealers and owners of Perls Galleries; Tom Armstrong, director of the Whitney Museum, and his wife, Bunty; Jean Lipman, longtime editor of *Art in America,* and her husband, Howard, president of the Whitney.

Lipman remembers that Bunty Armstrong was wearing a Calder-style dress she had designed for the occasion, and she asked Sandy to sign it for her. *I always sign my gouaches when they are flat,* he told her, *so lie down, Bunty.* Sandy took out his big pen, and as he bent down to sign Bunty's dress, he tumbled flat on top of her. Surrounded by a huge group of the opening-show crowd, he squirmed and struggled, trying to get up. A helping hand ended the impromptu event, with howls of laughter from the museum audience.

Both Sandy and Louisa were dedicated dancers, and Louisa in particular could dance up a storm. At the Whitney opening, she and the choreographer Merce Cunningham showed the gathering of celebrants how to do the Charleston right.

Before preparing to return to France, Sandy, the ringmaster, arranged all of his circus denizens where he thought they belonged. He put them in place for what turned out to be his last official act. A few days afterward, on November 11, I learned that he had died. *He woke up early one morning and said, 'I have a terrible pain in my chest,'* Louisa told my journalist daughter, Susan, in an interview some years afterward. *Three hours later he was dead. For him it was marvelous,* she added, explaining that the end was merciful for a man *who wasn't happy unless he was fiddling with wire.*

Only looking back at those last circus images at the museum did I detect any signs of age. Sandy's energy, animation, and joy in his work with the circus had masked his years. He had seemed as buoyant and lively as at our first meeting in Roxbury.

Louisa reflected in her interview with Susan that for the family, Sandy's death *was terrible. We had been planning to go back to our house in France, but after he died I had nothing particular to do. I didn't have to do the things one does when one has a house—I used to love to cook, have people around— and I stayed with one daughter and then the other. I crocheted for two years.*

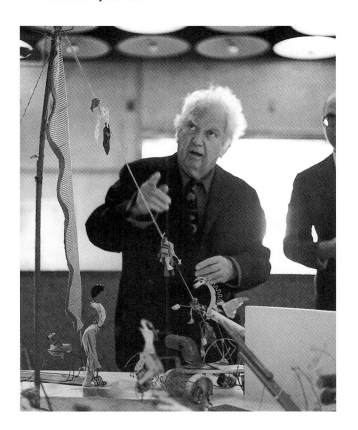

Surrounded by friends, patrons, and other admirers, Sandy carefully set up his circus tent poles and pennants and then tenderly arranged his performers, as he had so many times before. Here, at last, they would be on public display for all to see and rejoice in.

Sandy was posthumously awarded the Medal of Freedom two months after his death, in early 1977, but Louisa declined to attend the White House ceremony. In a letter to President Gerald Ford, Louisa—who in 1975 had been named the Woman of the Year by the United Nations—expressed her strong feelings about freedom, *particularly that freedom should lead to amnesty after all these years*. Amnesty for those who opposed the Vietnam War seemed, she wrote, *as though it were not going to happen*. Given this, to attend the ceremony would be inappropriate.

Louisa lived another twenty years and found time to publish a book on one of her own special interests: *Creative Crochet by Louisa Calder* (1979, Penguin Books). She spent time in Roxbury and traveled to Saché to visit with Sandra Davidson. I saw her for the last time at Mary and Howard Rower's house on MacDougal Street in New York City. She died on August 6, 1996, at the age of ninety-one. The properties in Roxbury and Saché—except for François Premier, which has been sold, *gouacherie* and all—remain in the family. Keeping the Calder legacy alive, the studio and the "new shack" are used for an artists-in-residence program.

Frank Lloyd Wright had been my mentor and hero, but Sandy Calder filled those roles as well as being my friend. Mr. Wright was a friend, too, although his aristocratic, somewhat aloof character never allowed me quite the same personal connection I experienced with Sandy. Frank Lloyd Wright was always "Mr. Wright" to me and to almost everyone who knew him. Sandy, down to earth and eminently approachable, was just Sandy. He would never have endured "Mr. Calder."

Sandy taught me to be myself, and his enthusiasm and joy were a constant inspiration. He came into my life just a few short years after Mr. Wright's death, giving it new direction. In the two decades since Sandy died, I have yet to encounter another such creative force who has had such a lasting impact on my life.

Sandy finished masterminding his circus for the last time. In the final photograph I took of him, he appeared pensive, perhaps sad. We made plans to meet again soon, but he died shortly before we had that chance.

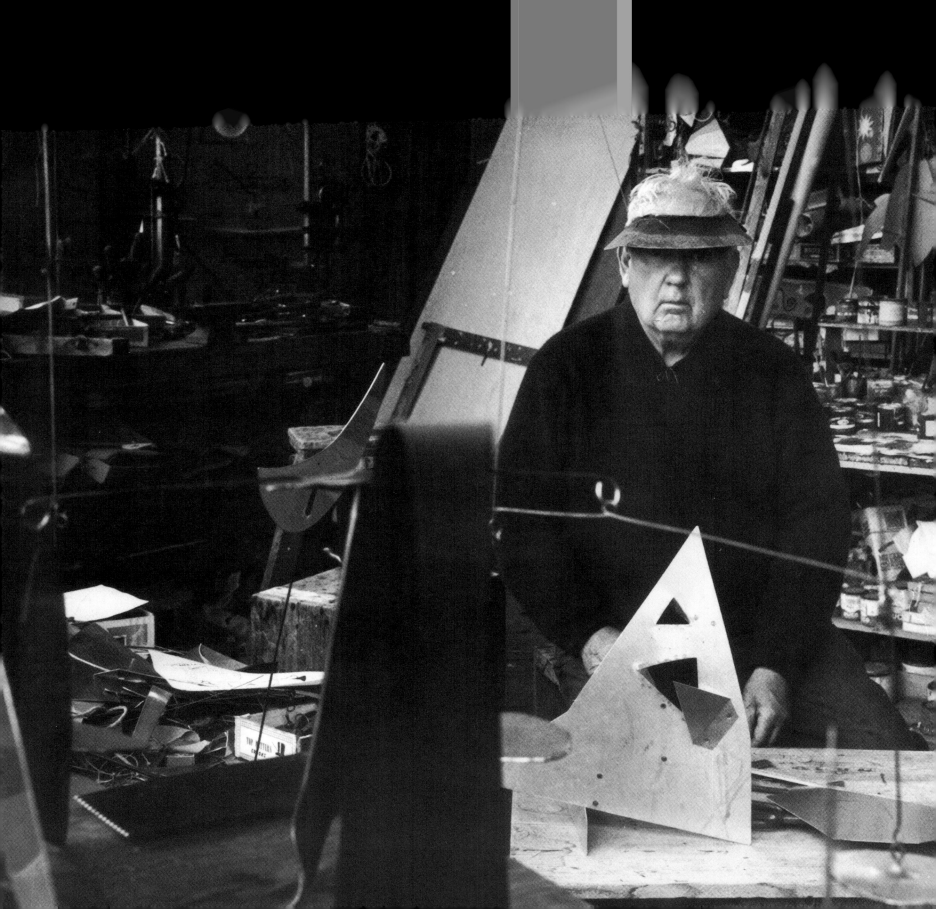

acknowledgments

For their assistance with this book, I am in the great debt of the following persons:

● My daughter Susan, for allowing me to quote from her interview with Louisa Calder.

● The other Sandy, Alexander S. C. Rower, director of the Alexander and Louisa Calder Foundation, for his research help and foreword.

● Mary Calder Rower and Sandra Calder Davidson, for their friendship and enthusiasm for this project.

● My friend Jean Lipman, for her encouragement and support over so many years.

● That tough taskmaster Diane Maddex and her top-notch creative staff at Archetype Press, including the book's designer, Robert L. Wiser.

● Finally, I owe special thanks to my dear friend Dixie Legler. Without her inspiration and help, this book would not have been possible. And so I dedicate *Calder at Home* to her.

Pedro E. Guerrero

Grateful acknowledgment is also made for use of the following quotations in this book:

● John Canady: From *Calder's Universe*. Text © 1976 by Jean Lipman.

● Katharine Kuh: From *Calder's Universe*. Text © 1976 by Jean Lipman.

● Thomas M. Messer: From *Alexander Calder: A Retrospective Exhibition*. © 1964 The Solomon R. Guggenheim Foundation, New York.

● Joan Miró: From *Calder's Universe*. Text © 1976 by Jean Lipman.

● Selden Rodman: From *Calder's Universe*. Text © 1976 by Jean Lipman.

● James Johnson Sweeney: From Preface, *Calder*. Maeght Editeur, 1971.

● E. Szittya: From *Kunstablatt*, June 1929.

Index

Published in 1998 and distributed in the U.S. by

Stewart, Tabori & Chang
A division of U.S. Media Holdings, Inc.
115 West 18th Street
New York, New York 10011

Distributed in Canada by

General Publishing Company Ltd.
30 Lesmill Road
Don Mills, Ontario, M3B 2T6, Canada

Distributed in Australia by

Peribo Pty Ltd.
58 Beaumont Road
Mount Kuring-gai, N.S.W. 2080, Australia

Distributed in all other territories by

Grantham Book Services Ltd.
Isaac Newton Way
Alma Park Industrial Estate
Grantham, Lincolnshire, NG31 9SD, England

Printed in Italy

10 9 8 7 6 5 4 3 2 1

Library of Congress Cataloging-in-Publication Data

Guerrero, Pedro E.
Calder at home : the joyous environment of
Alexander Calder / Pedro E. Guerrero ; foreword
by Alexander S. C. Rower
p. cm.
Includes index.
ISBN 1-55670-655-3 (hardcover)
1. Calder, Alexander, 1898–1976. 2. Sculptors—
United States—Biography. I. Title
NB237.C28G83 1998 97-28454
730'.92—dc21 CIP

Produced by

Archetype Press, Inc., Washington, D.C.
Project Director and Editor: Diane Maddex
Designer: Robert L. Wiser
Assistant to the Author: Dixie Legler

The typography for titles and initial letters used
in *Calder at Home* was adapted by Robert L. Wiser
of Archetype Press from lettering drawn by
Alexander Calder in 1966. Calder's signature was
written for his friend Pedro E. Guerrero to use on
the cover and spine of Guerrero's book *Calder*,
with text by H. H. Arnason (1966, Van Nostrand).
Based on these and additional letters and
numerals prepared for that earlier book, a special
font was developed expressly for *Calder at Home*.

The text was typeset in Foundry Sans, a sans-serif
typeface designed by David Quay of London.

Symbols appearing on the chapter divider pages
were drawn by Calder in 1966 for the book *Calder*
and used there within the text.

Front photographs: Page 1, *Portrait of a Young
Man* (1945). Page 6, Shelves in the Roxbury
studio. Page 7, Calder in Roxbury. Pages 8–9,
The Roxbury studio. Page 10, Calder outside his
Saché studio with *Bucephalus* (1963). Page 11,
Teacups and utensils made by Calder for the
Roxbury house. Pages 12–13, The view from the
Saché stabile studio, with *Sabot* (1963) and
Sagesse (1964). Page 14, Calder at the foundry
in Tours. Page 15, A table in the Roxbury studio.

Back photographs: Page 156, Calder in his
Roxbury studio. Page 157, Pedro E. Guerrero
as seen by Calder in 1966. Page 160, *Acrobat
Sign* (1928).

Endpapers: *Splotchy* wallpaper (1949).